# The World's Most Photographed

# The World's Most Photographed

Robin Muir

National Portrait Gallery, London

Published in Great Britain by
National Portrait Gallery Publications,
National Portrait Gallery, St Martin's Place,
London WC2H OHE
www.npg.org.uk/publications

To accompany a BBC TWO ten-part series and a major
exhibition at the National Portrait Gallery, London from
6 July to 23 October 2005

ISBN 1 85514 353 4

A catalogue record for this book is available from the
British Library.

Publishing Manager: Celia Joicey
Editor: Denny Hemming
Picture Research: Joanne King
Production: Ruth Müller-Wirth
Design: Andrew Ross
Reproduction by DL Repro Limited, London
Printed by Printer Trento, Italy

Jacket illustrations (front flap to back flap):
Mahatma Gandhi, 1944 (p.33); John F. Kennedy with
wife Jackie and daughter Caroline, 1960 (p.95); Marilyn
Monroe, 1956 (p.119); Audrey Hepburn, 1955 (p.133);
Elvis Presley, 1956 (p.159); Queen Victoria, 1887 (p.29);
Greta Garbo, 1930 (p.79)

Sponsored by Taylor Wessing

TaylorWessing
European law firm

# Contents

# Foreword

The aim of *The World's Most Photographed* is to bring overlooked photographic portraits to public attention, and to demonstrate one way in which photography and modern history are now inseparable. The ten selected figures could not be more different. Ranging from a crowned head of state, a US president and a fascist dictator to film stars, a rock and roll singer and a world-beating boxer, they share only the fact of lives pursued under public scrutiny, whether the curiosity of a nation or the intense glare of media attention. For each of them, there were choices to be made – how to appear, how often to be posed, how much to try to edit or control. Other people, crucially, also made choices around them.

Henri Cartier-Bresson wrote of what he called 'the decisive moment' in the taking of a photograph: 'the simultaneous recognition, in a fraction of a second, of the significance of an event as well as the precise organization of forms which gives that event its proper expression'. This definition perfectly encapsulates the brilliance of a few great photographers and photojournalists, those who have exploited circumstances, forging a telling image from a specific occasion. And such an image may have helped make an occasion still more historic, that photograph being the defining witness to the nature of the event.

In *The World's Most Photographed* we are offered a way of thinking about how 'the decisive moment' is constructed, how particular opportunities emerge in ways that were not always planned or expected. And equally, how the images of each of these figures have survived differing editorial processes. Some were hidden away by design, suppressed from view. Others were lost or forgotten. By being contrasted with more familiar, 'standard' images, they allow new readings of their subjects to be explored. This analysis may undermine a myth or stereotype but equally importantly it offers insight into the histories of celebrity and notoriety, demonstrating how an iconography is produced and repeated, often endlessly re-circulated as well-known images within magazines and newspapers.

All kinds of photographic genre are included – from the well-organised set piece portrait in the studio to spontaneous reportage photography – and all can play a part in the images that emerge of these well-known figures, both good and bad. This connects with part of the National Portrait Gallery's mission – through exhibitions, displays, publications and the education programme – to explore portraiture in all forms, seeking a wider understanding of how portraiture plays its part within cultural history.

This book is the outcome of a model collaboration with the BBC. I am grateful to Mark Harrison for suggesting the initial area for investigation and to Chris Granlund and Kim Thomas, together with the various directors and other colleagues at the BBC who have worked with us so closely and so positively. The images would not have been

available without the patient and diligent work of Joanne King, who with Celia Joicey, Denny Hemming, Andrew Ross and Ruth Müller-Wirth have created this exceptional publication. The book has been written and the exhibition curated by Robin Muir, and he deserves special thanks for editing huge amounts of visual and written material into intelligible, coherent and delightful form. I should also like to express the Gallery's thanks to the sponsors of the exhibition, Taylor Wessing, and to Michael Frawley. Their help has been invaluable in making this innovative project possible.

In the paparazzi age in which we now live, when media intrusion into the lives of public figures is a matter for continuing debate, the earliest photographs in *The World's Most Photographed* appear to belong to a distant era. It is the changing technology of photography combined with a less respectful set of editorial codes that has opened up images of the famous to even greater scrutiny. Indeed the book could ultimately be said to represent a kind of nostalgia, as we may already have passed the moment when unexpected images can remain a secret, or photographs can be lost from view.

**Sandy Nairne** Director, National Portrait Gallery

# Sponsor's note

It is a great honour for me to contribute to this book as Robin Muir and I share a common interest in the history and use of photography. My firm originally became involved in *The World's Most Photographed* project as we were looking to sponsor an event that would not only enable us to increase awareness, here in the UK, of our international legal capabilities but would also be of interest to our clients and contacts abroad. Taylor Wessing arose from the joining of two major law firms in 2002, Taylor Joynson Garrett in the UK and Wessing in Germany. We subsequently opened an office in Paris in 2003. While we are a law firm for the twenty-first century, we recognise the value of lessons to be learned from history and those who have shaped our world. It was clear to us that *The World's Most Photographed* book and the accompanying exhibition at the National Portrait Gallery would appeal to a wide audience, irrespective of age and culture, yet one which shared a similar perspective on life to our own.

 The subjects have been chosen not only because they represent some of the most photographed individuals of the twentieth century but also because photography was used to such great effect to create, alter or enhance their public persona. On one level, these images can be viewed as an historical record and on another level, as art; but there is more to the selected photographs than meets the eye. Queen Victoria, for example, was the first to use photography as a form of mass media to demonstrate to her subjects that she was in mourning. Likewise, Mahatma Gandhi used photography to convey his political message at a time when a substantial number of people in India could not read or write.

 It is thought provoking to compare 'official' photographs with the 'unofficial' ones taken when a subject's guard was down, such as those of Elvis Presley's infamous behaviour at a Munich strip joint and Greta Garbo's contemptuous gaze at the photographer who stalked her towards the end of her life. In addition, while these photographs were taken before the digital age, a number of the early techniques and tricks are still used to good effect today. For example, Freddie Mercury used his hands to frame his face for the *Bohemian Rhapsody* photographs, a technique used by Greta Garbo in the 1920s. A number of the photographs have never been in general circulation and it is interesting to read how they came to be taken, how they related to that particular time in the individual's life and why, in some cases, they were never released.

 This book by Robin Muir is an ideal way to ensure that you get the most out of the exhibition and the ten-part television series produced by BBC TWO. Whether you are a member of the art loving public, or a client or member of Taylor Wessing, I hope that you will enjoy the photographs and the stories behind them as much as I have. The question is, will you look at these individuals in the same light afterwards and will you now be encouraged to look for the story behind other such photographs?

**Michael Frawley** Managing Partner, Taylor Wessing

*Diane Arbus: A Biography*
Patricia Bosworth, 1984

'A photograph is a secret about a secret. The more it tells you the less you know.'

Diane Arbus

# 1  Queen Victoria

## Queen Victoria (1819-1901)

Opposite
1 The Royal Family at Buckingham Palace
Roger Fenton, 1854

The Royal Family in the Palace gardens (left to right:
Prince Leopold; Prince Alfred; Princess Helena;
Princess Alice; Albert Edward, Prince of Wales;
Prince Arthur (front); Princess Louise; Queen Victoria;
Victoria, Princess Royal; Prince Albert). Despite the
prearranged nature of the group, the picture has the
character of a snapshot; it was taken quickly not least
because of the weather and the proliferation of children.
It is perhaps the first such picture of a reigning monarch
and her family. Fenton, popularly known for his
photographs of the Crimean War, was a frequent visitor
to the royal households in the 1850s.

Shortly before lunch on 22 May 1854, a group of children and two adults arranged themselves for a photographer in the gardens of Buckingham Palace (fig.1). The adults were Queen Victoria and her consort, Prince Albert; the children the eight royal siblings. The Queen noted in her journal: 'a very windy, dull morning after much rain. We were photographed with all the children, an instantaneous picture, which is very curious as it even seizes & fixes motion ...' It was one of the first informal photographs of a reigning monarch and her family, an early example, perhaps, of the 'snapshot aesthetic', which would reach a climax – as far as this family was concerned – in the final years of the following century.

This picture was not strictly 'instantaneous', either technically or creatively, for the subjects were prearranged in an attempt at a harmonious gradation, with the smallest on the left and the tallest to the right. However, a family for whom informality in self-presentation was not traditional was portrayed with the spirit of spontaneity. The photographer that day was Roger Fenton, who would become a seminal figure in the development of British photography and an early war photographer. His 'instantaneous pictures', despatched from the Crimean peninsula, were reported as occasionally contrived. But he would not be the last practitioner to challenge the notions of truth and fidelity, which were already enshrined at this early stage in photography's history.

A group shot taken earlier, in 1852, by William Edward Kilburn (figs 4, 5) – the earliest photograph of the Royal Family to survive – had not received similar approbation. While the children looked presentable, the Queen did not. As the shutter was depressed, she moved slightly and was caught with her eyes shut. 'Horrid', she wrote in her journal. When she saw the result on the metal daguerreotype plate, she obliterated her image by erasing it with her thumb. Kilburn would continue to be luckless with the Queen. At a sitting arranged for the morning of her eldest daughter's wedding in 1858, she moved again: 'I trembled so, my likeness has come out indistinct ...' Despite such early misgivings, in the decades to follow Queen Victoria would sit for the camera on hundreds of occasions, becoming the most photographed woman of her age.

The Queen became fascinated by, and curious about, the possibilities that this new art form afforded. Both she and Prince Albert encouraged photography in its infancy. They became Patrons-in-Chief of the Royal Photographic Society on its founding, by Roger Fenton, in 1853. The royal couple's enthusiasm was prescient and far-reaching. In 1837, at the beginning of the Queen's reign, the discovery of photography was yet to be announced. By the time of her death sixty-four years later, from the mainland of the United Kingdom to the furthest reaches of the most powerful empire in the world, the camera was a pervasive force. Photography, which saw rapid technical advancement in the intervening years, would play a vital role in defining her sovereignty, not least in the dangerous times of fomenting republicanism. Though it was until then untried and

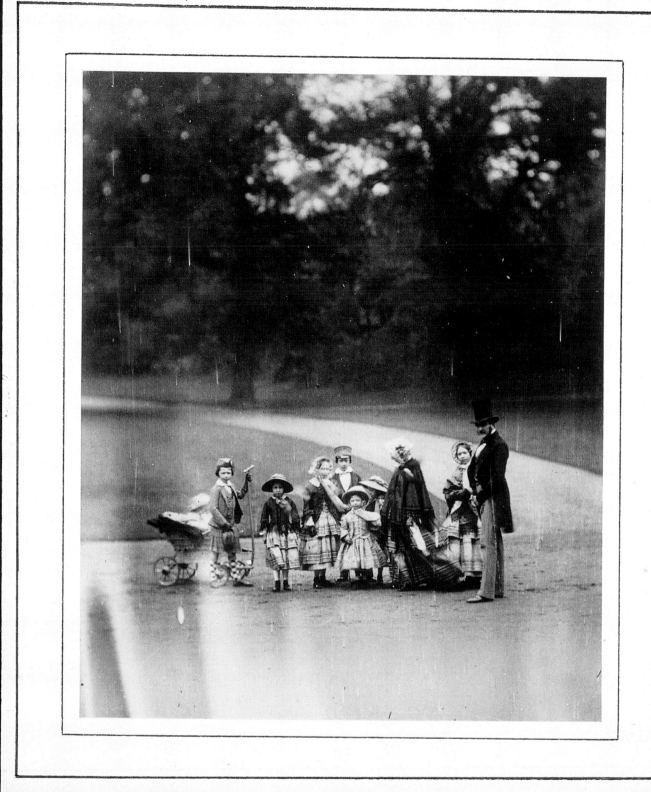

*The Queen, The Prince & eight Royal children,*

*in Buckingham Palace Garden. 22nd May. 1854.*

2

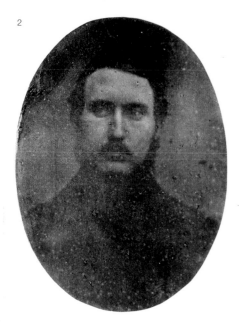

2 Prince Albert
Attributed to William Constable, 1842

This diminutive print of Prince Albert, taken from a now
faded daguerreotype, is the first photograph taken of
a member of the British Royal Family. In 1855 the Prince,
an enthusiast of the new art of photography, gave £50
to fund a study of why photographs faded.

Opposite
3 Queen Victoria with her Daughter,
the Princess Royal  (detail)
Attributed to Henry Collen, c.1844-5

Two years or so after her husband's visit to the Brighton
studio of William Constable, the Queen sat for a
photographer, believed to be Henry Collen. He had
been her 'Painter of Miniatures' but was also proficient
in the calotype process of photography. The result,
surprisingly informal for such an occasion, is the earliest
known photograph of the Queen. She is posed with her
eldest daughter, Victoria, the Princess Royal.

untested as a political weapon, it stabilised the Queen's position. It helped to re-establish
the supremacy of the monarchy after her decade-long seclusion following her husband's
death in 1861 and, concomitantly, rekindled a nation's affection for a widow who, in the
meantime, had been so rarely seen. Personally, Victoria derived from photography both
pleasure in her years of marriage and comfort in her time of inordinate grief. She used the
discipline, the potential of which Albert had been so quick to recognise, to keep – almost
obsessively – his memory alive.

To the early Victorian viewer, photography was a means by which to glimpse the world.
The play of light upon sensitised plates and papers, though primitive in execution,
exposed landscapes, peoples, architecture and ways of life that had seemed as
unfathomable as photographing the stars and planets. These documents became tangible
pieces of visual information, the first real links in the age of Darwinism to distant cultures.
In turn, photography would make available to the inhabitants of Britain's dominions and
colonies – said to be a quarter of the world's population – the face of their sovereign. And
owning a photograph of Queen Victoria was distinct from owning an engraving of one.
Unlike a stamp (fig.6) or the obverse of a coin, a photograph was 'real', a true likeness
captured at a particular time, not an idealised or estimated representation.

And when scrutiny of their content was exhausted, these photographs might be
marvelled at as objects of remarkable beauty. Prince Albert recognised this inherent duality
of the new medium. In the earliest private albums in the Royal Archives at Windsor Castle,
it is clear from his organisation and annotations that he regarded photography not just as
an instrument of documentation but also as a record of a growing art form.

On 7 March 1842 the Prince visited – unannounced – William Constable of Brighton,
one of Britain's earliest photographic studios. The one surviving daguerreotype has faded,
but copies exist that record the first portraits taken of a member of the Royal Family
(fig.2). Later that month, Albert sat for another photographer, Richard Beard, who first
patented in Britain Daguerre's invention of quickly 'fixed' positive images. Moreover,
recognising the medium's potential for scholarship, Albert began to add to the royal
collection of photographs. The acquisition of daguerreotypes from Claudet & Houghton in
1840 prompted his 'highest admiration for such a wonderful discovery'.

But the daguerreotype process was expensive, time-consuming and unstable. And, as
the Queen herself showed, the results were easy to tarnish. Every image was vulnerable
and unique, and replication impossible. Not until 1857, when the carte-de-visite process
that enabled the inexpensive printing of photographs in their millions was introduced in
Britain, could their subjects share in the royal couple's enthusiasm.

Despite her husband's visits to Constable and Beard, which conferred respectability on
the medium, it was two years before the Queen could be persuaded to sit for a
photographer. In 1844 she chose Henry Collen, who had been her family's 'Painter of
Miniatures'. He was adept at the calotype method of photography. Relying on the
negative-and-print process, this British invention, patented by William Henry Fox Talbot in
1840, is regarded as the forerunner of modern photography. And it departed from the
daguerreotype process in one important respect: multiple prints could be made from a
single paper negative. The Queen posed with her eldest daughter Victoria, the Princess
Royal, and the sitting was deemed a success (fig.3). For such a momentous event, the
first photographic portrait of a reigning monarch, it is a surprisingly intimate arrangement
and there is nothing in either dress, pose or backdrop to suggest the exceptional social
standing of the sitters.

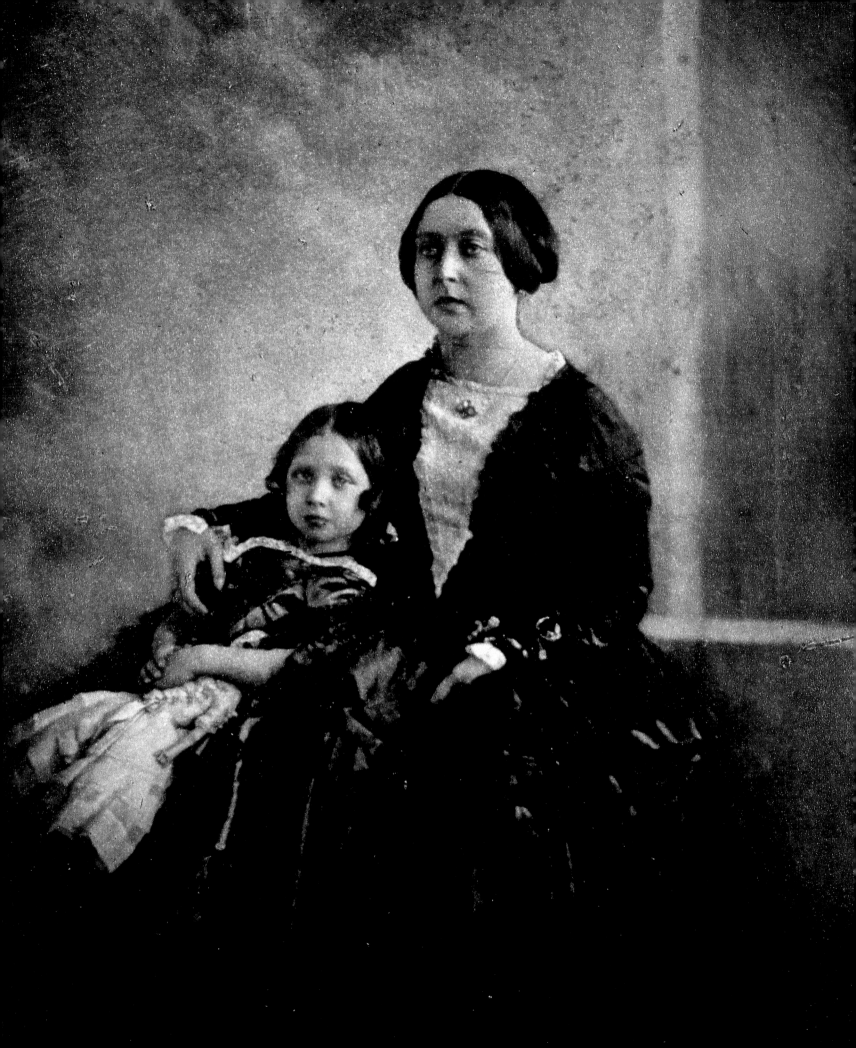

4, 5 Queen Victoria with her Children
William Edward Kilburn, 1852

This is probably the earliest extant group shot of the Royal Family to survive – in two variants. Although Kilburn had won a prize for his photography at the Great Exhibition, he would not be fortunate with his royal sitter. As he depressed the shutter the Queen moved slightly and was caught with her eyes shut. When she saw the result, she obliterated her image on the metal plate with her thumb. Fig.4 shows the unflattering carbon copy print. A daguerrotype (fig.5, opposite), reversed as they often were, shows left to right the Princess Royal, the Prince of Wales, Queen Victoria, Princess Alice (in front), Princess Helena and Prince Alfred.

This style of presentation would in time change as the nature of Victoria's reign changed. Elevated in 1876 to Empress of India, she was portrayed in full majesty on the ivory throne presented to her by the Rajah of Travancore. Similarly, for official portraits commemorating her regnal jubilees, Golden in 1887 and Diamond in 1897, she was portrayed with all the insignia of high office – and with a gravity of expression that complemented it. But even then she was aware of the curious democratising nature of photography. Her private albums reveal among the portraits of high-ranking military officers and politicians, musicians and artists, photographs of ordinary people in whom she showed genuine concern and delight. She owned portraits of the last survivors of Wellington's battalions at Waterloo, the last living serviceman present at the Battle of Trafalgar (a Frenchman) and those of her subjects who, though ordinary in other respects, had accomplished something unusual. 'I do feel strongly,' she wrote to her eldest daughter, 'that we are before God all alike'.

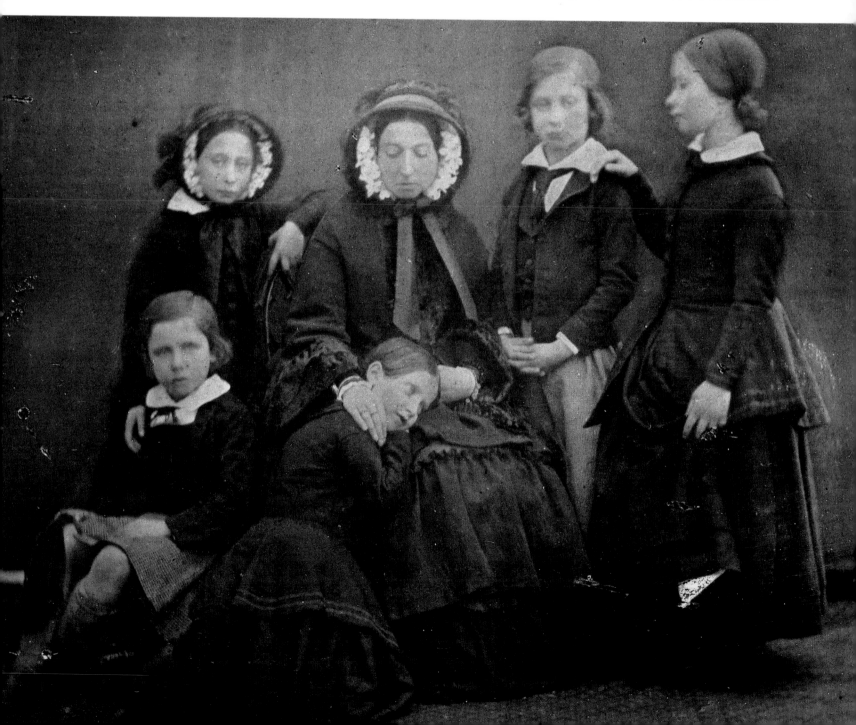

In 1848, however, the dissatisfaction of the humblest, poorest and lowest manifested itself. Against a background of revolution sweeping through Europe (the French king was forced to abdicate in February and to seek sanctuary in England), Chartism threatened the British monarchy. The movement, which campaigned to devolve political power to the working classes, gathered momentum as economic depression in the mid-1840s led to mass unemployment. It was announced that a protest meeting would be held on 10 April on Kennington Common, south London. A crowd of around 200,000 was expected and among the first to gather there was Kilburn, who set up his camera at a vantage point. His photographs of the 'Great Chartist Meeting' remain remarkable – he had managed to capture the unfolding day in the rain with the unwieldy daguerreotype process. Not only were they the first pictures ever taken of a mass public event; for the first time they also gave a sense of participation in an episode of historic significance.

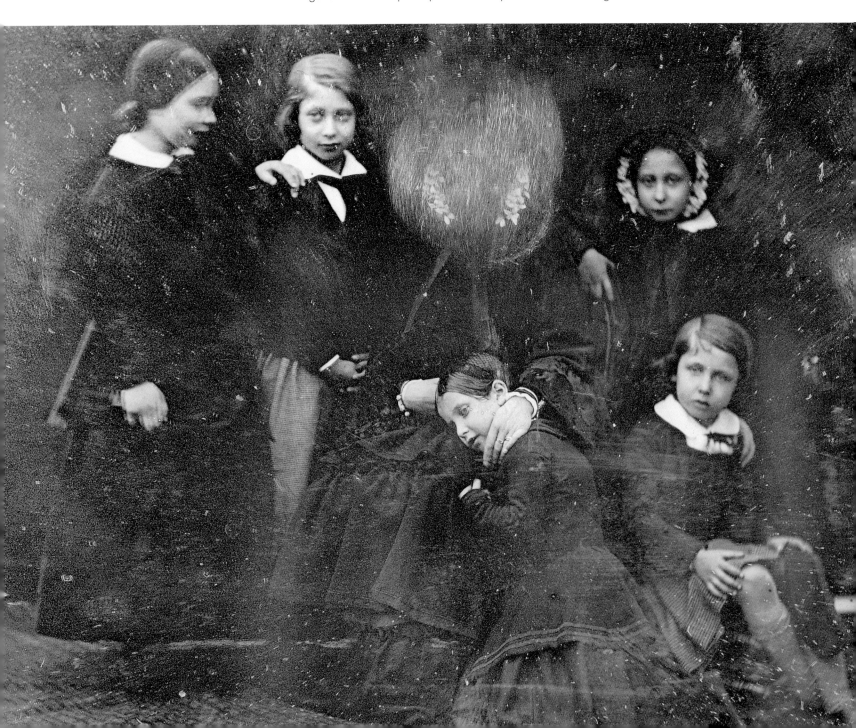

6

6 'Penny Black'

Until the advent of photography, the face of the sovereign would be known to those inhabiting Britain's dominions and colonies largely from a stamp, or the obverse of a coin, or a newspaper illustration. Unlike an engraving, the photograph seemed 'real', a true likeness captured at a particular time, rather than an idealised or estimated representation.

Opposite
7 Cartes-de-visite of Queen Victoria
John Mayall, c.1860

By 1860 the carte-de-visite portrait had become widely popular. Small in size (they were no bigger than a visiting card), they were inexpensive to produce and were issued by the thousand. The Queen authorised the American photographer John Mayall to release as cartes-de-visite a series of portraits he had taken of her in May 1860. This form of photographic reproduction, more than any other, enabled the Queen to reach out to her subjects. Some 60,000 sets went on sale in the first week.

As it so happened, the Queen's fears were unfounded. Only 10,000 participants turned up for what was a peaceful demonstration. Chartism was defeated and discredited, but it had galvanised the monarchy. The royal couple acquired Kilburn's daguerreotypes, which served as a reminder of how close the monarchy had come to extinction. The rise and fall of Chartism, as the writer and curator Roger Taylor has suggested, 'may be said to have inspired the British monarchy to come out from behind the cloak of court procedure and make an open commitment to philanthropy'. It had also demonstrated how vital was the support of the people to its survival.

The Great Exhibition of 1851 in Hyde Park was intended to display British industrial progress and provided an ideal means of boosting public morale (and raising the royal profile). Of the Exhibition's thirty subdivisions, photography occupied two. 'Never before,' reported the Exhibition jury, 'was so rich a collection of photographic pictures brought together.' The exhibition attracted six million visitors. The Queen was entranced by the latest developments in photography, especially by the stereoscope, which optically transformed into one three-dimensional image two photographs placed side by side on a card. Also demonstrated was the collodion process, by which means these cards were produced en masse. The daguerreotype and calotype processes were quickly outmoded. On a later visit to the Exhibition in 1855 (the site had moved to Sydenham, south London), the Queen was accompanied by the Emperor and Empress of France. The day was recorded, by either P. H. Delamotte or Henry Negretti and Zambra (the authorship remains unclear), in perhaps the earliest documentary photograph of the sovereign. The Queen was as impressed by the numbers that had turned out to view the distinguished visitors as by the exhibits: 'there were between 30 and 40,000 people assembled, cheering very loudly'.

As the techniques of mass-production advanced, so too did the ubiquity of professional photographic establishments. Throughout the 1850s, the Queen and her family were photographed in earnest by numerous photographers but still only for a private audience. Prince Albert continued to be enthralled by the medium and Queen Victoria used it as a token of her affection for him. In May 1854 the Prince had sat in profile for the photographer Brian Edward Duppa. Unknown to her husband, the following July the Queen instructed Duppa to portray her in the reverse profile. In her hands, she held a framed print of his earlier portrait of Albert. 'I was photographed,' she confided in her journal, 'as a surprise for Albert, by Mr Duppa, & I hope successfully.' For the Queen, in years to come, photographs and likenesses of her beloved husband would attain almost fetishistic significance.

Nothing demonstrated their mutual affection so clearly as a set of photographs commissioned in May 1854 from Roger Fenton. Summoned to Buckingham Palace, he recorded the Queen in what is customarily described as 'court dress'; but the ensemble appears nothing so much as a replica of her wedding trousseau, set against Fenton's dark backdrop (fig.12). A further portfolio showed the Queen and the Prince facing each other, he in a field marshal's uniform with the insignia of the Garter (which he had worn on his wedding day), plucking a flower from her bouquet, her gaze and posture devotional. Photography had been in its extreme infancy when the Queen married in 1840 and there were no photographs of their union. Here, as a symbol of their love, was a re-enactment for the medium they embraced so readily in the years that followed.

As the Queen had professed herself curious about her subjects, so too were they fascinated by her. In 1858 she allowed for the first time the public display of a likeness of

3206

3208

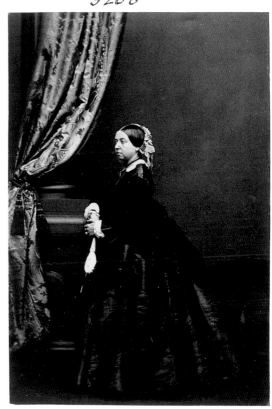

3205

3207

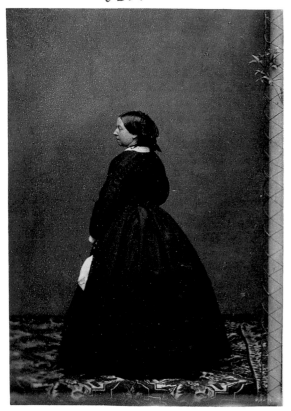

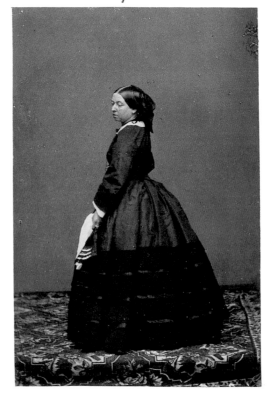

8

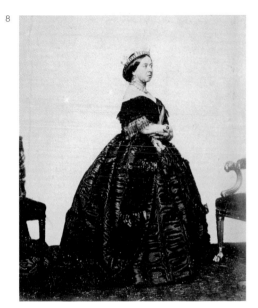

9

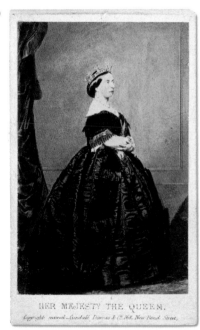

HER MAJESTY THE QUEEN.
Copyright reserved—Caldesi Downes & Cº 168, New Bond Street.

8, 9 First State Portrait of Queen Victoria
Charles Clifford, 1861

Opposite:
10 First State Portrait of Queen Victoria
Anonymous Photographer after Charles Clifford, 1861

The first state portrait of the Queen, taken by Charles
Clifford, Court Photographer to Queen Isabella of Spain,
became one of the best-known portraits of the Queen,
reproduced widely and in various formats. It is not known
quite why an anonymous photographer made a copy of
the full version of Clifford's portrait (fig.10), but it remains,
in the words of Frances Dimond of the Royal Photograph
Collection, 'an object with its own oblique interest'.

herself by Leonida Caldesi – though she was hardly prominent in an arrangement with her
nine children, taken in a salon that was, by most accounts, overcrowded and dimly lit. By
1860, the carte-de-visite portrait, patented by A. A. E. Disdéri, had become widely
popular. Diminutive – the size of a traditional visiting card – they were cheap to produce
and rapidly available in their millions. The Queen authorised the American photographer
John Mayall to release in carte-de-visite form a series he had taken in May 1860 (fig.7).
She considered him 'the oddest man I ever saw' but conceded he was 'an excellent
photographer' and 'a tremendous enthusiast'. Perhaps no other gesture brought the
monarch closer to her public. At last thousands of her subjects were able to own a
likeness of their sovereign and 60,000 sets went on sale in the first week. It had further
significance, as Frances Dimond, Curator of the Royal Photograph Collection, has
pointed out: 'In one sense publication of the portraits was a tacit acknowledgement that
the public could invade her privacy through the agency of photography.'

Mayall's set showed Victoria and Albert as – almost – an ordinary husband and wife.
With her popularity soaring, the following year the Queen authorised the circulation of her
first state portrait, taken by Charles Clifford on 14 November 1861, at the suggestion of
Queen Isabella of Spain. This photograph, produced in various formats from cabinet
portrait to carte-de-visite (figs 8, 9), remains one of the most widely recognised portraits
of Queen Victoria. Quite distinct from Mayall's portrayal, it was vital in reflecting an image
of the full majesty and authority of the reigning monarch. She wears formal mourning for
her mother, the Duchess of Kent, who had died eight months earlier. A contemporary
hand-tinted variant reveals her dress to be of 'Royal' purple. It would mark one of the last
occasions she would be seen wearing anything other than deepest black.

A month to the day, on 14 December 1861, Prince Albert died and plunged Victoria
into inconsolable grief. Her loyal subjects appeared to share it: 70,000 cartes-de-visite of
the late Prince were sold within a week of his funeral as were hundreds of thousands of
Mayall's series. But for the next decade their monarch would be all but invisible. Victoria
withdrew to Windsor, to Osborne House and to Balmoral, her remote Highland retreat.
The photographs she commissioned in these years reflect the devastation of her loss and
compulsive desire to perpetuate her husband's memory. Family photographs by William
Bambridge at Windsor, by John Mayall in London and by George Washington Wilson at
Balmoral, reveal the unavoidable presence of the Prince Consort in death as in life.
A bust of Albert, wreathed with flowers, loomed large in these surviving prints (the bust
substituted at Balmoral by a painting). Beneath the first of these memorial tableaux, with
her husband's image bathed in light and the family group arranged in the shadows, the
Queen wrote 'Day turned into Night'. Victoria's second son, 18-year-old Prince Alfred,
made the most contrived of these images, though perhaps the most poignant. His series
of photographs shows the Queen and her daughter Princess Alice in an expression of
private grief, which the Queen would not have volunteered to a commercial photographer.
The Queen's disengagement was dramatically emphasised by Mayall's wedding
photographs of the Prince of Wales in 1863. Clad in black, she ignores the bride and
groom – and the camera – her gaze focused upon the now familiar bust of Albert (fig.11).

Without her husband's guidance, Victoria's image became increasingly austere.
According photographers the privileges of artists, Albert had encouraged informality in
royal depiction. After his death they were perceived as commercial tradesmen and the
Queen imposed restrictions. In 1869 the *British Journal of Photography* reported the
restraints of protocol: 'The Queen merely takes her seat, and intimates through her

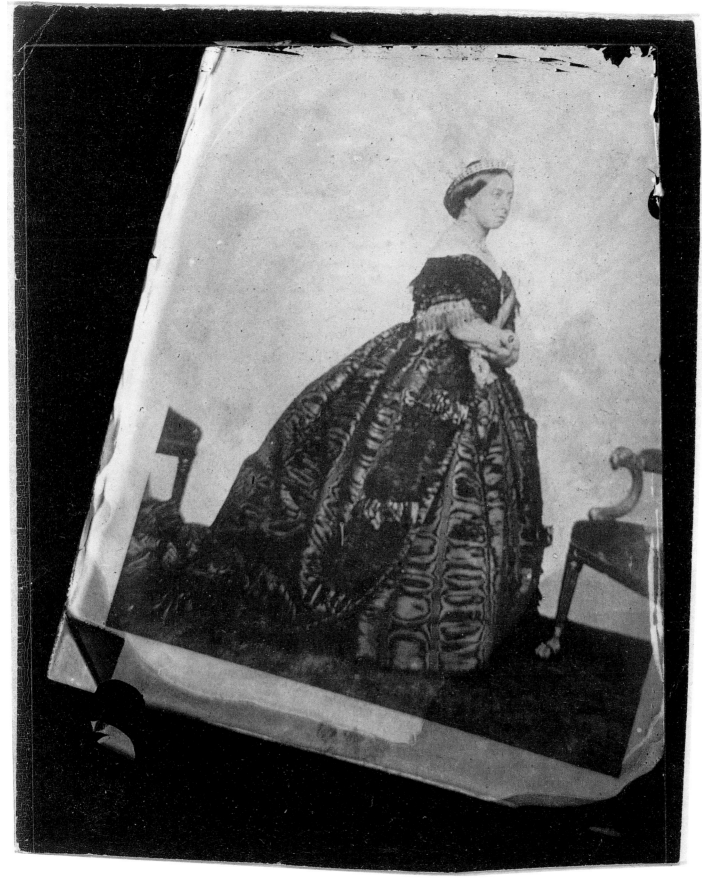

11 The Wedding of the Prince of Wales and
Princess Alexandra of Denmark
John Mayall, 1863

The profound devotion that Queen Victoria and her
Prince Consort felt for each other, in death as in life,
was recorded through the photographic medium. Family
albums containing photographs commissioned by the
Queen in the years following Prince Albert's death in
1861 reveal his continuing presence. A larger-than-life-
size bust of the Prince, wreathed with flowers, appears
in many surviving prints. The full depth of the Queen's
misery was emphasised by Mayall's wedding
photographs of the Prince of Wales (the future Edward
VII) and Princess Alexandra of Denmark in 1863.
The Queen, seated centre stage and clothed from head
to foot in black, ignores both the bride and groom and
the camera, her gaze focused upon the image of her
dearly departed husband.

Opposite
12 Queen Victoria in Court Dress (detail)
Roger Fenton, 1854

The mutual affection of Victoria and Albert was clearly
demonstrated by a set of photographs commissioned
from Roger Fenton. He photographed the Queen in what
was described as 'court dress'; but with its white lace
overskirt and floral headpiece securing a long veil, the
ensemble was patently a replica of her wedding gown.
'To look in those dear eyes and that dear sunny face,'
she had written to her uncle, King Leopold of the
Belgians, the day after her wedding, 'is enough to make
me adore him. What I can do to make him happy will
be my greatest delight.' Photography was in its infancy
when the Queen married in 1840 and there were no
photographs of their union. Here, as a symbol of her
love, was a re-enactment.

11

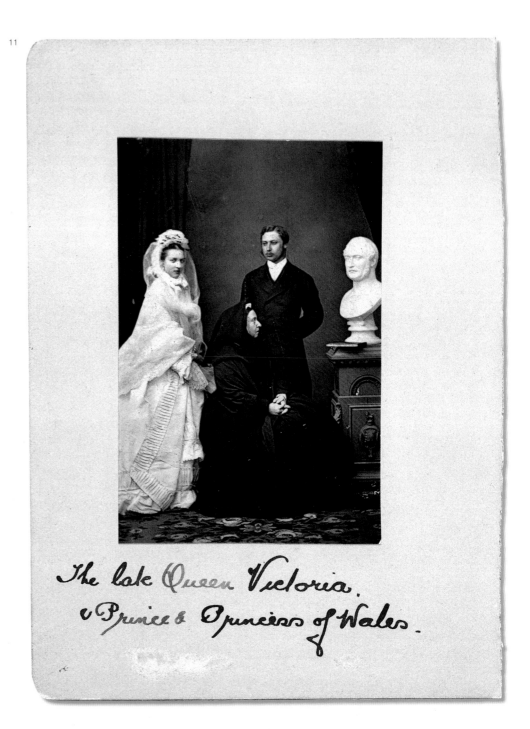

*The late Queen Victoria.
& Prince & Princess of Wales.*

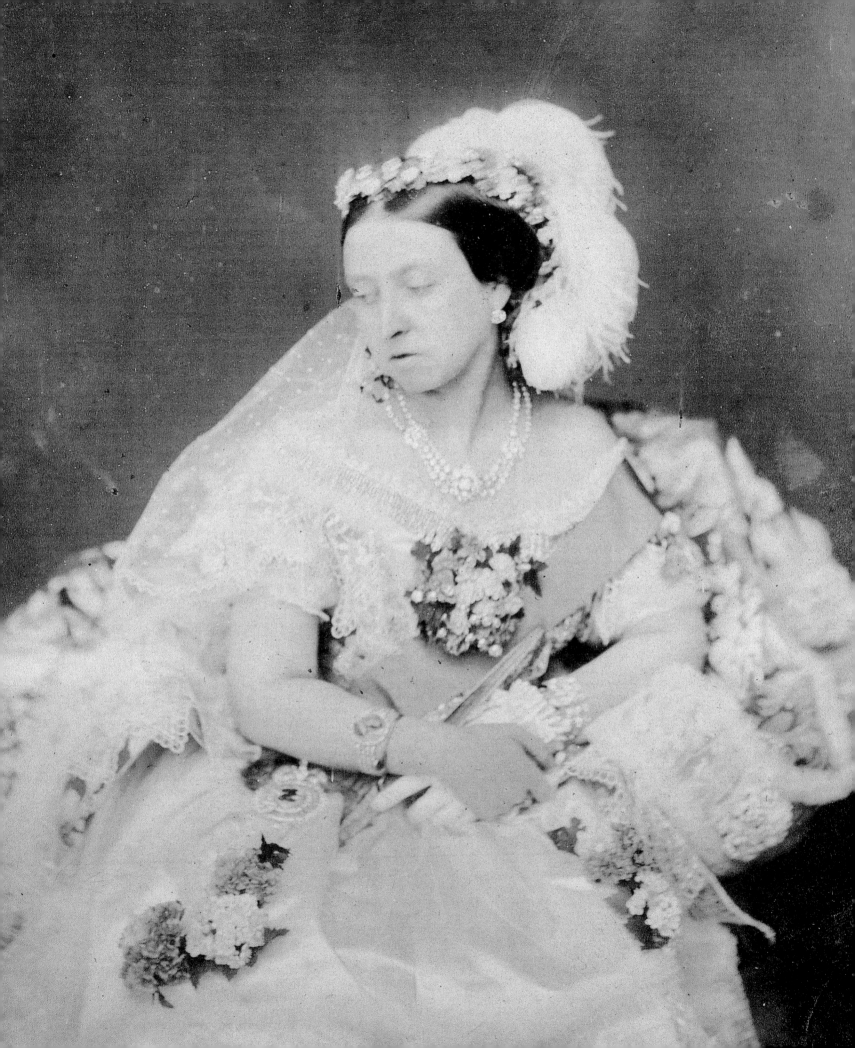

13

W. & D. DOWNEY
PHOTOGRAPHERS

COPYRIGHT

57 & 61, EBURY STREET.
LONDON, S.W.

14

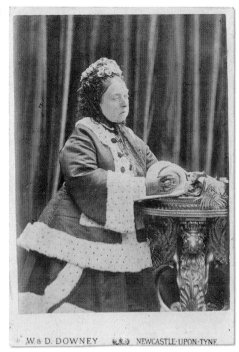

W. & D. DOWNEY    NEWCASTLE·UPON·TYNE

14 Queen Victoria at a Service of Thanksgiving
W. & D. Downey, 1872

The Queen's first major public appearance in ten years
was her attendance at a service of national thanksgiving
for the recovery from serious illness of the Prince
of Wales at St Paul's Cathedral. The occasion resulted
in a state portrait. Her habitual black dress was now
trimmed with regal ermine as she revealed herself to
her public once more.

Opposite
13 Queen Victoria with her Dog, 'Sharp'
W. & D. Downey, c.1866

The invisibility of 'The Widow of Windsor' after Prince
Albert's death led to public discontent. To compensate
for the lack of any personal appearance, Queen Victoria
hoped to reach her subjects through the photographic
medium. But well-meaning attempts such as this image
of the Queen with her dog seemed contrived.

secretary that she wishes to be taken in a certain attitude and [the photographer] has
nothing to do but comply with the order …' Mourning photographs reinforced the notion
that the Queen's grief disabled, indeed excused, her from carrying out state duties, but
many viewers found their intimacy and theatricality repugnant.

Her prolonged invisibility led to public discontent. She was obliged to write to *The
Times*: 'The Queen heartily appreciates the desire of her subjects to see her and whatever
she can do to gratify them in this loyal and affectionate wish, she will do …' This did not
extend to public appearances, however. Instead, she attempted to appease the nation
with a series of glimpses into her sad life. These comprised mostly well-intentioned,
though ultimately absurd, attempts at informality and humility: the Queen at her spinning
wheel and at her writing desk, or the Queen with her dogs (fig.13). The more agreeable –
and least contrived – were the *en plein air* portraits, in which she was accompanied by a
Scottish servant, John Brown, shown holding her horse. Brown's familiarity with the
monarch provoked fevered speculation then and is now the stuff of legend.

The Queen's almost decade-long inactivity led to the airing again of republican views,
fanned by a sympathetic press. The cost of maintaining 'The Widow of Windsor' in a
succession of residences for no discernible benefit to the nation was articulated by the
Liberal MP Sir Charles Dilke. The Prime Minister, William Gladstone, refused to censure
his colleague and a constitutional crisis loomed. At length two factors averted it. First,
Dilke was discredited in a divorce scandal and second, the Prince of Wales fell
desperately ill. The thought of the loss of the heir to the throne banished republicanism for
the time being. However, on 14 December 1871, ten years to the day after his father's
death, he rallied and the Queen capitalised upon a resurgence of public feeling by
organising a service of national thanksgiving at St Paul's Cathedral. It was her first major
public appearance in ten years and produced the first state portrait since Charles
Clifford's of 1861. She sat, in February 1872, for a portrait taken by W. & D. Downey in
which she revealed herself to her public in the most commanding of ways, as a fully
operative Head of State (fig.14). Over the next decade the firms of Downey and Bassano
would collude with her new vision of self-representation, endowing her with a gravity that
befitted, from 1876, her position as Empress of India.

Now in her fifties, Victoria possessed a figure and a demeanour that portrait
photographers found, for the most part, unflattering. Devoid of personal vanity, this had
never alarmed her but it did others. As Princess Victoria wrote to her: 'You say I am
particular about photographs [of you]. Perhaps I am, but as I admire my dear Mama and
want others to see her as I see her, I feel vexed when a portrait does not do her justice.'
Her mother replied: 'I fear I do not think … much of artistic arrangements in photographs
and God knows there is nothing to admire in my ugly old person.'

The Queen's image had been flattered since the 1860s, mostly in the form of hand-
tinted colour enhancement. From the 1880s on, with the Queen appearing markedly older
and more rotund, the studios of fashionable photographers such as Bassano, who
undertook the official portraits for her Golden Jubilee (1887), turned retouching into an art
form (fig.20). They retouched the glass negatives themselves, which dramatically altered
the mood of the finished prints. Here the historian John Plunkett has identified an
unassailable fact: 'The introduction of a larger format of cabinet photograph presented a
greater threat to a sitter's vanity.' Bassano produced in large format some of the most
enduring images of Queen Victoria in her final years. Though dignified, regal and more
youthful, she also appeared somewhat unapproachable and it was the imperious tableaux

15

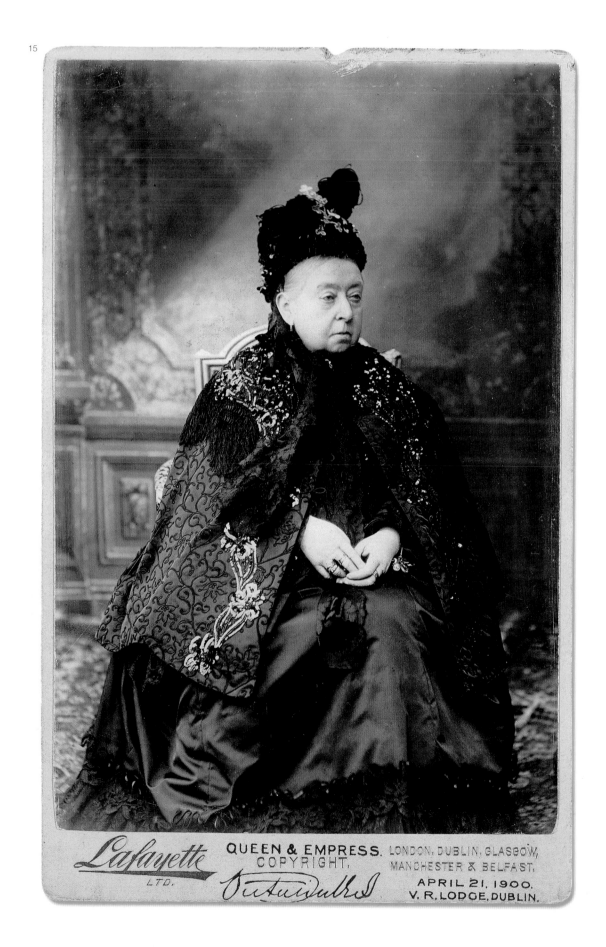

Lafayette
LTD.

QUEEN & EMPRESS.
COPYRIGHT.

LONDON, DUBLIN, GLASGOW,
MANCHESTER & BELFAST.

APRIL 21, 1900.
V. R. LODGE, DUBLIN.

16

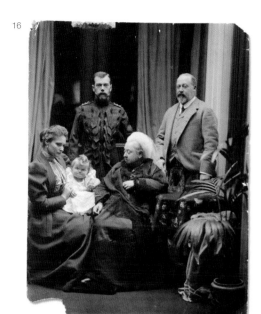

18

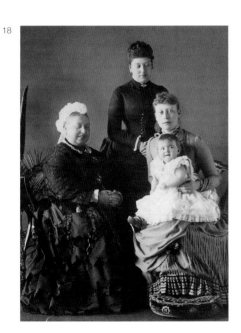

17

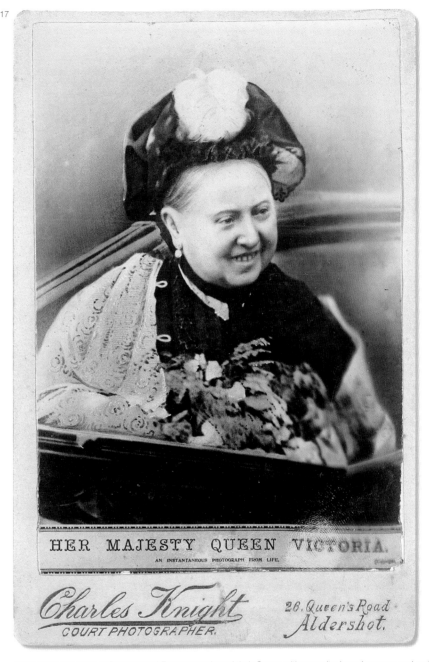

HER MAJESTY QUEEN VICTORIA.
AN INSTANTANEOUS PHOTOGRAPH FROM LIFE.

Charles Knight
COURT PHOTOGRAPHER.

26. Queen's Road
Aldershot.

Opposite
15 'We Are Not Amused'
Lafayette, 1900

16 Two Imperial Families
Robert Milne, 1896

17 'Her Majesty's Gracious Smile'
Charles Knight, 1887

18 Four Generations
Gustav Mullins, 1886

From 1876, the firms of Downey and Bassano endowed their Queen with a gravity, imperiousness and majesty that befitted her status as Empress of India. It is likely and understandable that a sense of dignity prevented her from smiling readily for the camera but such portraits contributed to an enduring notion that the Queen was habitually 'not amused' (fig.15). Despite her position as 'Queen Empress', Queen Victoria possessed a *joie de vivre* that was occasionally irrepressible. She authorised the reproduction of this cabinet portrait (fig.17), taken on the day of her Golden Jubilee. For the first time in half a century of rule, the public could see their Queen smile. The visit to Balmoral of the Emperor and Empress of Russia was also a joyful occasion, commemorated with a group photograph (fig.16). The Czarina holds her daughter, the Grand Duchess Olga; to her left stands the last czar, Nicholas II; and to the right of the Queen stands Edward, Prince of Wales. But the Queen laughed most readily of all in the presence of her grand- and great-grandchildren. She positively beamed for Gustav Mullins in the company of four generations of female royalty: her daughter Beatrice stands behind a granddaughter Victoria, Princess Louis of Battenberg, who holds her daughter Princess Alice of Battenberg (the future mother of Prince Philip, Duke of Edinburgh) (fig.18).

19 Queen Victoria Lying in State
Unknown Photographer, 1901

The last photograph of the Queen shows her lying in
state, surrounded by wreaths and, as in life, by portraits
of her consort, Albert. It is believed that she was also
buried with a photograph of her adored Highland servant
John Brown, who provided solace in the years following
her husband's death. Brown's familiarity with the
monarch provoked fevered speculation. His gentle
encouragement had rekindled the sense of public duty
that had begun to fail her. He was, she declared on
his death, 'My best & truest friend – as I was his.'

19

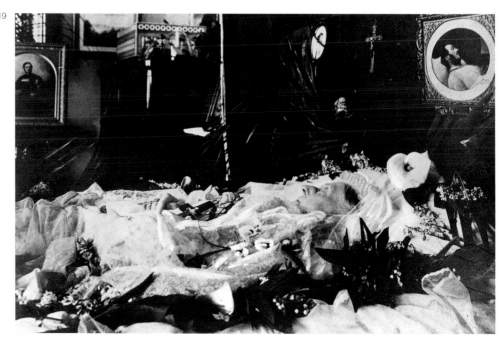

Opposite
20 Queen Victoria on her Golden Jubilee
Bassano, 1887

The Queen's image had been flattered since the 1860s in
the form of hand-tinted colour enhancement. From the
1880s, as the Queen appeared markedly older and more
rotund, the studios of fashionable photographers such as
Bassano, who undertook the official portraits for her
Golden Jubilee, turned retouching into an art form.
Despite the Queen's early misgivings about photography,
during the course of her reign she sat for the camera on
hundreds of occasions and was indeed the most
photographed woman of her age.

of firms like Bassano and Lafayette that contributed to the enduring notion that the
Queen was habitually 'not amused' (fig.15).

But despite her life-long devotion to her husband's memory and her gravitas as Queen
Empress, she never entirely lost her *joie de vivre*. This emerged for the camera on
occasions such as a visit to Balmoral of the Emperor and Empress of Russia, celebrated
with a photograph of the two imperial families (fig.16). She adored the young and several
examples exist of her laughing readily with her grand- and great-grandchildren. For
Gustav Mullins in 1886 her personality shone through as she beamed in an arrangement
depicting four generations of female royalty (fig.18). 'Her smile came very suddenly,'
reported one commentator, 'in the form of a mild radiance over the whole face.' The
following year, in 1887, for the first time in half a century of rule, the public saw Victoria
smile. She authorised as a cabinet portrait a photograph taken on the day of her Golden
Jubilee by Charles Knight, entitled 'Her Majesty's Gracious Smile' (fig.17).

Over the next decade she was invariably photographed with generations of royal
children, portraits that did much to cement her popularity. By 1897, her Diamond Jubilee
year, she had decided that for the first time there would be no copyright restrictions on an
official portrait. Thus photographs and memorabilia would ensure that across the globe
the face of their sovereign would be recognisable to her 500 million subjects.

She died aged eighty-two in 1901, her popularity at its zenith (fig.19). For six decades
she had survived grave crises, her public image skilfully, and sometimes fortuitously,
crafted to reflect precisely how she wished her people to view her: loving wife and
mother, loyal widow, empress and, dignified to the end, grandmother to a grateful nation.
The earliest photographs ever seen in Britain – daguerreotypes imported from France –
were shown to the Queen on 15 October 1839, the very morning that she proposed, as
protocol dictated, to her beloved husband. Her Diamond Jubilee had been the first public
event committed to film; and her funeral was to be marked by the moving image rather
than still photography. For Queen Victoria, and her consort Prince Albert, photography
had been totemic.

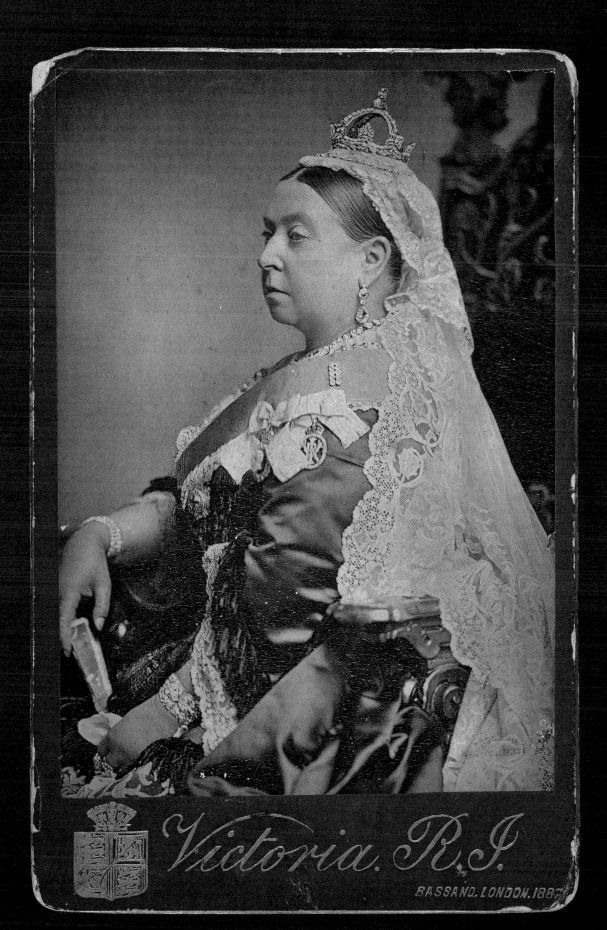

Victoria R.I.

BASSANO. LONDON. 1887

# 2  Mahatma Gandhi

## Mahatma Gandhi (1869-1948)

Opposite
1 Mahatma Gandhi Receiving the Tilak
D. R. D. Wadhia, 1944

Gandhi spent much of his long life reconciling a vast country of disparate languages and cultural identities, a disharmonious and fractured sub-continent. Its strength would surely lie in unification, as much as in freedom from British colonialism. Though he achieved the latter after half a century of work – he would survive only six months in an independent India – he was able to allay only briefly the deep-rooted antagonisms of Hindu and Muslim. Gandhi was quick to see the potential in photography, and iconic images of 'the Mahatma' such as this helped win a largely illiterate populace to his cause. Here Gandhi receives the tilak, the traditional symbol of Hinduism.

In the spring of 1946 the photographer Margaret Bourke-White negotiated the backstreets of Poona, near Delhi. One of the great photojournalists of her time, in her field she was already a legend. She had been the only Western photographer to document the German assault on Moscow in 1941 and, as World War II ended, she entered the death camp at Buchenwald. Her themes, as her biographer Vicky Goldberg has noted, 'were always large, [she] needed momentous events to match the levels of challenge she had built into her working life.' *Life* magazine had sent her to India to cover something that was surely commensurate: the fall of the British Empire. India was its flashpoint and she had set out to find the 76-year-old man who had progressively ignited it for over forty years, the Father of India, Mahatma Gandhi.

For millions he was a figure of hope, their voice, the hand that guided their destinies, into which he had entwined himself inextricably. He was responsible almost single-handedly for the seismic shift in the balance of power in the sub-continent with his concept of Satyagraha or 'soul force', in effect, 'passive' or 'non-violent' resistance, terms Gandhi had mistrusted but which he conceded were the only words suitable to convey its notion of self-control. As the historian and archivist Peter Rühe has explained:

*Only through non-violence could there be respect for different ways of life. Animating this belief was the ancient Hindu idea of ahmisa (literally non-violence). Gandhi fortified the concept, turning it into a source of strength, rather than the last refuge of the weak and powerless …*

Gandhi, in the mid-twentieth century, was a figure of striking contradictions. His nationalist ideals were rooted in archaic traditions but he used modern methods to promote them. Behind the mythologisation of Gandhi (which he did much to advance), and the simplicity of his ideals, lay a skilful self-publicist who harnessed the mass media to his pursuit of political success. Gandhi knew precisely what he wanted from photography and recognised its importance to his campaign for Home Rule. Though he was an eloquent man of words, both spoken and written, he acknowledged the impact and potency of the photographic image. 'My life,' he famously explained, 'is my message' and images of Gandhi, revered still by India's millions, would help bind the largely illiterate nation to his cause. In a land of so many who had never seen or heard a prominent politician, the photograph played a decisive role. Above all, Gandhi saw how the medium could help to create abroad a new identity for India.

Bourke-White found Gandhi living among the 'Untouchables', the lowest Hindu caste, in an effort to end social and religious discrimination. He was spinning at his wheel. This was an occupation redolent with symbolism as the British supremacists had seized Indian raw materials to feed their industrial enterprises back home. Thus Indian cotton was turned into cloth in British mills and sold back to India. Gandhi's association with spinning encouraged the nation to break this chain of dependency.

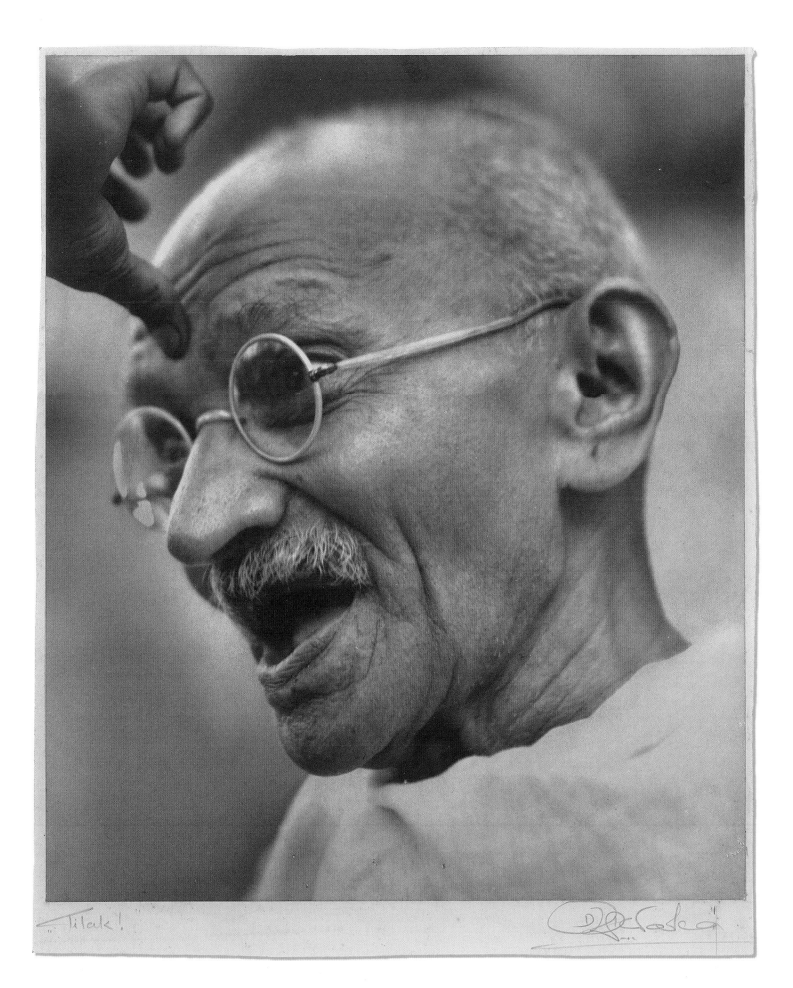

"Tilak!"

2 Indian National Flag

On 15 August 1947, India gained her independence and the national flag was raised for the first time: orange represented Hinduism; green the Muslims; and the white space in between stood optimistically for peace. In the centre, in blue, was a simple but significant motif: a spinning wheel.

Opposite
3 Gandhi with Spinning Wheel
Margaret Bourke-White, 1946

One of the last century's great photojournalists, Bourke-White was captivated by India and by its spiritual leader. Her meeting with Gandhi in 1946 resulted in perhaps the most recognisable image of the Mahatma. It was no easy undertaking and Bourke-White had obstacles to overcome. She was forced to learn to spin – and to a standard that satisfied Gandhi's protective retinue. She was warned that it was Gandhi's day of silence and that he would not speak to her, nor could she address him. Artificial light was strictly forbidden, but she stood her ground and was reluctantly allowed three flashbulbs. Two failed, but the third worked to produce this famous picture. 'It is,' as her biographer Vicky Goldberg wrote, 'an icon for a secular saint, humble, meditative, graced by light and accompanied by his spinning wheel much as western saints are accompanied by their emblems'.

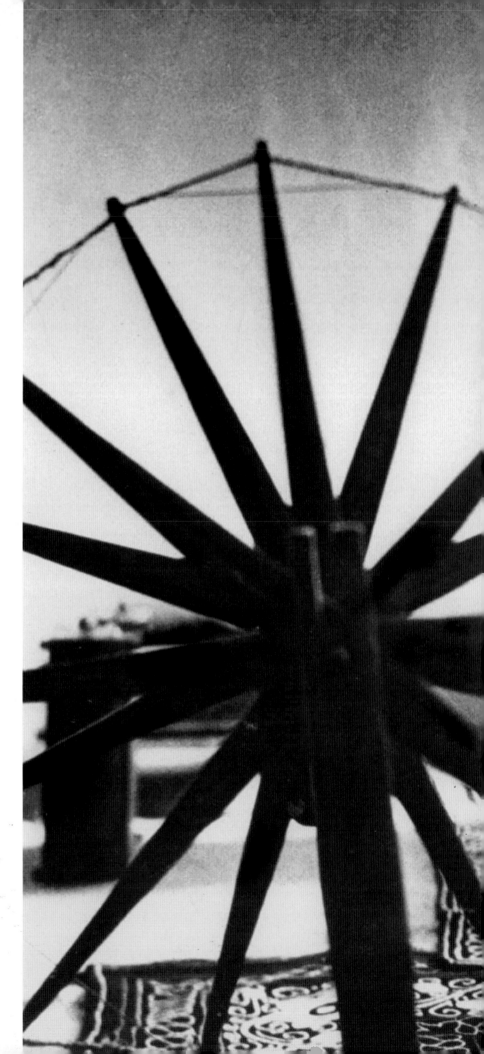

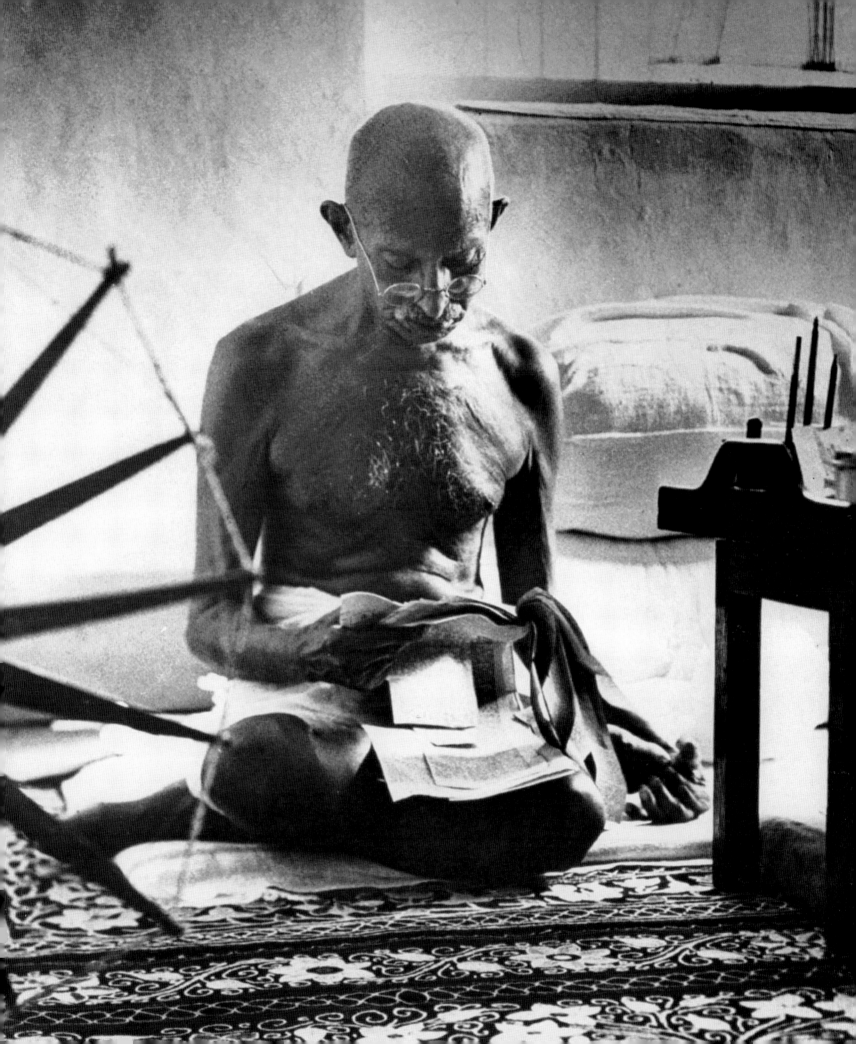

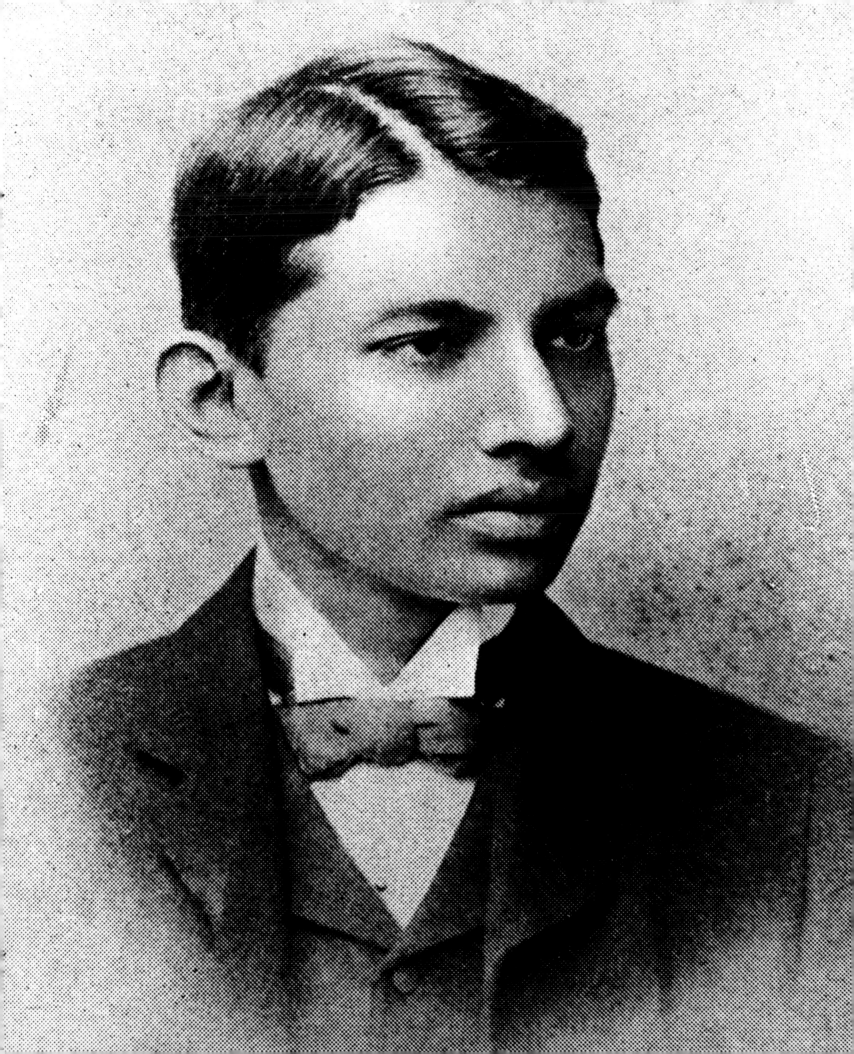

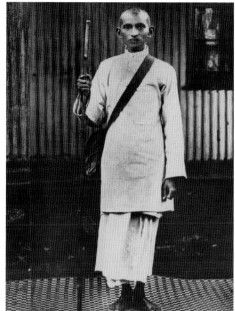

5 Gandhi during a Campaign of Satyagraha
Collection Vithalbhai Jhaveri, 1913/14

Gandhi's self-transformation would frequently be played
out for the camera – always for Gandhi a reliable tool.
This full-length portrait, simply posed, is an early example
of Gandhi's belief in harnessing photography for political
ends, providing tangible proof for those that needed it of
his identification with, and commitment to, the plight of
the 'ordinary' Indian.

Opposite
4 Gandhi as a Law Student
Elliott and Fry, 1888

In 1888 Gandhi, aged nineteen, travelled to London
to study law, and quickly became anglicised. Here he
made the first of many personal transformations, this
time, as he put it himself, into 'the perfect dandy'.
This studio portrait, sent home to India, shows him in
the conventional attire of the late-Victorian professional:
bow tie, starched collar and shirt. The photographic
firm of Elliott and Fry was well known for drawing sitters
from many spheres of British political and cultural life
including Charles Dickens and John Ruskin.

Bourke-White was coerced into learning to spin before unpacking her cameras but her
portrait of Gandhi was in turn emblematic of the passive resistance to self-regarding
colonial rule advocated by the frail and elderly man in a loincloth, sitting cross-legged on
the floor of a slum dwelling (fig.3). That it was a success was testament to Bourke-White's
determination. For a quarter of a century, Gandhi's simple lifestyle had resisted the power
of modern technology. Bourke-White had won a battle of wills over her photographic
equipment and in recognition Gandhi referred to her, affectionately, as 'my torturer'.

Within a year India had gained independence, but had been partitioned as two nations,
an act accompanied by political rivalry and widespread violence. Against this backdrop
Life sent Bourke-White again to India for a set of images that would be seen by over three
million readers. She met Gandhi on 30 January 1948. Having spoken of 'the darkness
and madness engulfing the world', they ended their meeting by shaking hands in Western
fashion: 'We said goodbye and I started off. Then something made me turn back. His
manner had been so friendly. I stopped and looked over my shoulder and said "Goodbye,
and good luck".' Two hours later, Gandhi was dead, assassinated on his way to prayer.

In 1888 Mohandas Karamchand Gandhi, aged nineteen, the son of a provincial official
administrating British colonial laws, left India to study law in London, the heart of imperial
rule. Out of necessity and convention the young trainee quickly became anglicised. A
studio portrait sent home to India (fig.4) shows him in the livery of the late-Victorian
professional. Gandhi had embraced a society he would later attempt to destabilise.

On qualifying as a barrister in 1893 Gandhi travelled from London to South Africa to
assume a position in his uncle's law firm. The racism and injustice he encountered
appalled him. The treatment of a small Indian population, introduced to the country for
manual labour, shocked him. He experienced such discrimination himself when, *en route*
to Durban with a first-class ticket and in Western clothes, he was ordered to sit in a third-
class compartment because of the colour of his skin. He refused and was ejected from
the train. This incident at Maritzburg station crystallised his beliefs. Thenceforth he
campaigned in earnest for the rights of the Indian minority, using both the resources of the
law firm he established in Johannesburg and the weekly journal *Indian Opinion*, published
in English and Gujarati, of which he was editor. 'Publicity,' he maintained, 'is our best and
perhaps our only weapon of defence.'

Gandhi pledged that his resistance to discriminatory legislation would never be violent,
no matter what brutalities he witnessed or encountered himself; nor would he ever submit
to unjust laws (he would spend over six years of his life in prison). A system of oppression,
he believed, maintained its potency only with the collaboration of the oppressed. If that
could be broken down by passive non-cooperation, then the system would collapse. In
1907 the British Government in South Africa passed the Black Act, which introduced a
rigorous structure of compulsory registration for all Indians. Gandhi urged a public burning
of registration certificates in a symbolic – and entirely peaceful – act of passive defiance.
The legislation was temporarily suspended and Gandhi was imprisoned. He emerged as
the leader of Indian protest in South Africa (fig.7).

In 1913 Gandhi continued the process of transforming his own image and for the first
time used photography to make a political statement. When British troops opened fire on
a group of peacefully protesting Indian miners, Gandhi responded by divesting himself of
the accoutrements that identified him as Westernised and were so conspicuous in the
portraits of Elliott and Fry. Now dressed in the clothes of an ordinary Indian, he posed in
highly visible defiance for the press. It marked a series of personal transformations that

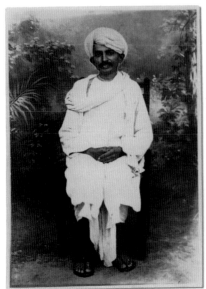

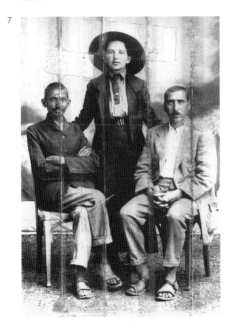

6 Gandhi in Kathiawadi Dress
Collection Vithalbhai Jhaveri, 1915

7 Gandhi in South Africa
Unknown Photographer, c.1913

Gandhi with one of his key European sponsors, the German-Jewish architect Herman Kallenbach, and Sonia Schlesin, Gandhi's secretary. Kallenbach prized this photograph. Travelling to Britain with Gandhi during World War I, he sewed it into his jacket. He was briefly interned but the creased print was never discovered.

Opposite
8 Commemorative Portrait, London
Elliott and Fry, 1931

would demonstrate his sympathy with the Indian people (fig.5). In manipulating his outward appearance, he registered in the most obvious terms his protest against the British Government. Gandhi's simple white clothes, emblematic of mourning in India, were also a gesture of solidarity with those Indians who had died in South Africa (fig.6). Two years later he left for his homeland to continue the struggle for Indian independence. The crowds that met his arrival in India found a figure who assimilated himself with them, walked among them, talking as they would talk and dressed as they might dress. These actions enshrined him in the consciousness of those he would come to mobilise.

After some twenty-five years, Gandhi found India changed and himself a stranger in his own country. He discovered great poverty, starvation and inhuman living conditions for the poorest. He also discovered exploitation and, as one commentator put it, the way 'the ordinary Indian shivered in the presence of a white man'. This was a disharmonious country of 300 million people of different economic strata and religious castes, speaking some 200 languages and practising a variety of religions. Gandhi spent the next few years attempting to establish a national identity, travelling the length of the continent by train, third class. He also established two weekly newspapers advocating non-violent protest.

In April 1919, in the Punjab, the British Empire's supremacy revealed itself at its most brutal. Troops, ordered to suppress sedition, encircled and then fired upon a crowd of peaceful demonstrators. The atrocity, known as the Amritsar Massacre, in which 379 were killed and over 1,000 wounded, provoked revulsion throughout the sub-continent and beyond, galvanising international support for Gandhi's objective of Home Rule and strengthening his resolve. 'How can we compromise,' he asked, 'while the British Lion shakes its gory claw in our face?'

One means by which the British suppressed the Indian peoples was by exerting a stranglehold on their economy. Cotton-producing communities faced poverty and starvation because of the British monopoly on cloth production. Gandhi urged all Indians to boycott British-manufactured clothes and to make their own with the traditional spinning wheel. Photographs of the spinning wheel circulated all over India, emblematic of a small action that might undermine Britain's economic authority. Further, in 1921, at a public burning of foreign cloth, he threw his loincloth and cap onto the pyre. Others followed his example. Predictably, Gandhi was arrested and imprisoned.

Over the next decade, millions joined Gandhi's campaign. On 15 March 1930 he embarked on a strategy that would attract world attention. In response to an increase in the levy on the manufacture of salt, which naturally hit the poorest first, Gandhi set out on a high-profile protest march (figs 9-11). His 200-mile, 24-day odyssey from his ashram at Ahmedabad to the coastal town of Dandi turned into a spiritual journey. The support was unprecedented, in spite of British vilification of Gandhi. Wherever he went, villagers welcomed him rapturously, Hindus joining with Muslims in defiance of their customary antagonisms. Gandhi's awareness of the dramatic effect of such a march had led him to alert months before, not just the Indian press, but agencies worldwide. The *Chicago Tribune* was especially responsive and its representatives were there when Gandhi and his followers reached the shores of the Arabian Sea. There, in full view of the world and in opposition to a punishing tax on a staple human resource, Gandhi knelt down and picked up a lump of salt. 'At present Indian self respect is symbolised in a handful of salt,' he said to the gathering crowds of onlookers. 'Let the fist be broken but let there be no surrender.' The photo opportunity this simple action presented shamed the British Government in the eyes of the world. Gandhi's gesture ignited a campaign of civil

8

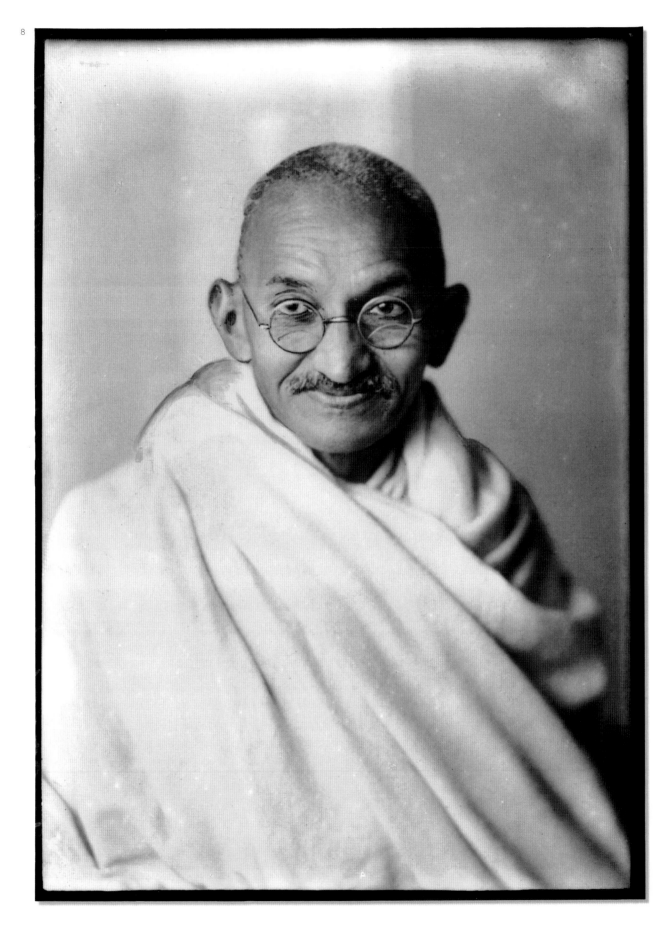

9

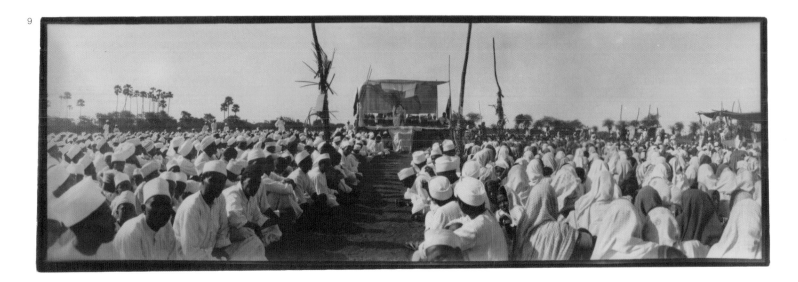

10

9, 10, 11 Salt March
Collection Vithalbhai Jhaveri, 1930

When the British increased the levy on the manufacture of salt (on which they had held a monopoly since 1882), Gandhi sought to highlight this aspect of imperial oppression by collecting salt from the seashore. On 15 March 1930 he embarked on a high-profile protest march and the 200-mile journey from his ashram at Ahmedabad (figs 9, 10) to the coastal town of Dandi, which he undertook barefoot, turned into something approaching a spiritual journey. The support was unprecedented, catching the British unawares. Wherever he went, Gandhi was welcomed ecstatically, the path before him strewn from village to village with green fronds for him to walk on. As the historian Judith M. Brown has pointed out, Gandhi's ability to conjure up large numbers of people rapidly was 'a political novelty and a useful ideological stick to beat imperial rumours and rouse foreign sympathy'. When Gandhi's marchers reached the shores of the Arabian Sea, the protest reached its climax. In full view of the world, Gandhi knelt down and picked up a lump of salt (fig.11, opposite). The photo opportunity presented by this simple yet provocative action proved historic and far-reaching.

11

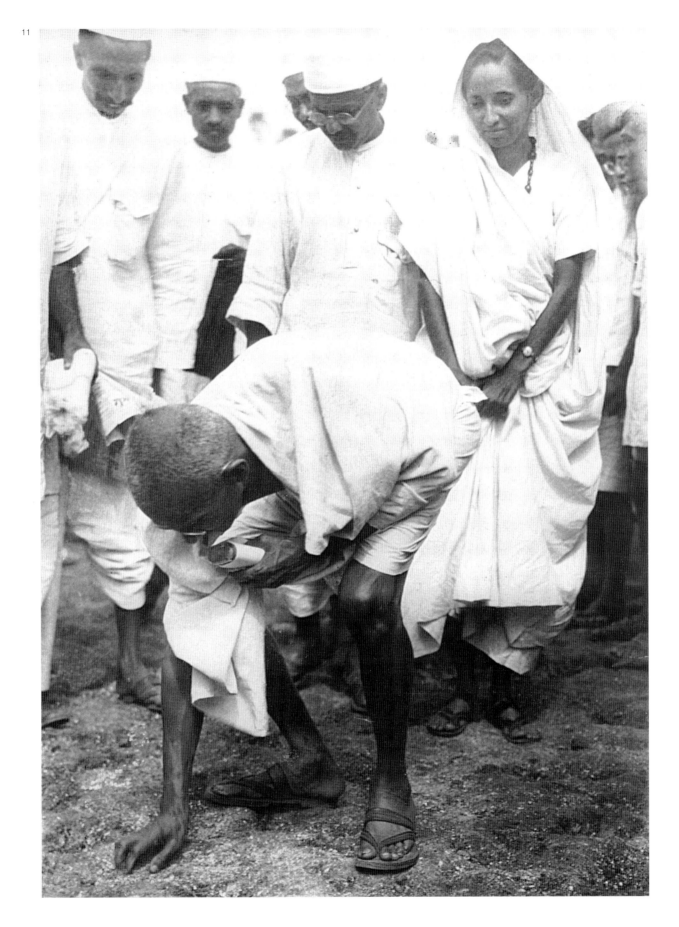

12

12 Gandhi at No.10 Downing Street, London
Topical Press Photographer, 1931

Gandhi's visit to London resulted in several high-profile
photo opportunities. He met the Archbishop of
Canterbury, George Bernard Shaw and Charles Chaplin,
of whom he had previously been ignorant, and attended
a reception in his honour at Buckingham Palace. Here he
is shown outside No.10 Downing Street, where he was
welcomed by the Prime Minister, Ramsay MacDonald.

Opposite
13 Gandhi with Textile Workers, Lancashire
Collection Vithalbhai Jhaveri, 1931

Gandhi was received rapturously wherever he went, not
least where such warmth was unexpected. At the mill at
Springvale Garden Village, Darwen, Lancashire, he was
cheered by the textile workers, despite their being badly
affected by India's boycott of foreign cloth.

disobedience and again he was arrested. Just as defiantly the salt tax remained, though in
a modified form. Yet Gandhi had succeeded in undermining British rule irrevocably and
independence, unthinkable twenty-five years previously, was now a possibility.

The following year, in 1931, Gandhi agreed to talks on Indian constitutional reform in
London with the Viceroy of India, Lord Irwin. A leader of international stature, Gandhi was
still dressed as an Indian peasant. For his twelve-week stay in England, during which he
met the Prime Minister Ramsay MacDonald (fig.12), he eschewed government-sponsored
luxury for the slums of the East End of London, ensuring in the process maximum
publicity for his campaign. With a retinue of photographers he made a symbolic trip to the
textile factories of Lancashire (fig.13), which no longer thrived on the British monopoly of
Indian cotton. 'Lancashire weavers,' noted *Vogue* magazine, 'were for him as important as
Oxford scholars.' Here he illuminated workers, whose redundancy he had effected, as to
the unimaginable poverty and desperation of their Indian counterparts. His simplicity of
dress and manner was markedly at odds with twentieth-century Britain yet he was treated
not as an anachronistic curiosity but as a modern-day celebrity. When invited to meet
King George V and his consort Queen Mary, he refused to wear anything other than his
habitual loincloth. Asked by the British press whether he felt he ought to have dressed
more appropriately, he replied 'His Majesty had more than enough on for the both of us.'

Gandhi's talks with Lord Irwin, who commissioned a portrait of Gandhi to mark his visit
(fig.8), were unsuccessful. Gandhi was undermined by British insistence that the historic
friction between Muslims and Hindus would imperil the stability of an independent India.
Though the talks reached a stalemate, Britain had been humbled into extending him the
courtesies and status of a world leader. For another decade the British would use many
devices to forestall independence for India, but they could not fight the all-pervasive image
of the Mahatma, now indelibly seared on the consciousness of the world.

In India Gandhi's reputation was at its zenith. Millions knew him as the Mahatma, 'the
Great Soul' (fig.20), a name popularised by the poet Rabindranath Tagore, who had won
the Nobel Prize for Literature in 1913. He was revered as a modern-day saint and his
image multiplied on street posters, in newspapers, on postcards and pamphlets.
However, he now faced, as the British had predicted, the one obstacle standing in the
way of his goal: the divisive religious differences that existed among his own people and
the injustices and inequalities that resulted from them. To be independent India had to be
a united nation. For the next five years, Gandhi retreated from domestic politics and
international diplomacy to concentrate on educating and uniting the disparate Indian
peoples. From openly encouraging the presence of the camera, Gandhi now dismissed it
from his life of asceticism, focused around prayer and fasting, and family life (figs 14-18).

The outbreak of World War II in 1939 brought Gandhi, aged seventy, back to political life
with renewed vigour. Conscious of his advancing years, he resolved to witness the
liberation of India in his lifetime. In 1942 he made a decisive speech, warning Britain to
'Quit India'. In spite of his absence from world politics, Gandhi's reputation had grown
immeasurably and as a wave of violence erupted against the British Government at
railway stations, administrative buildings and other targets of colonial relevance, Gandhi
was arrested. He had not sanctioned such action and was powerless to halt it. For the
first time in modern history, India had confronted British rule, admittedly at its lowest ebb,
with methods it had least expected. India was offered dominion status but refused it.
Gandhi hailed an offer of a constituent assembly with the promise of a full constitution
after the war as 'a post-dated cheque on a crashing bank'. The Labour government that

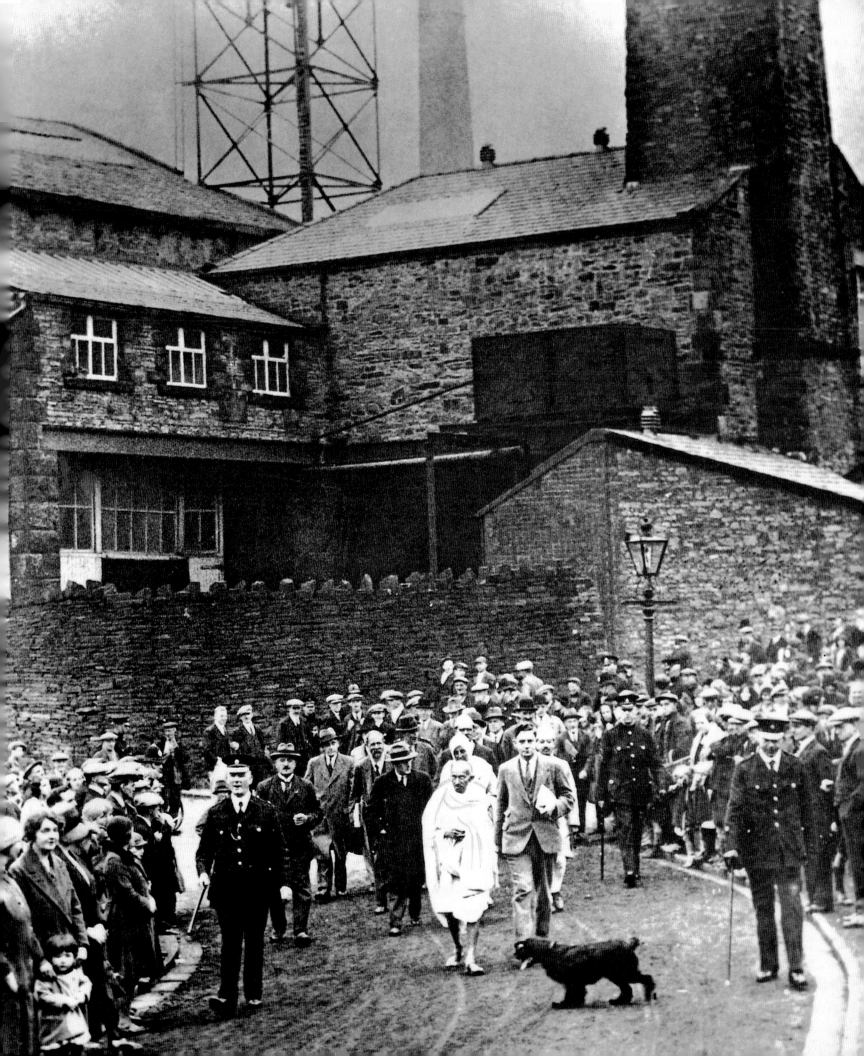

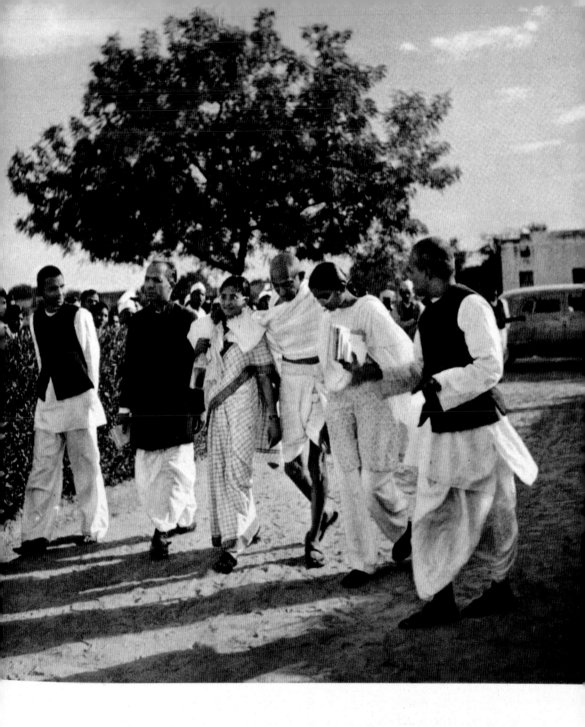

MOHANDAS K. GANDHI, INDIA'S GREAT SAINT,
WITH FAMILY AND FOLLOWERS

*A very rare (and recent) colour photograph by Vogue's Constantin Joffé*

Opposite

14 Gandhi with his Family, Birla House, New Delhi
Constantin Joffé, 1948

Gandhi spent his last months in New Delhi living at the
residence of the industrialist G. D. Birla, one of Gandhi's
benefactors. Many press agencies and magazines from
Magnum to *Life* had representatives nearby, but none
more surprising perhaps than *Vogue*. Its photographer
Constantin Joffé exulted in the natural colours of the
subcontinent and produced a vivid essay on its textiles,
costumes and flora. This page from US *Vogue* (March
1948) shows Gandhi walking with his family and is
significant for being in colour, a comparative rarity.

15, 16 Gandhi by the Indian Ocean, Juhu, Bombay
Collection Vithalbhai Jhaveri, 1944

These two faded studies of Gandhi and his family were
taken at the beach at Juhu, Bombay. Believing in the
restorative powers of sea air, Gandhi had gone to Juhu
immediately on his release from prison on medical
grounds (he had suffered hookworm, anaemia and the
effects of a bad attack of malaria). His wife, Kasturba,
had been interned with him but shortly before his release
and these snapshots, she died in prison. They had been
married for sixty-two years. With Gandhi (fig.15) is their
son, Devdas, and walking behind him (fig.16), together
with family and friends, is Kanu, Gandhi's great-nephew.
Kanu Gandhi would keep an insightful photographic
record of the Mahatma's daily life (fig.20).

17 Gandhi Cycling to Evening Prayers
Collection Vithalbhai Jhaveri, 1929

An unusual postcard-sized print captures Gandhi
attempting to reach the ashram at Ahmedabad from
Gujarat Vidyapith in time for evening prayers. Gujarat
Vidyapith was the national university he had founded
in 1920 and of which he was first Chancellor.

18 Gandhi with his Family
Unknown Photographer, *c.*1948

Another rare portrait of Gandhi and his family in colour,
taken it is believed in front of Birla House, New Delhi.
His granddaughter, Manu, stands to his right and Abha
Gandhi, the wife of Kanu, to his left.

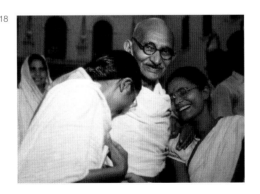

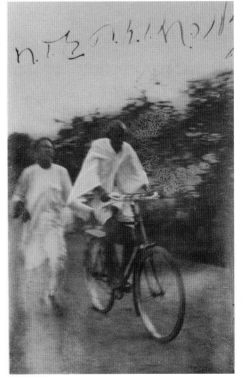

19 Mourners at Gandhi's Funeral Pyre
Henri Cartier-Bresson, 1948

19

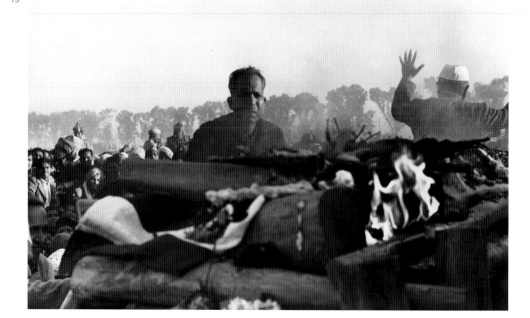

Margaret Bourke-White, who had been with Gandhi in New Delhi just two hours before his assassination, rushed back as word spread of his death and managed to enter Birla House where Gandhi lay. As she focused her lens for a photograph she felt it was her duty to take, her camera was seized and the film ripped out. She fled the building as resentment gathered. Refusing to give up she re-loaded her camera and attempted in vain to return. In the confusion that followed, her colleague and rival Henri Cartier-Bresson discreetly snatched, in over thirty rolls of film, the shots that had eluded her. Gandhi's funeral drew one of the largest crowds in history, over a million strong. Bourke-White made a last attempt to photograph his body as it lay on a weapons carrier strewn with flowers. Scrambling onto the bonnet of a truck she lost her footing and much of her exposed film was trampled underfoot. Cartier-Bresson failed, too, but was more resourceful. A diminutive man, he simply entrusted his camera to someone with a higher vantage point. The photographs published in his name were seen worldwide, images of a nation united for the first time in grief. Gandhi's body was laid in a bower of sandalwood and at 4.45 pm on 31 January 1948, his son Ramdas ignited the pyre. The cry went up: 'Mahatmaji amar ho gae' ('the Mahatma has become immortal').

Opposite
20 The Mahatma
Kanu Gandhi, 1946

The Mahatma gives the traditional gesture of greeting, after alighting from a train in Madras, where he was due to meet a British parliamentary delegation. His great-nephew Kanu was the only photographer permitted to record his daily regime while he travelled throughout India in pursuit of solutions to the religious divide between Hindus and Muslims that threatened Indian unity. No artificial light was sanctioned; nor would Gandhi pose in any form of staged tableau. The resulting images are made all the more vital by the proximity of the photographer and his untutored eye. Around 150 of these photographs were published, a personal document of consummate simplicity, and in their informality a reflection of Gandhi's aphorism 'my life is my message'.

replaced the earlier wartime coalition in Britain was committed to independence and negotiations finally began in earnest.

At midnight on 15 August 1947, Lord Mountbatten, the last Viceroy and Governor-General, formally granted India independence from almost a century of British rule. The flag of the new Indian nation was raised for the first time (fig.2). But the one thing he had feared overshadowed Gandhi's moment of victory: Indian disunity. The sub-continent had been partitioned, as India and Pakistan, and he regarded this as his great failure. Within hours of independence, violence between Hindus and Muslims erupted. Now an elderly man, Gandhi embarked upon a highly publicised fast, a threat to end his life by starvation unless the bloodshed ceased. This was Gandhi's last and biggest gamble using, literally, his life as his message. On 18 January 1948, the fighting stopped.

Twelve days later Gandhi walked, as was his custom, among the crowds that lined his route to a regular prayer meeting at Birla House, New Delhi. A figure came forward from the crowd and made as if to bend down in supplication. Gandhi advanced towards him and at a distance of no more than three feet, the figure pulled out a revolver and shot him three times. His assassin was a fellow Indian of his own religion, a Hindu militant who was disenchanted by Gandhi's sympathy for the Muslim faction and partition. His violent death stood in marked contrast to the views he had advocated.

Gandhi's funeral drew one of the largest crowds in history, over a million strong (fig.19). The photographs of this event, published in Henri Cartier-Bresson's name, were seen worldwide, images of a nation united for the first time in grief. Unlikely as it might appear, the fashion magazine *Vogue* had a reporter there, too – Nada Patcèvitch, wife of its publisher. She despatched a little-known but entirely evocative coda:

*He was a small thin old man with the rosy smooth skin of a baby, large bony hands that made calm peaceful gestures, and eyes full of humour. It was impossible to speak with him for even a few minutes and not feel the immensity of the man; and the spiritual force that emanated from him was so potent and tangible that it touched one like a bird's wing.*

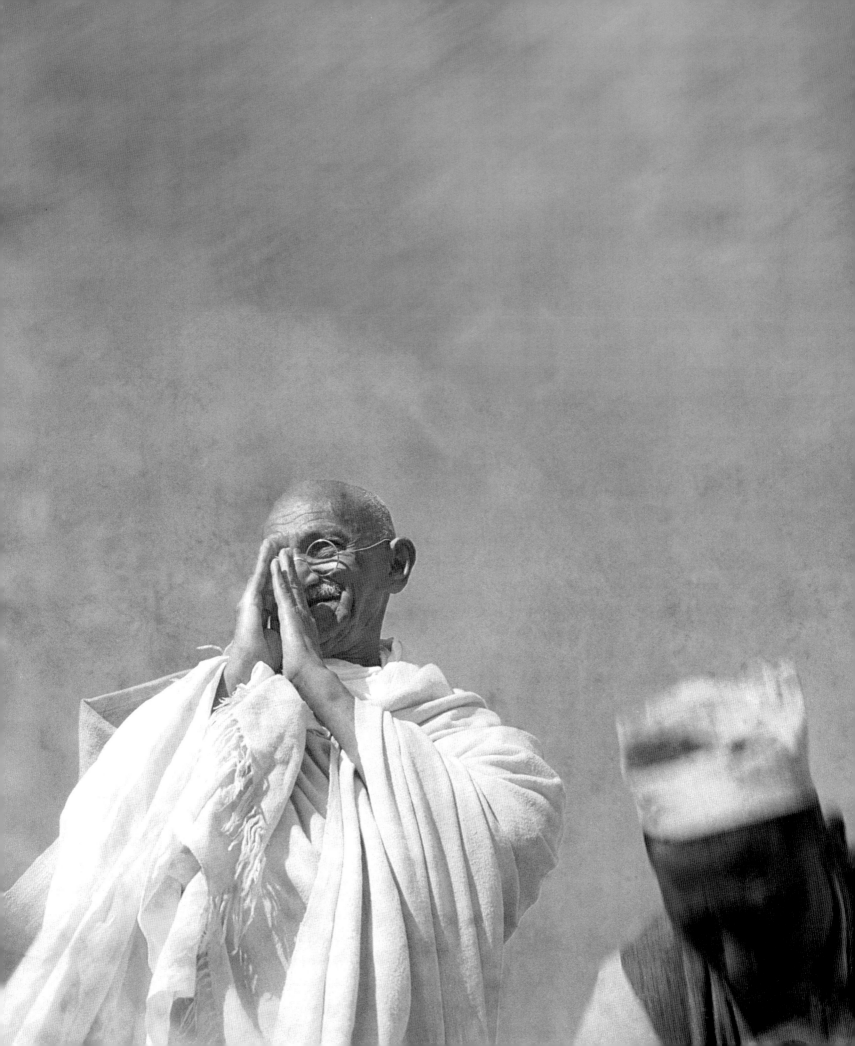

# 3  Adolf Hitler

## Adolf Hitler (1889–1945)

1889  Born on 20 April in Baunau-am-Inn, Austria
1907  Fails entry exam to Academy of Fine Arts, Vienna
1914  Fights for Germany in World War I and receives Iron Cross for bravery
1921  Takes control of the Nazi Party with the help of a private militia, the SA (Sturmabteilung)
1923  Convicted of high treason after the Munich Putsch, writes *Mein Kampf* in prison
1932  Takes German citizenship in order to stand in presidential election
1933  Becomes Chancellor and plots the burning of the Reichstag
1934  Hindenburg dies and Hitler becomes Führer and Reich Chancellor
1936  Hitler's Germany hosts the Berlin Olympics
1939  Orders German invasion of Poland, which starts World War II
1941  Hitler's troops invade Russia but he fails to prepare them for the harsh winter
1944  Assassination plot against Hitler fails
1945  Commits suicide on 30 April, seven days before Germany surrenders

Opposite
1 Portrait of Adolf Hitler, Munich
Heinrich Hoffmann, 1925

Janet Flanner, Paris correspondent for *The New Yorker*, noted in her profile of 1936 entitled 'The Führer' that 'though Hitler takes the worst photographs in the world, there are several thousand of them, all different poses'. She was quick to discern the propaganda value of photography, and Nazi Germany's use of it in a more concentrated and professional fashion 'than any other region on earth – except Hollywood'. Not all of Hoffmann's attempts met with his sitter's approval. This glass positive remained unauthorised and was subsequently shattered.

On the reverse of a creased reproduction of a portrait in crayon of Adolf Hitler, dating from 1936 and to be found at the Wiener Library, London, a typewritten caption reads:

*For a long time Herr Hitler has been displeased with the many photographs taken of him by German and foreign camera-men – & more especially by snapshots at public meetings, which – he protests – only serve to spur the malice of newspaper cartoonists particularly in France and the United States …*

Modern history's most brutal demagogue, the architect of the Holocaust, the ruthless conqueror of all but a small part of Europe, the wagerer of hostilities against two mighty powers, the United States and the Soviet Union, Hitler revealed himself throughout his dictatorship as a vain and conceited man, obsessed with the potency of his image.

Hitler had commissioned the crayon study for his forty-seventh birthday from the portrait painter Carl Rosemann, a friend from earlier days in Munich where Hitler had enlisted in the German army. Clearly it delighted him. For the first time in fifteen years of struggle and success, he put his official signature beneath an image of himself, declaring it 'a truly life-like presentation'. The portrait did not show what several observers had noted: that in the past year Hitler had gained over 15 lbs in weight; that pouches had gathered beneath his eyes; and that, in common with many 'mistaken middle-aging men', his receding hair had been brushed forward in 'a wig-like wad', which drooped towards his left eye.

As the caption indicates, Hitler had an innate distrust of photography. Once in power, he pursued with inordinate determination those whom he knew to have unauthorised and possibly compromising pictures of him. But he came to rely on the medium and used it extensively to document the relentless might of the Nazi regime.

Until 1923 Hitler had gone to great lengths to avoid being photographed. He believed that an air of mystery cultivated around his identity would best serve the emergent NSDAP (Nazi Party), of which he had been chairman since 1921. When he felt it was propitious, he would put into motion this 'cult of the personality', with the added intention of cementing his position in the Party. But this tactic revealed its inherent flaw when, in 1923, the Associated Press of America offered $100 to whoever could photograph the elusive Party chairman. Nazi sympathisers smashed the camera of an Italian who attempted it and were charged with threatening a foreigner, but to Hitler's fury, a press photographer eventually succeeded. The publicity strategy was redrawn and Hitler submitted – reluctantly – to his first official portraits.

Photographs of Hitler soon became a key weapon in the promulgation of Nazi propaganda, promoting him as compelling and heroic, a Messianic leader for a country spiritually and economically crippled by the humiliation of defeat in 1918. He was promoted as assiduously as any Hollywood screen idol and, initially, with much the same battery of artifice, subterfuge and trickery. In fact, he learned much from the excessive and over-emphasised gestures of silent film and, it is believed, took acting lessons.

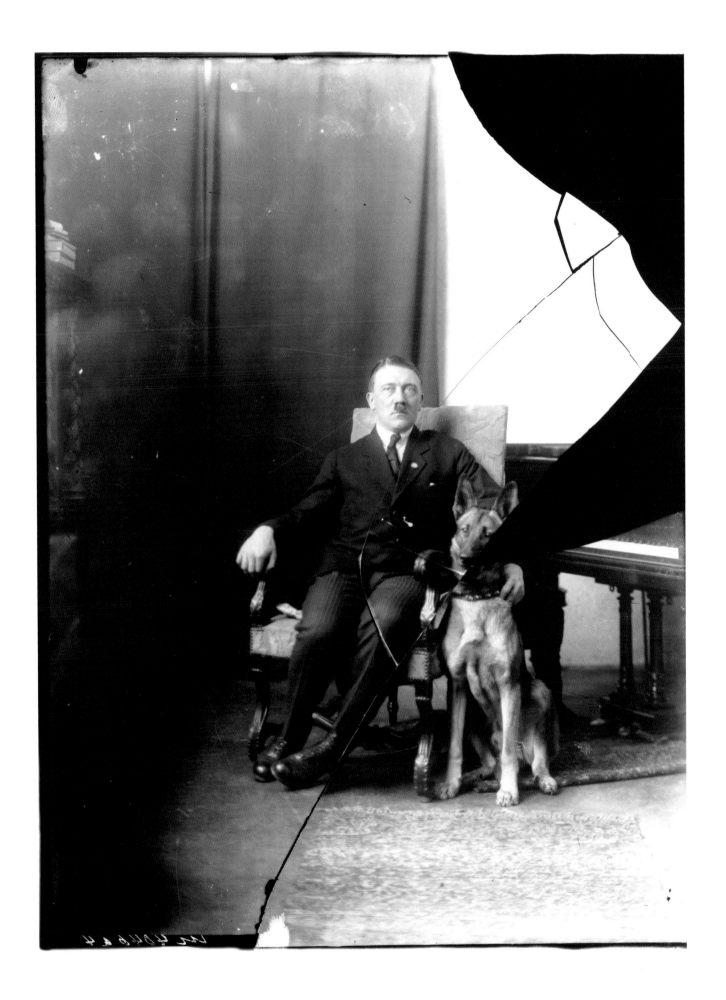

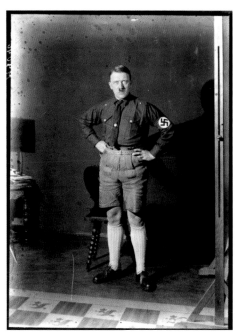

3 Hitler in Bavarian Dress, Munich
Heinrich Hoffmann, *c.*1926

4 Hitler in Evening Dress, Kaiserhof Hotel, Berlin
Heinrich Hoffmann, 1936

Opposite
2 Germany Declares War on Russia, Munich
Heinrich Hoffmann, 1914

When crowds gathered in the Odeonplatz, Munich, to celebrate Germany's declaration of war on Russia, Hitler too had taken to the streets, seized with patriotic fervour. When Hoffmann made a series of enlargements of this photograph, he found the figure of the 25-year-old Adolf, raising his hat in his right hand.

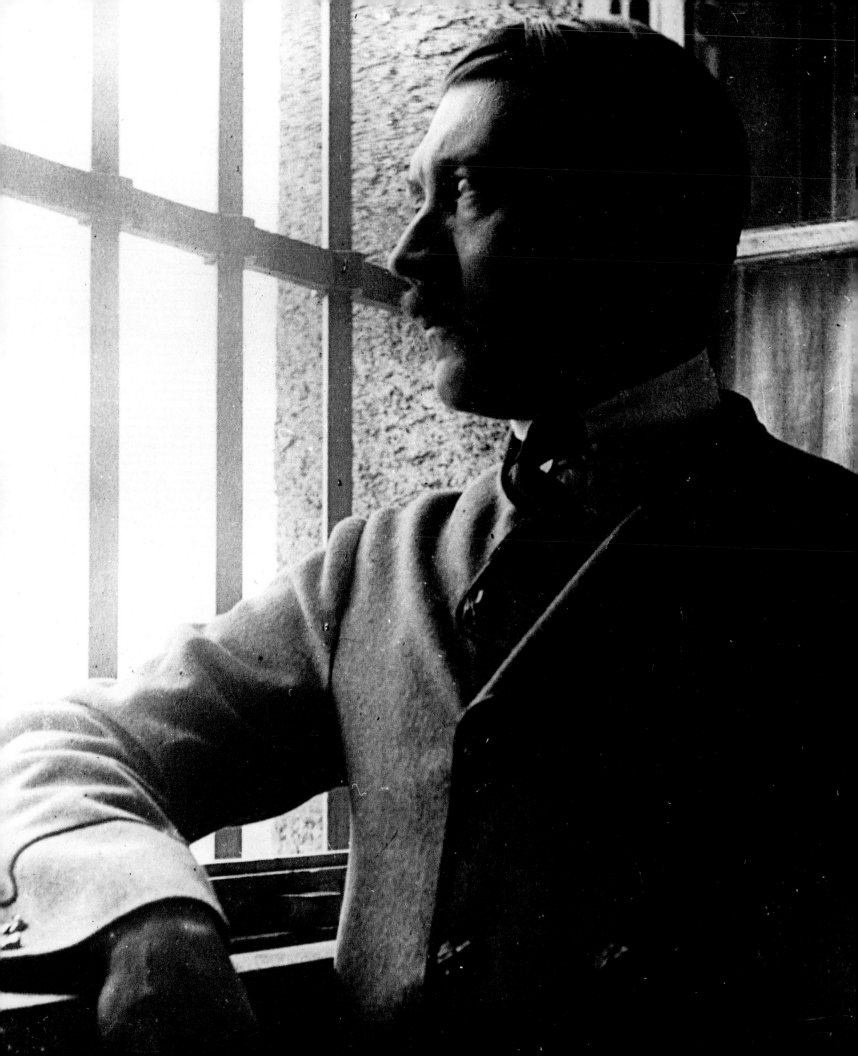

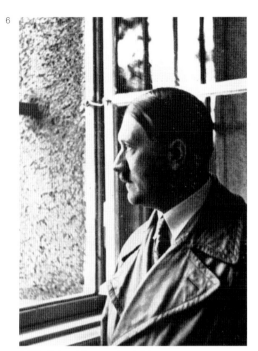

6 Hitler in Landsberg am Lech Prison
Heinrich Hoffmann, 1934

Opposite
5 Hitler in Landsberg am Lech Prison
Heinrich Hoffmann, 1924

After the debacle of the 'Munich Putsch', Hitler was
sentenced to five years in prison at Landsberg
am Lech, of which he served only nine months. The
publicity surrounding his trial, however, transformed him
from a minor politician to a rallying figure for the extreme
right. It was in prison, in some comfort, that he wrote
*Mein Kampf*. He received over 500 visitors, including the
ever-loyal Hoffmann who photographed him gazing out
of the bars of his cell. As the destiny of the Führer took
shape, these months of incarceration assumed
significance in Nazi ideology and, ten years later, Hitler
and Hoffmann returned to re-stage this defining moment
in the history of the German nation (fig.6) – and the
mythologising of Adolf Hitler.

Photography helped his rise to power and, once he was in office, helped further to
hypnotise, to the point of corruption, a nation of sixty-five million people. Before the age of
mass media, Hitler saw, more than any other politician of his era, how photography could
be used first to convince and then to manipulate his followers. The visual self-
representation Hitler presented to Germany in the interwar years, combined with the
potency of his spoken words, was without precedent. It was decisive in endorsing his
seizure of power and validating him as a leader of resolution and charisma. In uniform,
Hitler presented himself as a military strategist the equal of the great Prussian generals; in
a dark suit (ultimately a rarity) the foremost exponent of *Weltpolitik*; and in Bavarian rustic
costume (a surprisingly frequent choice) the compassionate father of a proud, if
downtrodden, nation (fig.3). Lederhosen, however, were deemed too comical in the formal
atmosphere of the studio and thereafter were acceptable only *in situ* in the Bavarian
mountains. Portraits in white tie at the opera were not repeated (fig.4), nor from 1928
were images of Hitler in the drab and jaunty kepi of the SA, or Sturmabteilung (the Nazi
terrorist militia). That he wore reading glasses was also kept from his public.

At the outset, and despite *Mein Kampf* (1924), few adherents truly understood Hitler's
political ideals because they were never logically imparted. Policy makers would, as
Hitler's biographer Sir Ian Kershaw has expounded, 'work towards the Führer', intuitively
guessing what might be expected and continuing along that path until halted or
corrected. What struck them most and what aided their divination, in individual
conversation or as part of the clamouring multitude, was the incandescent force of the
Führer's personality and its concomitant acts of theatre. One observer recalled:

*Suddenly I noticed Hitler's eyes resting on me. So I looked up. And that was one of the
most curious moments in my life ... the gaze ... went straight through me into the
unknown distance. It was so unusual ... He was a wonderful phenomenon.*

General von Blomberg, later appointed Hitler's first field marshal, was heard to say that
a handshake from the Führer would ward off the common cold. Photographs of the
Führer were totemic to the most fanatical. Joseph Goebbels never forgot his first meeting
with Hitler. He recalled it in his diary for November 1925: 'those big blue eyes. Like stars
... I am in Heaven ...' Two weeks later: 'How I love him ... He gives me his photograph.
With a greeting to the Rhineland.' And Heinrich Himmler, a party worker in the years
before his elevation to the Nazi hierarchy, could be found on occasions communing with a
photograph of Hitler on his office wall.

The photograph to which Himmler murmured in all likelihood would have been taken by
Heinrich Hoffmann, a commercial photographer based in Munich and Hitler's first official
photographer (fig.1). Hitler was shrewd in his choice. Hoffmann was a superb technician,
but he made no claims to artistry. The results of their many formal sessions together
would produce, for the most part, compositions of striking and beautifully lit banality –
easily assimilated by the masses. The visual significance of power was not lost on Hitler,
or from 1933 on Goebbels, his newly designated 'Minister of People's Enlightenment
and Propaganda'.

By the mid-1930s there were hundreds of thousands of Hoffmann's official photographs
of Hitler in circulation but few unofficial ones (fig.10). On the eve of World War II, in August
1939, Stalin proposed a toast in the Kremlin: 'To the health of Germany's greatest
photographer.' Hoffmann had been an early member of the Nazi party and would be
retained by Hitler for the next twenty-five years, almost until the end of Hitler's life
(Hoffmann was given his own room in the Führerbunker).

7 Hitler as Political Orator
Heinrich Hoffmann, 1927

In the mid-1920s, Hitler experimented widely with the possibilities photography might afford him in his struggle for power. His exclusive collaborator was Hoffmann, whose *oeuvre* was for the most part studio-bound, simple in composition and uninventive in execution. These images represented a departure. Displayed as a series of vignettes, these 'collector's cards', vital pieces of propaganda, mimicked the potent theatricality of Hitler's speech-making. Though revealing the future dictator at his most impassioned, and among the photographs of Hitler best known to his subjects, such exercises in drama were rare.

His first official portraits of Hitler were taken in 1923 after media interest in the previously obscure figure at the centre of German political life had reached its zenith. Hoffmann revealed a sober figure, self-consciously posed in an approximation of the 'statesmanlike'. His gaze is grim and determined, his countenance all but dominated by his small moustache ('brief and without humour', observed Janet Flanner, Paris correspondent for *The New Yorker*, of this emblematic feature).

In the same year, in Munich, Hitler attempted to seize power from the Weimar Republic, which he and others regarded as symbolic of Germany's defeat. The 'Munich Putsch' was a disaster for the Nazis: fourteen members of the Party died in a confrontation with the Munich police; Hitler was arrested and tried for treason. His sentence of five years imprisonment was derisory (he served barely nine months). However, his trial transformed him from a minor southern German politician to a figurehead of the extreme right and Hoffmann's photographs of Hitler in his prison cell record this defining moment (figs 5, 6).

Despite Hoffmann's immoderate alcohol consumption and flagrant sexual behaviour (anathema to Hitler when indulged in by others), Hitler demonstrated loyalty to a comrade from 'the time of combat'. He was also alert to serendipity and Hoffmann's sense of propitiousness. In 1914 Hoffmann had taken a sweeping photograph of the crowds in the Odeonplatz, Munich, celebrating Germany's declaration of war on Russia (fig.2). Hitler remarked that he too had taken to the streets in patriotic fervour. So Hoffmann made a series of enlargements of his photograph and found the face of the 25-year-old Hitler, which he encircled to emphasise their early and indelible bond.

In August 1927, in preparation for the national elections the following May and the Nazi Party's assault, Hoffmann took an extraordinary series of portraits of Hitler, one of the

LER
n einen Willen hätten,
nust würden die Waffen
Deutschland der Marxis-
für ewig seine Fesseln.

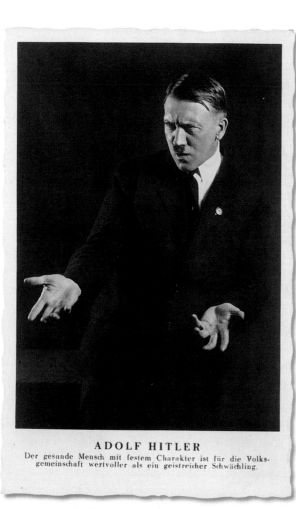

**ADOLF HITLER**
Der gesunde Mensch mit festem Charakter ist für die Volks-
gemeinschaft wertvoller als ein geistreicher Schwächling.

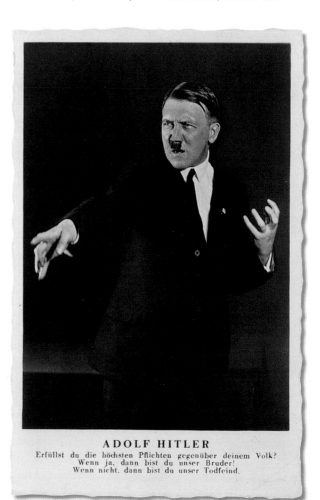

**ADOLF HITLER**
Erfüllst du die höchsten Pflichten gegenüber deinem Volk?
Wenn ja, dann bist du unser Bruder!
Wenn nicht, dann bist du unser Todfeind.

Overleaf
8 Hitler at a Meeting of the Reichstag, Berlin
Hugo Jaeger, 1938

The full power of the Nazi aesthetic is made visible at
a meeting of the Reichstag in the Kroll Opera House,
Berlin. Hitler makes a keynote speech answering
President Roosevelt's fruitless appeals to avoid war.
Though raised above the other attendees and deputies,
Hitler, the Chancellor of Germany, was still intentionally
dwarfed by the pageantry of the setting.

most significant shoots of his career. As Hoffmann played a recording of an impassioned
political speech, his subject was transformed. He took up aggressive, wild-eyed and
theatrical poses, the start of a life-long and chilling obsession with the theatre of power.
Hoffmann's photographs captured the emergence of the most ruthless dictator the
modern world had encountered – and at his most fanatical (fig.7). Disseminated as
propaganda cards and in the *Völkischer Beobachter* (the Party newspaper), the results
of these few hours defined for millions the inexhaustible energy of their aspiring leader.
Hitler remained obsessed with the manufacture and potency of his own image, absorbing
the significance of body language and learning the sequencing of gestures to create the
greatest impact at public rallies.

Hoffmann's images of Hitler, like those of film stars and stage actresses, appeared in
pocket books (fig.13), on picture postcards and cigarette cards, with a commensurate
number of albums in which to contain them. Hitler was also the subject of 'collector's
cards', larger than a postcard and captioned on the reverse, which were sold all over
Germany to profit the Party. These were augmented by Hoffmann's numerous
compilations in book form, a groundbreaking strategy in political propaganda, which
showed the Führer in a variety of sympathetic tableaux (fig.12). Goebbels instituted a
rigorously controlled publicity machine, giving and withdrawing access to the Führer and,
in collusion with Hoffmann, staging photographic opportunities.

Thus Hitler's image dominated public life. The thirteen million who voted for him in
1932, and who welcomed him as Reich Chancellor, were dependent on manufactured
images that appeared in newspapers and in Hoffmann's souvenir books. Copies of *Hitler
wie ihn keiner Kennt* (1932), *Hitler in seinen Bergen* (1935), and *Hitler Abseits vom Alltag*

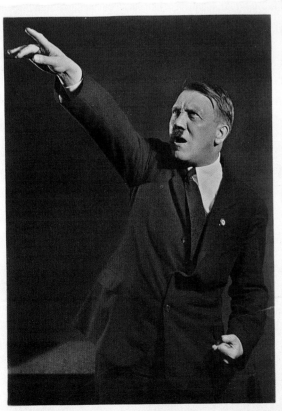

**ADOLF HITLER**
Mögen Jahrtausende vergehen. so wird man nie von Heldentum
reden dürfen, ohne des deutschen Heeres des Weltkrieges zu
gedenken.

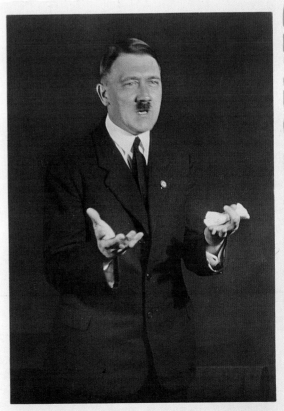

**ADOLF HITLER**
Falsche Begriffe und schlechtes Wissen können durch Belehrung
beseitigt werden, Widerstände des Gefühls niemals. Die Voraus-
setzung zur Tat ist der Wille und der Mut zu Wahrhaftigkeit.

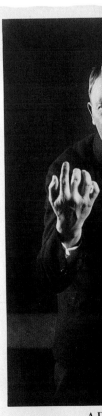

AD
Wenn an der Front
zu Hause wenigsten
räterischen Burschen
hüd

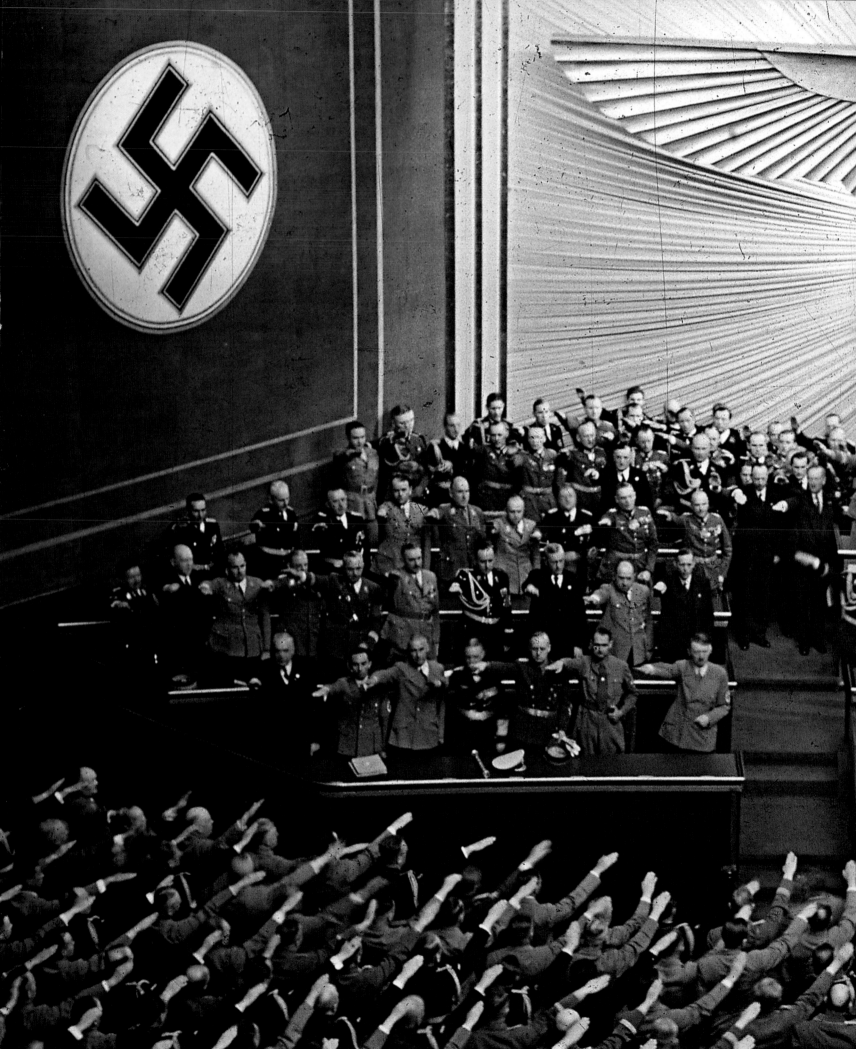

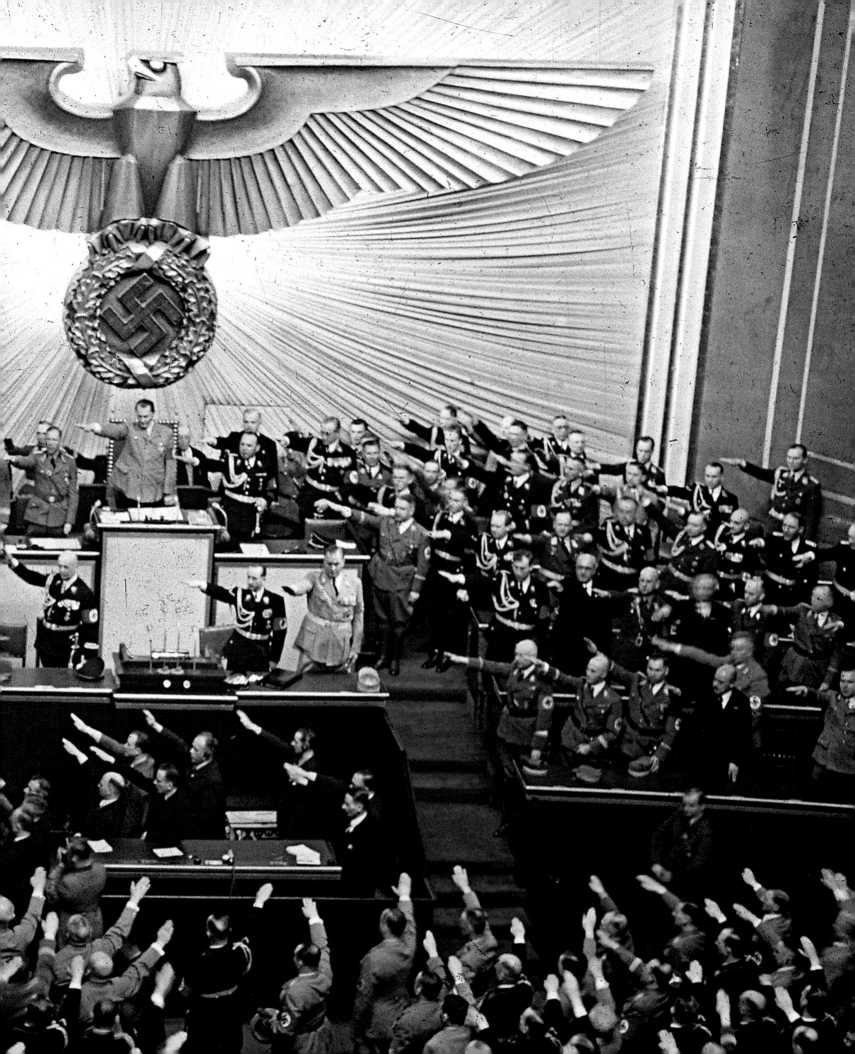

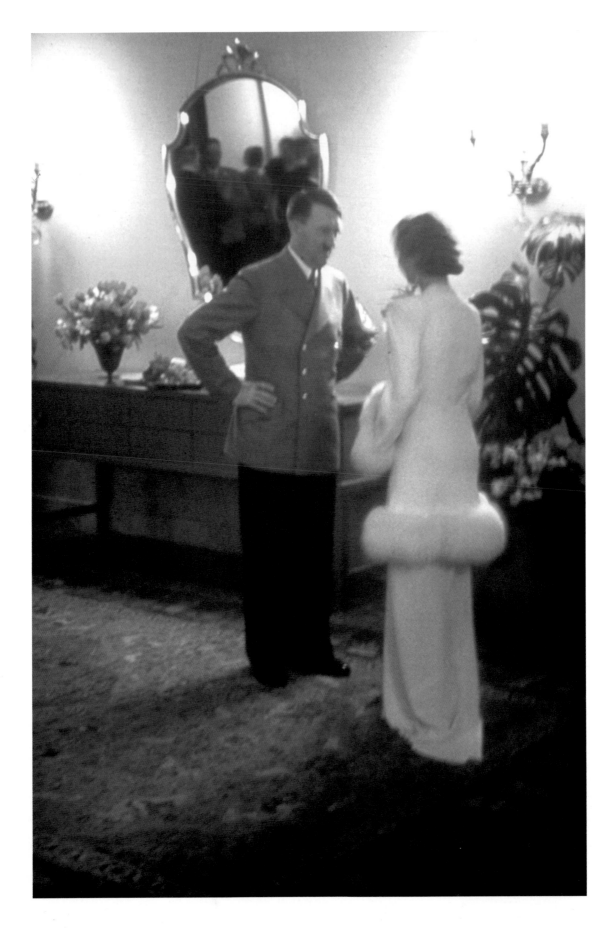

10

11

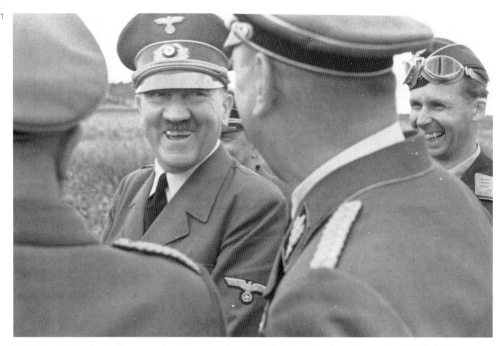

10 Hitler with Party Supporters at a Café, Munich
Tim Gidal, 1929

Gidal's distinguished career began in Munich in 1929 with the *Münchner Illustrierte Zeitung*, whose contributors often gathered at an open-air café near its offices. Here he encountered Hitler, and snatched what is considered to be one of the few photographs of him before 1933 to be taken without his knowledge.

11 Hitler Exultant at the Fall of France
Walter Frentz, 1940

Hitler celebrates news of the fall of France with Max Amann (controller of Germany's newspaper industry), Julius Schaub (Hitler's adjutant) and Nicolaus von Below (his Luftwaffe attaché). Walter Frentz was himself a second lieutenant in the Luftwaffe. He was allowed an almost free hand when photographing Hitler and so was able, unlike Heinrich Hoffmann, to produce pictures of the Führer at his most unguarded.

Opposite
9 Hitler Greets the Wife of a Party Official
Hugo Jaeger, *c*.1939

Once an assistant to Hoffmann, Hugo Jaeger took colour photographs that revealed a side to the Führer arguably more intimate than his former employer's *oeuvre*. Though snapshots, they remain intriguing for their aesthetic qualities, and some derive extra impact from being taken in low light at a slow shutter speed on a hand-held camera. The best of them reveal both the triteness of Hitler's social life in the Bavarian mountains and his scarcely concealed appeal to the wives of Nazi party functionaries.

(1937) sold in their thousands. It was estimated that in the decade up to 1945, Hoffmann and his legions of assistants took over two-and-a-half million pictures of the Führer, a formidable productivity rate of around 5,000 images each week. His royalties earned him a fortune – and ultimately a ten-year prison sentence in 1947 for profiteering.

The propaganda value of Hoffmann's books was considerable, portraying the Führer as a populist leader. Hitler customarily wore a uniform without decorations or the insignia of high office, simply the Iron Cross of a World War I veteran and a swastika armband. Indeed, he actively encouraged the flamboyance of his colleagues' uniforms in order to enhance the simplicity of his own. A visit to Mussolini in 1938 necessitated frock coats and gold braid for his retinue but simple soldier's buff for their leader. 'My surroundings must look magnificent,' he remarked. 'Then my simplicity makes a striking effect.'

The Nuremberg rallies of 1933 and 1934 provided the most dramatic display of Nazi aesthetics yet seen. Though he dominated the multitudes that came to pay him homage, Hitler was dwarfed, as he intended, by the pageantry of the staging: banners, flags, swastikas, uniforms, marching men and anthem-singing crowds (see also fig.8). The photographer Leni Riefenstahl was charged with filming the spectacle and Hitler gave her finished work its title – *Triumph of the Will*. It remains the apotheosis of the cult of the Führer and was to him proof of the synthesis of the Party and the people.

Riefenstahl's chief cameraman, Walter Frentz, emerged as an enthusiastic and talented stills photographer. Though he remained largely uncredited by Riefenstahl, it was his hand-held *verité* style that made Hitler's declamations vibrant and vivid. He became known towards the end of the war – and to the chagrin of Hoffmann – as 'Hitler's photographer'. Hoffmann's skill lay in his carefully stage-managed images of the emergent Nazi leader, taken for the greater glorification of the Führer. In contrast Frentz's talent was for dispassionate reportage. As Hitler metamorphosed from politician to strategist to commander-in-chief, patrolling the command centres of the Axis fronts, Frentz's unobtrusive documentary style brought an immediacy to the depiction of the Third Reich at war. Unlike Hoffmann, he was neither an intimate of the Nazi inner circle nor even a Party member, though he had met Albert Speer, Hitler's architect, as a student in Berlin.

12 Pages from *Deutschland Erwacht!*
Heinrich Hoffmann, 1933

Hoffmann's numerous compilations of photographs were a groundbreaking strategy in political propaganda, and showed the Führer in a variety of staged tableaux. The most popular adopted the sylvan setting of Hitler's country home in the Bavarian mountains, heralding a new Arcadian age for the German nation. Here he might pet small animals as well as children, welcome world leaders, promenade with them on snowy slopes, take tea with the wives of party dignitaries and, in moments of solitude, reflect upon the course of German history.

12

Opposite
13 Promotional Photograph for Miniature Books
Unknown Photographer, 1930s

Nothing appeared so infinitesimal that it might not spread the word. Nazi propaganda came in all shapes and sizes from large cards, intended for collectors' albums, to these diminutive books, which appeared to be nothing so much as traditional good luck 'charms'. Hoffmann's photographs were used almost exclusively for such commercial ventures and he reaped sufficient reward to be indicted at the war's end for profiteering.

Although he would be known as 'the Eye of the Reich', Frentz's impartiality (in as much as it can be called that) enabled him to be, for the most part, a detached observer.

Frentz had made a friend of Eva Braun, who in distress remarked of her life with the Führer that he had kept her in a 'golden cage'. Braun's relationship with Hitler had started in 1929 when, aged seventeen and an assistant to Hoffmann, she had slipped a note into Hitler's overcoat pocket. Hitler kept his intimacy with her a secret, conscious of his allure as a man of destiny, wedded only to the ambition of Germany. Braun was marginalised for sixteen years and, after at least two suicide attempts, was by the mid-1930s residing permanently in the Berghof, near Berchtesgaden. In an unexpected piece of propaganda, published in the same month that Hitler sanctioned Kristallnacht and barely a year before the outbreak of war, the British magazine *Homes & Gardens* gave the public a glimpse of the Führer's home life (fig.14). While Frauen Goebbels and Goering 'in dainty Bavarian dress, arrange dances and folksongs', Hitler's mistress remains unmentioned.

No official portraits of Braun were ever sanctioned. Frentz encouraged her photographic skills, which had been curtailed since her relationship with Hitler began. In one of her own photographic albums a snapshot made reference to the hopelessness of her situation. An Italian emissary, visiting Hitler on the orders of Mussolini, was caught by an official photographer looking up to an open first-floor window. Underneath it Braun wrote, 'There is something upstairs that they cannot see – me!' And through the open window, she took her own photograph of the visiting emissary, capturing a moment forbidden to her. Despite their closeness, Frentz was careful to avoid the fate of a colleague, Ernst Baumann, who made a series of photographs of Braun talking with friends, walking her dogs, even acting out minor hostess roles (fig.15). His reward was rapid despatch to a Front from which he was not expected to return.

As a second lieutenant in the Luftwaffe, Frentz was ideally placed to cover the theatres of war. He recorded in moving and still film Hitler's return in triumph to Vienna after the Anchluss and the victory march into Warsaw. He accompanied Von Ribbentrop's

14

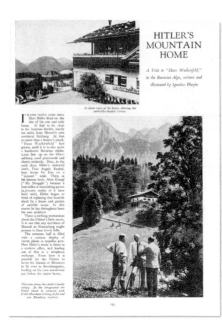

14 'Hitler's Mountain Home' from *Homes & Gardens*
'Ignatius Phayre', 1938

*Homes & Gardens* magazine (November 1938) invited readers into 'Hitler's mountain home', the Berghof, near Berchtesgaden in the Bavarian Alps. It marvelled at the views, 'the chain of drowsy lakes' and 'ancient shrine-chapels hidden in ferny folds of towering rocks', where 'rustics sit at cottage doors carving trinkets and toys in wood, ivory and bone'. The feature appeared in the same month that Hitler sanctioned Kristallnacht, the systematic looting and destruction of Jewish businesses in Berlin and beyond. The photographs are in fact by Hoffmann, not the pseudonymous 'Ignatius Phayre'.

Opposite
15 Portrait of Eva Braun
Ernst Baumann, *c.*1941

Hitler's mistress Eva Braun was as trapped in their mountain retreat as the Harz canaries in their gilded cages, dotted about its airy rooms. No official photographs of her were ever taken. When it was discovered that Ernst Baumann, a photographer based in Berchtesgaden, had made a series of intimate photographs of Braun, he was despatched to the recently established Eastern Front.

diplomatic mission to Moscow and documented Hitler's reaction to the capitulation of France (fig.11). In 1941 he was seconded to the Wolfschanze, Hitler's East Prussian headquarters. It was a privilege denied to Hoffmann. The Hoffmann studio continued photographing for the Ministry of Propaganda, but Frentz was allowed almost unfettered access to the Führer. One of his pictures showed the unthinkable: Hitler's disillusionment in the face of German defeat on the Eastern Front, his crest-fallen face caught gazing out of a plane window (fig.17). It remained unpublished. The younger photographer was able to produce vignettes of Hitler at his most unguarded as, unlike Hoffmann, Frentz was never appointed an official photographer and the images he made were never intended for publication. Hoffmann and Frentz became rivals, the more so when the latter resisted the former's invitation to work alongside him.

In July 1944, a plot to assassinate Hitler at the Wolfschanze was conceived by disenchanted army officers. It is a measure of Frentz's access to the Führer that he was singled out as the ideal candidate for the task. He refused, but made no attempt to frustrate the plot. The attempt went ahead and Frentz was present to record the aftermath and Hitler surfacing unscathed from the wreckage.

As the Reich's fortunes changed (figs 18, 19), Frentz accompanied Hitler on his final journey to Berlin and the Führerbunker beneath the Reich Chancellery. But Hoffmann was there, too, and had the distinction of taking, on 20 March 1945, the last published pictures of the Führer, shaking and dejected, aged far beyond his fifty-six years, decorating youthful members of the Volkssturm, while Frentz captured it on moving film. Frentz's photographs remain the most compelling, however, not least his snapshot of Hitler scrutinising models of buildings for a postwar Germany that he knew would never be constructed (fig.16). Hoffmann left the bunker first, followed a few days later by Frentz, who took the plane to the Berghof that had been intended to take the Führer to safety. Finding photographs of Eva Braun among Frentz's collection, the SS confiscated them and then destroyed much of his colour film.

At around the same time more colour film was being saved from a similar fate. Hugo Jaeger had been an assistant to Hoffmann and worked with colour film in contrast to the latter's more typical black-and-white. In a west German town, in 1945 as the war was

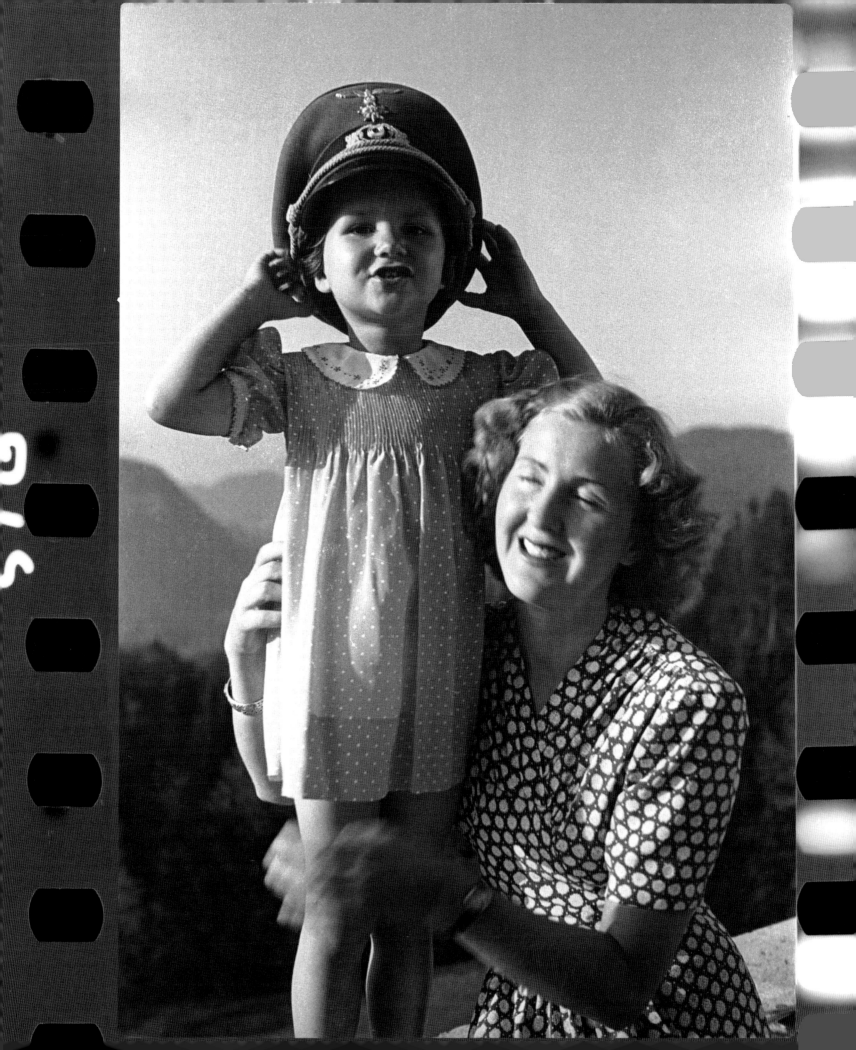

16 Hitler Reviews Maquette of Postwar Linz
Walter Frentz, 1945

Barely a month before his suicide, Hitler still
contemplated a future for the Reich that would never be
realised. Here in the bunker beneath the shattered Reich
Chancellery, Hitler examined a maquette of postwar Linz,
'The Jewel of Austria'. Hitler, an Austrian national until
1932, had declared that Linz, his boyhood home,
would become a 'World Town' and that he would
in time retire there.

16

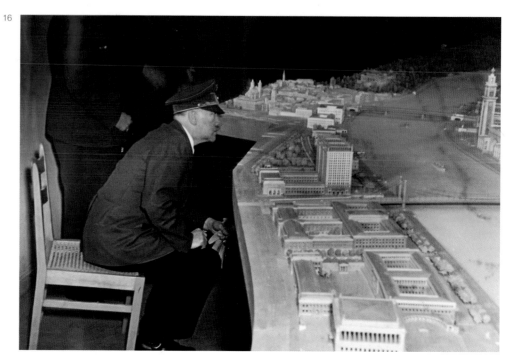

Opposite
17 Hitler Reflects on Defeat at Stalingrad
Walter Frentz, 1943

Hitler's greatest strategic error was perhaps 'Operation
Barbarossa', the name given to his Russian campaign,
which began in earnest in 1941. It ended in defeat for
the German army at Stalingrad in the winter of 1942-3.
Pictured in an aircraft that was probably heading for, or
leaving, the Wolfschanze, Hitler's East Prussian
headquarters, his grim expression may indicate his
realisation that the campaign had been a disaster of
catastrophic proportions. German losses at Stalingrad
were put at 147,000 with over 90,000 men taken prisoner.

clearly ending, Jaeger hid his photographs in jars underground. Salvaged by him years
later, they show an arguably more intimate and revealing view of the Führer than the
documents of his employer or of Frentz: the triteness of Hitler's social life at the height of
the war in the Bavarian mountains, where conversation, recalled Speer, rarely rose above
the level of triviality; and in the Chancellery, too, where the elegant wives of Party officials
attended him in rapt adoration (fig.9). Though snapshots, they are for the most part
compositions of unexpected harmony and originality.

Hitler resigned himself to death by his own hand. Photographs taken of the grotesque
display of the corpses of Mussolini and his mistress, shot and then hoisted upside down
from lamp-posts, would have appalled him. That his own image, which he had crafted
assiduously over twenty years, could end in such a manner was unimaginable. On 2 May
1945, three days after Hitler and Eva Braun's marriage – there were no photographers left
to record the event – and two days after their double suicide, the Russian army broke into
the Reich Chancellery and Germany surrendered. The Russians exhibited pictures of
Hitler's corpse. In death, as in life, images of the Führer were thought to be compelling but
they were, of course, all fakes. Hitler's body had been immolated before the Russians
broke through, but photographic evidence to prove his death was considered vital to the
Russian victory. No authentic picture of Hitler's body has ever been found.

Hoffmann, Frentz and Jaeger survived the war. Jaeger disinterred his photographs and
sold them to *Life* magazine. Hoffmann published one more book before his death in 1957,
*Hitler was my Friend* (1955), which featured numerous black-and-white photographs by
Hoffmann and endpapers illustrated with Hitler's doodles. He refused to paint the Führer
in a bad light. Frentz, who died in 2004, had a clear conscience. As he told Gitta Sereny,
biographer of Speer, 'I only reproduced, never produced.' Hitler was finally true to only
one ideal, that of the Führer, as demonstrated by the work of his photographers,
filmmakers and documenters.

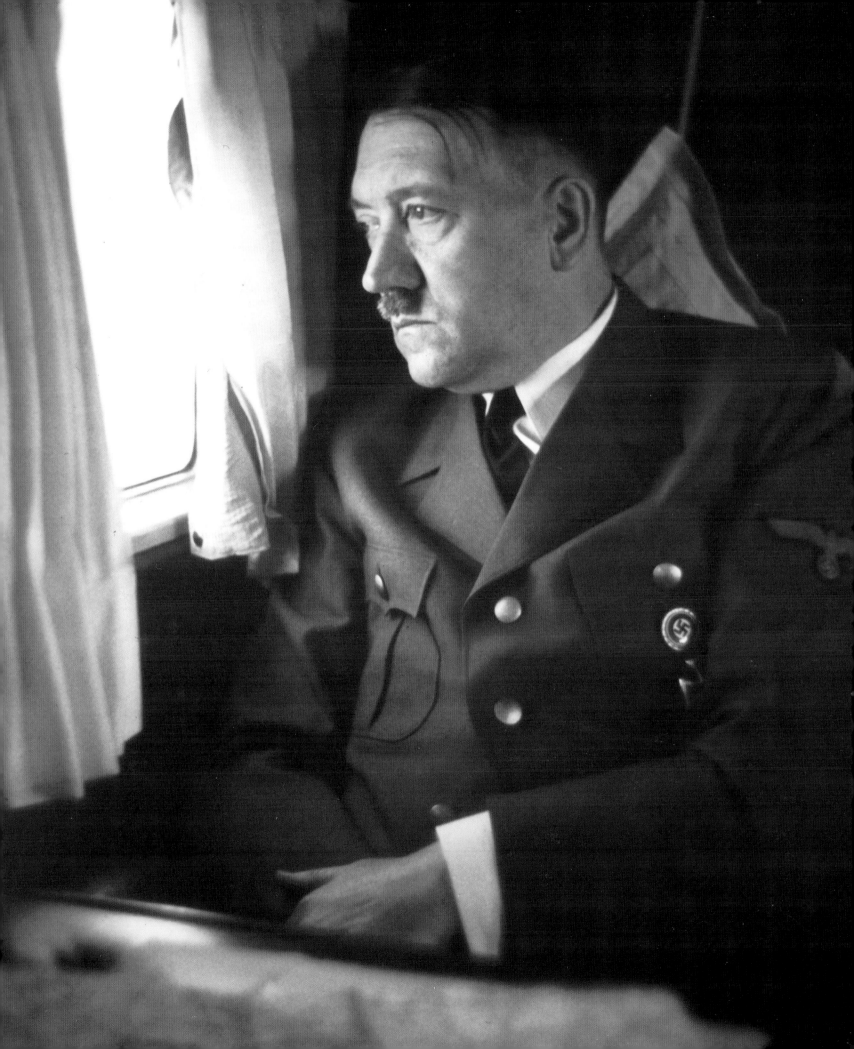

18 Suicides in the Town Hall, Leipzig
Lee Miller, 1945

As the war entered its final stages, Hitler's image had lost its potency for all but the most fanatical. The burgomaster of Leipzig, several members of his staff and his family killed themselves in the city's municipal offices, rather than risk capture. A propped-up portrait of their Führer (by now dead himself) oversaw their suicides.

Opposite
19 Hitler at the Berghof
Walter Frentz, 1941

An elegiac snapshot of Hitler on a terrace at the Berghof, overlooking Berchtesgaden, in June 1941. His purposeful gait reflects perhaps the decisiveness of recent events. He had mobilised around three million soldiers and 3,500 tanks for 'Operation Barbarossa', the attack on Russia. The early stages of the 'Drive to the East' were successful, though ultimately it would end in disaster for the German army.

# 4　Greta Garbo

## Greta Garbo (1905-90)

Opposite
1 'A New Star from the North'
Arnold Genthe, 1925

Garbo posed for the German photographer Arnold Genthe in New York *en route* to Hollywood. Published in *Vanity Fair* in November 1925, these dramatic portraits were for many readers their first glimpse of the leonine actress.

In May 1940 the photographer Cecil Beaton sailed to New York on an advertising assignment for Pond's Cold Cream. On board, he struck up a conversation with a fellow passenger, one Professor Loewi, a scientist dispossessed of his position and his property by the Nazis. Their conversation might have touched upon the scientist's misfortunes, or perhaps his researches into the chemical transmission of nerve impulses, or even the photographer's anxiety for his country's future in its darkest hour. Instead they talked of something more universal. As Beaton recalled it, 'Loewi talked of Garbo.' He added, 'But in what a way he talked of her! He has no money for the cinema but makes one exception each time there is a Garbo film.' Beaton asked himself, 'Why should Garbo appeal – to him, to me, to millions of others?' And he noted Loewi's response:

*He considers that she, as with certain lyric poetry, is the condensation, the concentration of the hidden, but ever-present sadness that is in all people. For every grown up person Garbo possesses, too, the sadness that is dormant in a child, when, robbed of its protective armour of courage against the world, it lies asleep …*

The mystique and the myth of Greta Garbo have been endlessly debated. Her mystery, declared Tallulah Bankhead, was 'as thick as London fog'. Her private life was the subject of conjecture after her on-screen partnership with John Gilbert in *Flesh and the Devil* (1926; fig.4) turned into an off-screen romance. What she chose to wear on and off duty was scrutinised in detail (the 'high-collar' look from *Ninotchka* was copied the world over). That she had formed a close friendship with the writer Mercedes De Acosta (see fig.11) raised eyebrows; that she should be photographed in her company, emerging from a tailor on Hollywood Boulevard wearing a pair of men's trousers, caused a scandal. She had by the mid-1930s given up interviews and publicity; she frequently failed to attend her own premières; she allowed no visitors on set and left promptly at six o'clock every evening. She was a public obsession, a riddle and an enigma. Clarence Sinclair Bull's well-known portrait of her face, photomontaged onto the body of the Sphinx (taken for *Inspiration* magazine) remained a favourite image of Garbo's, though one that she greeted with laughter. She was a contemporary siren, a legend of the movies (she had starred in twenty-four films by 1940), a survivor, as one commentator remarked, 'of the vulgar exhibitionism of Hollywood'.

Though opportunists in pursuit of the 'real' Garbo would harry her unremittingly, she contrived – with the tacit acquiescence of Metro-Goldwyn-Mayer – that in the sixteen years she was in Hollywood, only seven photographers were authorised to take her photograph. She was aware that the selection of a print depended not upon aesthetic considerations, but upon a meticulous strategy devised by the studio publicity department. The artfully crafted Hollywood portrait was an instrument of protection and projection, fabrication and deception. The key to the collective infatuation with Greta Garbo was her reluctance to participate fully in the studio publicity machine.

# An Early Ame

### The Vicissitudes of a Visitor Caug

By GEORG

ARNOLD GENTHE

## A New Star from the North—Greta Garbo

GRETA GARBO is the latest adjunct to the Swedish film colony in Holly-wood which includes Victor Seastrom and Benjamin Christianson. Dis-covered by a *regisseur* of the films madly studying the rôles of the Norse dramatists, Ibsen, Strindberg *et al* in the Royal Academy of Dramatic Art in Stockholm, she was offered an opportunity to play the lead in "The Story of Gösta Berling," the opus, which, for reasons now forgotten, gained Selma Lagerlöf the Nobel Prize. Thus Miss Garbo, aged 19, revealed such a nne dra-matic instinct that many continental film companies bid high for her. Finally, the officials of Metro-Goldwyn in America, attracted by her rare promise, pro-posed a contract for a series of pictures to be made in Hollywood. The offer was accepted, and Miss Garbo has recently arrived in this country to begin work on her first American picture, the title of which has not yet been announced

I HAVE just been spend-ing a week-end with my friends, the Cartwrights, who live in the northwestern corner of Connecticut. It is a country to which I am partial and I am fond of the Cartwrights, too, but, as I look back over my two days ex-perience, I question whether I should be able to repeat it without having my love turn to hate.

past year Tom Cartwright has been about the old house which he and remodeling. Every time I met him bunch of photographs to show me. it during every phase of Still, I had no definite appearance for if there is that leaves me cold it is pic-foundations, scaffolding, piles and plaster-stained work-

I received my invitation the job was done. They at last and Laura was busy furnishing. Even that, I understand, was virtually It was pure American, Tom expressed the hope that it pure and was assured that had no moral signifi-I accepted.

at Millerton and driven fourteen the house. Dusk had fallen so that I little impression of its appearance we passed on the terrace while Tom lined what he had done.

"I wish you could have seen this place a year ago," he said. "There is the old main house, you see, where Laura and I have our rooms. The din-ing room is in that con-necting section that used to be the horse-barn. We made the kitchen and pan-try out of the woodshed. Then comes the living room, which was the hay-barn, and for the guest-rooms, at the other end we hooked up a lot of out-buildings."

"Very effective," I murmured, though in the gloom the impression I had was of a row of ill-assorted freight-cars or a circus elephants waiting to be jumped Laura stood in the doorway waving watchman's lantern and I was welcomed hay-barn living room where the square to a murky region spanned by outlined trusses. I caught my knee on corner of a chest which stood near

the door and col present while m pain.

"It's hard to Tom said, "be

"I couldn't th in this old pla sides the near away."

The pupil o ually dilated in size and I h solid object stools which shadows. Th thrown on th ance of a ma

**LANTERN**
Night watchman's lantern. Not s bright as an elec tric flash but surer

They glass, I r stems one's movng

"I I said, to whic "Yo "You Don't ought "I for m

**COMFORT**
chair author's useful piece ing or cloth purposes

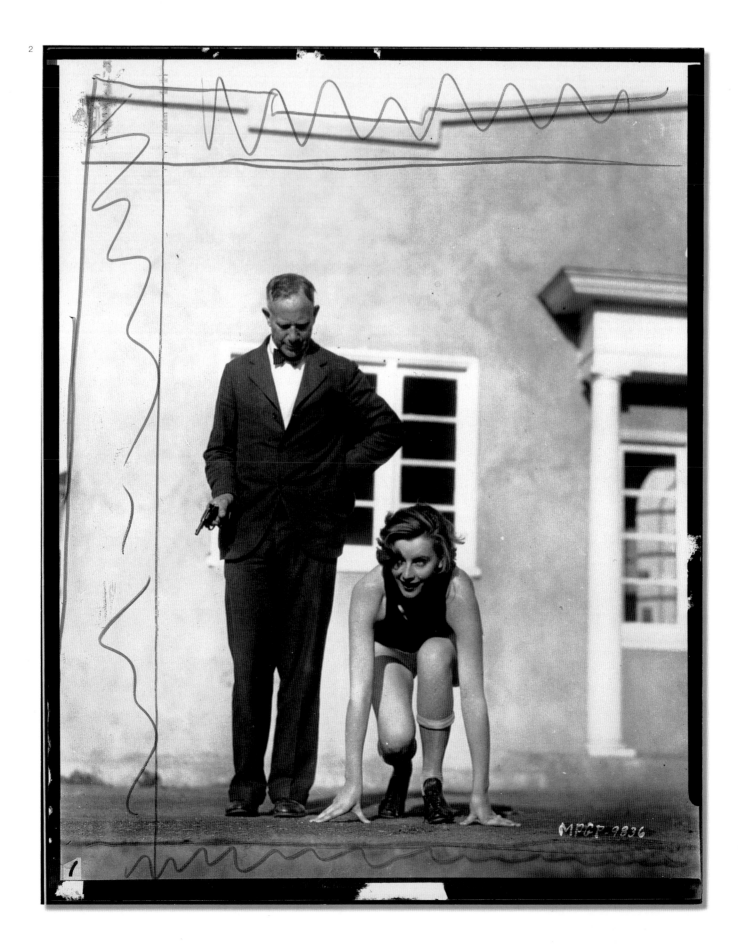

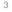

3

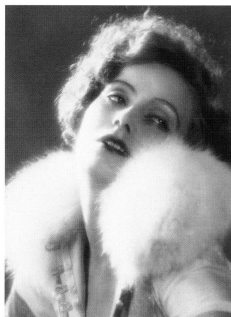

4

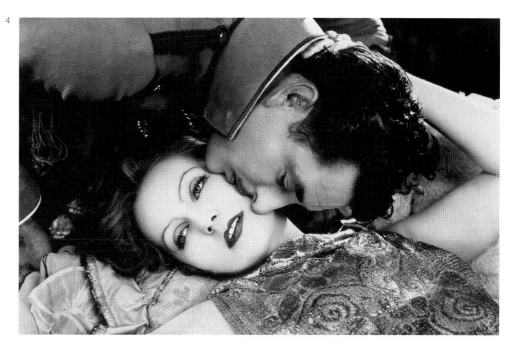

3 Early Portrait of Garbo for MGM
Ruth Harriet Louise, 1925

A print from Garbo's first portrait session for MGM.
Her photographer, Ruth Harriet Louise, supplied the
formal portraits to accompany each of her first nine
American films. This image appeared in *Picture Play*,
on the cover of the French magazine *Mon Ciné* and
on a postcard sent out to fans.

4 Garbo with John Gilbert in *Flesh and the Devil*
Bertram Longworth, 1926

A translucent Garbo and a dominant John Gilbert
in the celebrated (and protracted) 'kiss' scene from
*Flesh and the Devil*. One critic wrote 'Greta Garbo
passes censorship. And every evening three hundred
men are unfaithful to their wives.'

Opposite
2 Hollywood Publicity Photograph
Don Gillum, 1926

Experiences such as this *en plein air* photo shoot,
staged in the winter of 1926 at a running track used by
the US track-and-field team, confirmed Garbo's resolve
to avoid the publicity circus. She told *Photoplay* in 1926
that she would be glad when she 'was a big star like
Lillian Gish. Then I will not need publicity and to have
pictures taken shaking hands with a prize fighter.'
This copy retains its original printer's instructions.

Garbo reduced the self-assured to inarticulacy (Beaton was so struck by her beauty he
had to clutch the back of a chair) and then bewitched the inarticulate with something
'hypnotic', as *Vanity Fair* put it, 'like sorcery'. The potency of her form and the depths of
emotion revealed in the timbre of her voice entranced audiences, even if they could not
understand one word of her films. This enigma was able to bind, if only for a while, a
Nobel Prize winner of gravitas to a capricious, self-regarding aesthete.

There were certainly more conventionally beautiful women than Garbo in Hollywood, as
intimated by the caricature that appeared on the cover of *Vanity Fair* in 1932 (fig.16). Her
frame was broad and masculine and she was flat-chested. Though perfectly poised, her
deportment was occasionally unfeminine, her stance as stiff as a guardsman's. Her mouth
was over-large, betraying an innate sullenness when she was caught unawares; her smile
was artificial (her teeth were later straightened and capped); and her cheekbones were
perhaps a little too high and 'Nordic'. Arnold Genthe's photographs of Garbo, taken in
1925 in the month in which she arrived in America, serve to show the extent of the MGM
transformation that was to take place. For Genthe's camera she radiated not sexual allure
but the intensity and determination of a serious actress. And yet she had an undeniable
presence. *Vanity Fair* was quick to publish a print, in November 1925, hailing the 19-year-
old Swedish actress as 'A New Star from the North' (fig.1).

Of all MGM's stars (famously 'more than there are in heaven'), none shone as brightly as
Greta Garbo and few quite so briefly. Her film career barely lasted sixteen years. In one
single likeness of her face were condensed the basic elements of movie-making: glamour,
beauty, fashion, drama. Disseminated to movie magazines, newspapers, fan clubs and
cinemas by a relentless studio machine, the Hollywood publicity portrait had a life of its
own, treasured in scrapbooks and in personal collections and admired in the cinema
lobby and on the domestic wall. The major studios received over thirty-two million fan
letters annually, the majority requesting photographs. These portraits were, arguably, more
influential in defining the nature of stardom and its attendant glamour than the movies they
promoted. In Garbo's case they lasted far longer, for in essence all her Hollywood movies
shared a similar plot. Her gift was to blind contemporary audiences to this inescapable

5

7

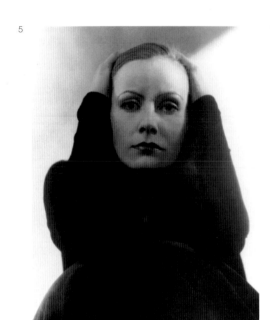

6

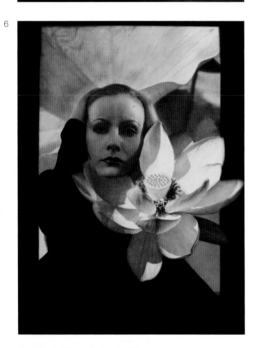

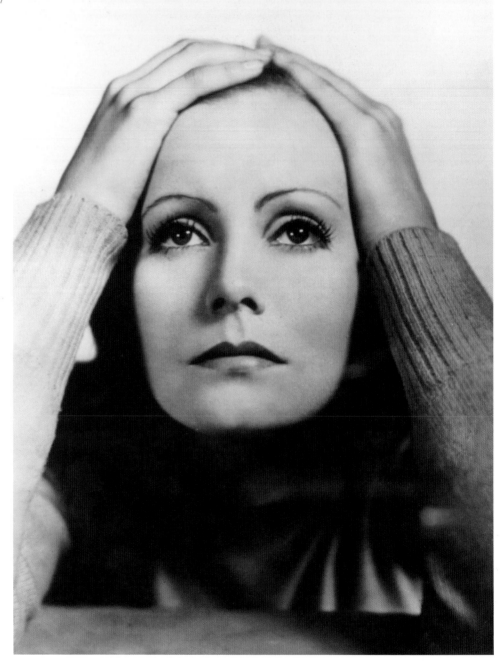

5, 6 Photo Shoot for *Vanity Fair*
Edward Steichen, 1928 and 1933

7 Garbo in *Anna Christie*
Clarence Sinclair Bull, 1929

Opposite
8 Garbo in *The Divine Woman*
Ruth Harriet Louise, 1927

In the portraits taken by Ruth Harriet Louise to accompany *The Divine Woman* (1927), Garbo had used her hands to frame her face in what Louise's biographers, Robert Dance and Bruce Robertson, suggest is 'the gesture, no doubt learned at the Swedish Royal Dramatic Theatre Academy, used to convey extreme distress' (fig.8). Barely a year later, Garbo repeated the pose for Edward Steichen of *Vanity Fair* (fig.5). The magazine was so struck with the picture that it was used again in 1933, hand-tinted in colour and montaged with an exotic flower (fig.6). Famously, the gesture had also revealed itself in moving film as a motif in *Wild Orchids* (1928). Steichen had noticed that Garbo's off-set routine involved her stepping into another closed world. Between takes she would sit on a chair, which an assistant surrounded with screens: 'She was in a little box,' he observed in his memoirs of his session on the set of *A Woman of Affairs* (1928). 'What bothered me most was her hair. It was curled and fluffy and hung down over her forehead. I said, "it's too bad we're doing this with that movie hairdo". At that she put her hands up to her forehead and pushed every strand of hair back from her face. At that moment, the woman came out, like the sun coming out from behind dark clouds …' While Steichen admired Garbo's mastery of the moment, it is likely that she had meticulously rehearsed for just such an opportunity. Garbo replicated the pose for Clarence Sinclair Bull in 1929 in publicity stills for *Anna Christie* (fig.7) and it did not go unnoticed by Cecil Beaton, who, in turn, rendered it as a line drawing in *The Glass of Fashion* (1954).

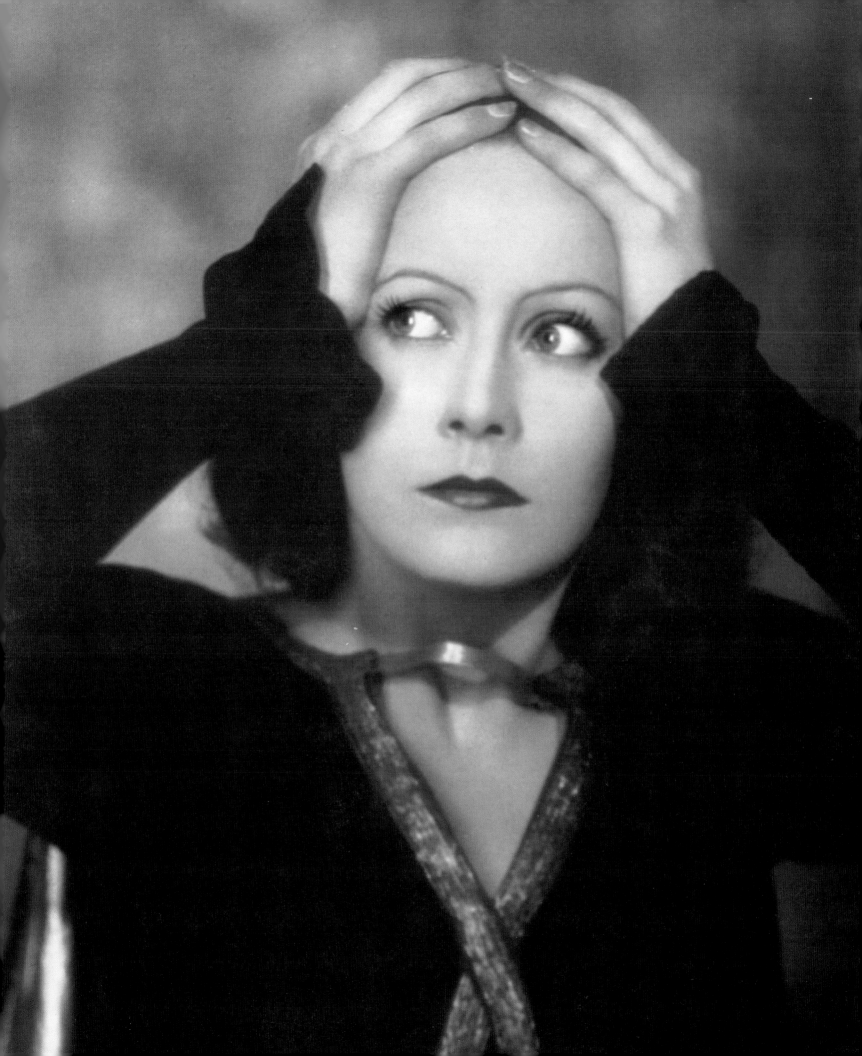

9

9 Garbo with Cecil Beaton and Noël Coward
Fox Photos Press Photographer, 1951

The relationship of Garbo and Beaton was
unconventional but, against the odds, they remained
friends until Beaton's death. Here a press photographer
has snapped the couple in the company of Noël Coward
and others. Garbo laughs – not as rare an occurrence
as her legend suggests. This image is a small, annotated
reference print kept in the picture archive of the National
Portrait Gallery, London.

Opposite
10 Garbo in *Anna Christie*
Clarence Sinclair Bull, 1930

A lesser-known portrait of the star by Clarence Sinclair
Bull, thought to be from a session for the German-
language version of *Anna Christie*. Bull capitalised on the
close-up, imbuing his subject with an intensity that the
movie camera was never able to attain. Significantly, this
was one of two Bull photographs treasured by Cecil
Beaton and kept at his bedside until he died. He was
particularly entranced by Garbo's eyes, immediately
noticeable in this image and seducing the viewer like few
others. Bull and Beaton, perhaps more than any other
photographers, contributed to the Greta Garbo myth.

fact. And so pictures of Garbo resonated. As the silent star Louise Brooks recalled:

*When you think of it, what people remember of those stars is not from the films, but one essential photograph … When I think of Garbo, I do not see her moving in any particular film. I see her staring mysteriously into the camera. No matter how many times I've seen her films, that is how I always see her. She is still a picture – unchangeable.*

From September 1925, almost the moment she stepped onto the MGM lot at Culver City, Garbo established a rapport with Ruth Harriet Louise, the only woman then engaged as a portraitist for a Hollywood studio. They worked together for four years in a sustained and productive relationship, Louise supplying the formal portraits to accompany each of Garbo's first nine American films, all 'silents', from her debut *The Torrent* (1925) to *The Single Standard* (1929) (fig.3). In Louise's backlot third-floor studio, a closed and rigorously controlled world, Garbo was able to stamp her imprimatur on her own image. Despite their peaceable charm and luminosity, the results were wrested from her with effort on the part of the photographer, who remained, as late as 1928, frustrated by the star's reserve: 'All the tragedy in the world seems hidden in her brooding, heavy-lidded eyes.' She added, 'I only wish I could capture it through my camera …'

Two months after Louise's first sitting, Don Gillum, a freelance photographer, tried some *en plein air* shots, staged at Selig Zoo (home to Leo, the MGM lion). Despite Garbo's obvious discomfort, these were admired – except by the subject, who disliked the play of chance, the vagaries of climate and the proximity of feral creatures. A second, less famous session with Gillum the following winter, at the running track of the US track-and-field team (fig.2), cemented for Garbo a resolve to remain within the hermetical environment of the studio and, more significantly, a determination to avoid publicity duties whenever possible. She insisted on a revised contract which ensured, should she choose to observe it, that she would only pose in character and only in direct connection with a forthcoming film. Unusually for a newcomer, she had been treated from the start as a star (a position consolidated by the success of *The Torrent*). The studio became ambivalent towards Garbo's aversion to publicity. As her star ascended, her reluctance to be seen became newsworthy in itself, adding to her mysteriousness rather than detracting from her popularity. She was, in effect, instrumental in the creation of her own myth, which would come back time and again to haunt her. Refusing interviews, fashion spreads and magazine features, all her insatiable but starved public had were photographs of her face.

Though Garbo might have looked anonymous and ordinary out-of-doors, in the studio beneath Louise's lights she shimmered, radiating the glamour that made her the greatest romantic star of her time. As their relationship matured, Louise was confident enough to ignore props and artifice, the traditional encumbrances of the studio photographer, and rely less on the accepted canon of full- or three-quarter-length poses. It was in a set of portraits taken to accompany *The Divine Woman* (1927) that Garbo devised her definitive gesture, captured first by Louise (fig.8) and later by Edward Steichen (figs 5, 6), Clarence Sinclair Bull (fig.7) and Cecil Beaton, who rendered it as a line drawing in *The Glass of Fashion* (1954). Her technique of using her hands to frame her face became emblematic of her self-presentation for the lens.

Steichen's commission for *Vanity Fair* was published in October 1929, announcing Garbo's forthcoming role in *Anna Christie*, her first 'talkie'. By this time she had completed *The Kiss* (1929), which marked the end of her relationship with Ruth Harriet Louise and the beginning of another, longer-lasting one with Louise's successor at MGM,

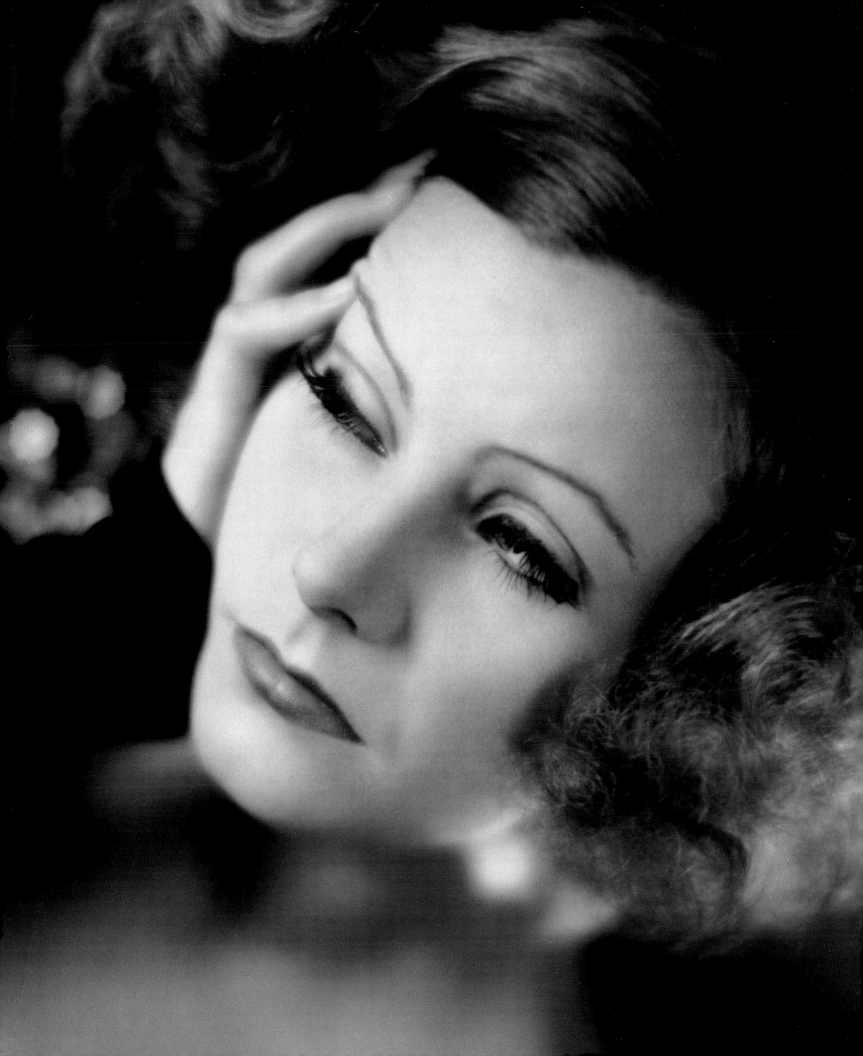

11

12

12 Page from Cecil Beaton's Scrapbook, c.1932

Despite entreaties and the cultivation of those who knew Garbo well (including her friend Mercedes De Acosta), Beaton was unable during his early visits to Hollywood to photograph the star. He did, however, meet his idol. Garbo gave him a yellow rose, which he kept for the next fifty years until his death. This mixed media montage, probably a page torn from one of Beaton's scrapbooks, incorporated details from portraits by Clarence Sinclair Bull and fetishistic illustrations of Garbo's alluring eyes drawn by Beaton himself.

Opposite
11 Bible of Mercedes De Acosta, 1922

A cache of letters, articles and objects was lodged with the Rosenbach Museum and Library, Philadelphia with instructions that they should not be opened until ten years after Garbo's death. The correspondence, opened in 2000, belonged to the star's friend and admirer (and perhaps lover) Mercedes De Acosta. She had also kept scrapbooks, fan magazines and several topless photographs of Garbo, taken during a vacation together in the Sierra Nevada mountains. De Acosta later turned the endpapers and flyleaf of her bible into a devotional object to her new friend.

Clarence Sinclair Bull. She had, however, sat briefly for Nickolas Muray (on assignment again for *Vanity Fair*).

Like the few before him, including his former studio apprentice Ruth Harriet Louise, Muray found photographing Garbo an enticing proposition but a confounding experience. She arrived for Muray, not in the evening gown he had requested, but in a man's white shirt, a jacket and tie and beret. He exposed a few frames of Garbo in this ensemble. She then removed first the jacket and then the shirt. MGM's publicity chief, Howard Strickling, who was in attendance, immediately called a halt and hurried from the studio to find some additional clothing with which to conceal his star. Muray continued to photograph. These few images are significant in the development of Garbo's projection of her public self, which she was clearly capable of subverting to her own ends. Muray had asked her to appear in eveningwear; she arrived dressed as a man. Strickland proposed to uphold the strict parameters of studio publicity; she contrived his absence. As the session progressed she made her own transition: discarding the beret, jacket, tie and ultimately her shirt, she demonstrated, in the most patent form, her femininity. Fully realising that her androgyny was vital to her sexual appeal (it has been estimated that she received around 90,000 fan letters a month, eighty per cent from women), the session was a calculated rebuke to MGM which, in the end, backfired. *Vanity Fair* 'killed' Muray's sitting. Nothing from this session was published and it is likely that Steichen's portrait was substituted for Muray's.

Louise was vital to Garbo's metamorphosis into a cipher for beauty, refining and perfecting the raw material presented to her in 1925, but until the compilation by Robert Dance and Bruce Robertson (*Ruth Harriet Louise and Hollywood Glamour Photography*, 2002) her contribution was undersung. Her inventiveness made possible the success of Bull, known forever as 'The Man Who Shot Garbo'. But he would work with a subject who by now knew precisely what worked for her and what did not, and held final veto over their joint efforts. It is his images of the star that have imprinted themselves onto the public consciousness and contributed to the persistence of the myth of Greta Garbo.

Garbo sat for Bull to publicise every film she made from 1929 (her last silent, *The Kiss*) to 1941 and her final role in *Two-Faced Woman*. An exception was *Romance* (1930), for which George Hurrell oversaw the publicity photographs. Hurrell and Garbo were mismatched, and Garbo disliked the results of their only session, probably because Hurrell rendered her, as one commentator observed, 'surprisingly corporeal'.

Bull's portraits of Garbo (figs 7, 10) are distinguished by an emphasis on the star's eyes, her outstanding facial characteristic: 'Like jewels in a shroud,' considered Clare Luce, 'heavy-lidded and slumberous beneath the gloom of her lashes'. Years later, Beaton wrote of her 'incredible eyes and lids' and 'the blue, clear iris' (see fig.12). Clarence Brown, who directed her in six films, observed further that Garbo had 'something behind the eyes that you couldn't see until you photographed it in close-up … then you could see thought.' Though clearly recognised as key features by Louise (especially obvious in the publicity shots for *Wild Orchids*, 1928), Garbo's eyes were almost fetishistic for Bull. For *The Kiss*, he chose to concentrate his lens purely on her face and, in the resulting close-up, it floats against a dark backdrop, her mouth descending into shadow but her eyes mesmeric. If she had looked but a fraction to her right, they would have met the viewer in direct – and unexpected – confrontation.

Bull capitalised on the close-up for *Anna Christie*, imbuing its star with an intensity that the movie camera could never hope to match. He noted his subject's participation: 'There was no need to say "Still". Or "Hold It". All I did was to light the face and wait. And

13, 14 'The Most-Missed Face of the Screen'
Cecil Beaton, 1946

In July 1946, *Vogue* published thirteen pictures of 'the most fascinating, the most-missed face of the screen'. Garbo had not agreed to a formal sitting for more than a decade and had never posed so intimately before Beaton took these images, which included fragments from a contact sheet (fig.13) and a finished print (fig.14, opposite) that remained unpublished. He persuaded her to appear in various costumes, including a Pierrot's suit and an austere 'High Renaissance' cap. She then posed with an oversize bunch of flowers and lay supine on a *chaise-longue*. She maintained the photographs were printed without her agreement and although she made her peace with Beaton, she never completely trusted him again. Visiting him in 1975 at his Wiltshire home after he had suffered an incapacitating stroke, she half wondered if he had hidden photographers up in the trees near Salisbury station.

13

16

16 Caricature of Garbo on the Cover of *Vanity Fair*
Miguel Covarrubias, 1932

The graphic cover of *Vanity Fair* for February 1932
emphasises the androgyny and angularity that
contributed to Garbo's mystique and so intrigued Cecil
Beaton. These factors overshadowed the sometimes
artificial nature of her smile, her over-high cheekbones
and her hairstyle, which often fell, as Clare Luce wrote in
the magazine, 'in a limp, untidy, dun-coloured mop upon
her thin shoulders'.

Opposite
15 Garbo on Holiday in Antigua
Harry Benson, 1976

A glimpse of the by-now reclusive former actress was
considered a trophy for the world's photographers.
Norman Parkinson caught Garbo on the streets of New
York and exposed a few frames, titling the sequence
'Garbo! Garbo!! Garbo!!!' Harry Benson, a Scotsman,
found her swimming off the coast of Antigua. It was, he
claimed, like 'sighting the Loch Ness Monster'.

watch.' Their productivity rate was formidable, each sitting yielding 200 to 300 large-format negatives, aided by Bull's recognition that 'she had no bad side, no bad angles' and 'she never seems to tire of posing'.

Cecil Beaton's fascination with 'the idea' of Greta Garbo reached its apogee in May 1946. Spellbound by Garbo since the 1920s, he had pursued her for decades as a fan and their 'affair' is one of the twentieth century's most unconventional love stories (he proposed marriage, she occasionally replied 'perhaps') (see fig.9). Her androgyny intrigued him and he recognised in her a narcissism that mirrored his own. Her flight from a public persona that she had herself created – in forced collaboration with still photographers – reflected, perhaps, Beaton's own pursuit of identity and his attempt to escape his middle-class upbringing for a world of languid privilege. To capture her beauty was, he admitted, his 'greatest ambition'.

Garbo entered Beaton's hotel suite at the Plaza in New York, having confirmed a session – at her instigation – for a new passport photograph. The portraits completed, Beaton cajoled her to adopt a variety of informal poses for his lens (figs 13, 14). He then hurried the contact sheets to *Vogue*, claiming that Garbo had earmarked frames for publication. Whether she had or not, whether Beaton's enthusiasm for an exclusive set of portraits blinded him to his sitter's lack of assent, *Vogue* rushed a double-page spread into production. For Beaton this was a self-aggrandising opportunity with his favourite magazine and a chance to demonstrate his intimacy with the most mercurial of twentieth-century icons in the most public way. For Garbo there was nothing so complex. She maintained she had never consented to publication. He had simply betrayed her. There would be few other formal sessions (she made a pointed exception for George Hoyningen-Huene – a close friend of Beaton's) and from this point on, likenesses of Garbo would be ungraciously snatched from her.

In the last fifteen years of her life perhaps Garbo did achieve a little of the solitude she craved, but she was never quite alone. A seized shot of the world's greatest recluse appeared to be a trophy for photographers, from opportunist paparazzi to established names such as Norman Parkinson and Harry Benson (fig.15). But one stalked her relentlessly. Ted Leyson – mostly obsessive fan but part freelance photographer in search of a lucrative shot – followed her in a quotidian pursuit until the very week before she died in 1990, aged eighty-four (fig.17).

Half a century before, while Loewi and Beaton talked aboard a liner bound for New York in 1940, production was beginning on *Two-Faced Woman*. Had the scientist and the photographer been able to look a mere eighteen months into the future they would have found much more to discuss. *Two-Faced Woman* was Garbo's swansong. Its plot was risible (Garbo played a ski-instructor who impersonates her fictional twin in an attempt to win back her husband). Her sorcery could not save it, nor her dancing of the 'Chica-Chocka' rumba, and her performance was savaged. Further, the film's morally dubious premise prompted calls from the Catholic League of Decency to frustrate its distribution. MGM released Garbo from her contract and from the age of thirty-six she never made another film. In the years that followed until her death, she would never understand – or sympathise with – the public's fascination with her; nor why photographers should want to take her picture when she had nothing left to promote. But what the camera now recorded was not Greta Garbo, the greatest movie legend of her time, but an elderly woman walking by, ordinary and anonymous on a sunny New York morning, a shadow of the sphinx she once was and, finally without much of a riddle to share.

17 Garbo Confronts her Stalker, New York
Ted Leyson, 1990

Garbo continued to manipulate her public image after her withdrawal from Hollywood and into old age. She resented intrusion into her private life, but perhaps felt unable, especially in her later New York years, to discourage it. The anonymous, 'dressed-down' look in which she chose to venture outside became, in time, less of a camouflage and more a badge of distinction. People learned to recognise Garbo precisely for her habitual bobble hat, black overcoat, large dark sunglasses and white or black umbrella. As ever, the more she shrank from the public gaze the more it sought her out.

Garbo may finally have achieved a little of the solitude she desired, but she was never quite alone. Freelance photographer Ted Leyson pursued her relentlessly in the last years of her life. She was adroit at foiling him, even when he took to camping outside her door. Leyson was meticulous in annotating his slides and some of his last exposures are dated 9 April 1990. By then, Garbo had given up fighting him. In what was perhaps her last public gesture, she met his gaze with contempt. A week later Garbo was dead, aged eighty-four.

# 5  John F Kennedy

## John F. Kennedy (1917-63)

1917 John Fitzgerald Kennedy is born of Irish descent on 29 May in Brookline, Massachusetts

1937 Interest in politics begins when father is appointed US Ambassador to England

1940 Graduates from Harvard and serves in US Navy; injured when his boat is hit by a Japanese ship

1946 Elected Democratic representative for the Boston area, becoming Senator in 1953

1953 Marries socialite Jacqueline Lee Bouvier

1957 Wins Pulitzer Prize for *Profiles in Courage*

1960 Narrowly beats Richard Nixon to become the youngest and first-ever Roman Catholic president

1961–3 Tensions with Soviet Union over West Berlin and the Cuban missile crisis escalate the arms race; Kennedy supports space exploration

1963 Proposes a bill in support of civil rights that later becomes the Civil Rights Act of 1964; assassinated on 22 November by Lee Harvey Oswald in Dallas, Texas

Opposite
1 Portrait of John F. Kennedy as President-Elect
Elliott Erwitt, 1960

The presidency of John F. Kennedy symbolised a new era for the American people, and he used photography to win public endorsement. Elevated to the White House in 1960, as leader of the most powerful nation on earth, he was its youngest elected incumbent. He also was arguably its most glamorous, unquestionably by then its most photogenic. By the time of his election, he was already the most photographed American politician of the modern era.

If President John Fitzgerald Kennedy had lived a day beyond 22 November 1963, a Dallas audience would have heard him speak these words:

*America's leadership must be guided by the lights of learning and reason – or else those who confuse rhetoric with reality and the plausible with the possible will gain the popular ascendancy with their seemingly swift and simple solutions to every world problem.*

This would have said much about Kennedy, as he ensured his words often did, for he was both eloquent and meticulous. This sentence, perfectly balanced, was characteristic of his equally balanced beliefs. 'Ask not what your country can do for you,' he famously said in his inaugural address, 'ask what you can do for your country.' For a life cut short at forty-six, it was one lived fully and with astonishing vitality. Remarkable triumphs – and more than the occasional failure – punctuated it. As one obituary writer declared, 'it had its own poignancy, its curve of nobility, of private tenderness and public passion …' It was also one played out for the camera to an extent that was ultimately as revealing as it was previously unheard of.

A charismatic and able politician, Kennedy seemed to symbolise a dynamic era for the American people, and he used the tool of photography to win their endorsement. Elevated to the White House in 1960 (figs 1, 11), as leader of the most powerful nation on earth, he was its youngest elected incumbent (though not the youngest to serve his nation in this capacity – Theodore Roosevelt was not yet forty-three when in 1901 he succeeded the assassinated William McKinley). Kennedy was also arguably its most glamorous and unquestionably its most photogenic president. The youthful figurehead held for millions of Americans great personal charm and, more significantly, represented even greater aspirations. By the time of his election, he was already, by grand strategy, the most photographed American politician of the modern era. He would become thereafter the first American president of the media age.

Pictures of Kennedy, reproduced in an almost endless stream in newspapers and magazines, advanced a vision of a president of almost superhuman robustness and ability. He was, by these accounts, a handsome patriot with an unimpeachable war record, a husband blessed with a harmonious domestic life, a skilful politician of penetrating acumen, a fully rounded human being of enviable athleticism and tireless energy. This coverage, enthusiastic and approving, embraced not just Kennedy the statesman but the ambitious Catholic dynasty that had impelled its scion all the way to the highest office. His family (fig.6) and his political inner circle basked in the President's reflected glory at the dawn of a new political golden age. As the playwright Larry Gelbart wrote thirty years after Kennedy's death:

*One way or another, he was going to win you over. He was going to charm you. You never had a chance. He would do it with his logic. Or with his wit. Or with his smile.*

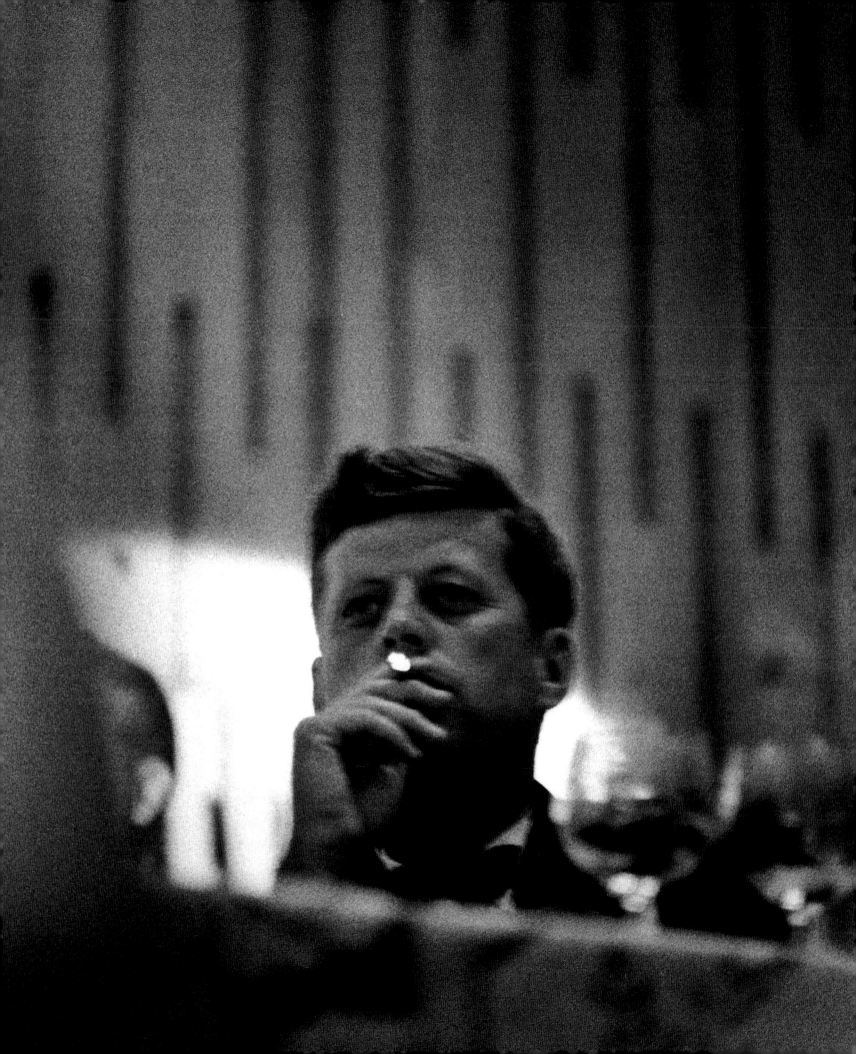

2

2 John and Jackie Kennedy on the Campaign Trail
Jacques Lowe, 1959

In 1959, Kennedy was one of seven candidates seeking
the Democratic nomination for President. He arrived in
Portland, Oregon for a series of campaign appearances,
to an underwhelming welcome. Only three supporters
met him on the tarmac. Barely a year later, the
nomination won, he would be mobbed uncontrollably.
For the Kennedys (and campaign manager Steve Smith
in the foreground), seen here in the diner of the Let 'er
Buck Motel, Portland, all but ignored by the other
patrons, the frenzy was yet to begin.

Opposite
3 'Kennedy for President', California
Cornell Capa, 1960

Despite his health problems, Kennedy regularly
worked eighteen-hour days. Here the Democratic
candidate reaches his hands into a crowd while
campaigning for the presidency in California. In Boston
an adoring crowd 15,000 strong turned out to greet him.
Jacques Lowe recalled an incident in Pekin, Illinois:
'[they] threw themselves into Kennedy's open car, tearing
the buttons off his coat and causing his hands to be sore
at night from relentless pressing of the flesh'. Kennedy's
shirt cuffs were so frequently shredded that his aides
carried replacements.

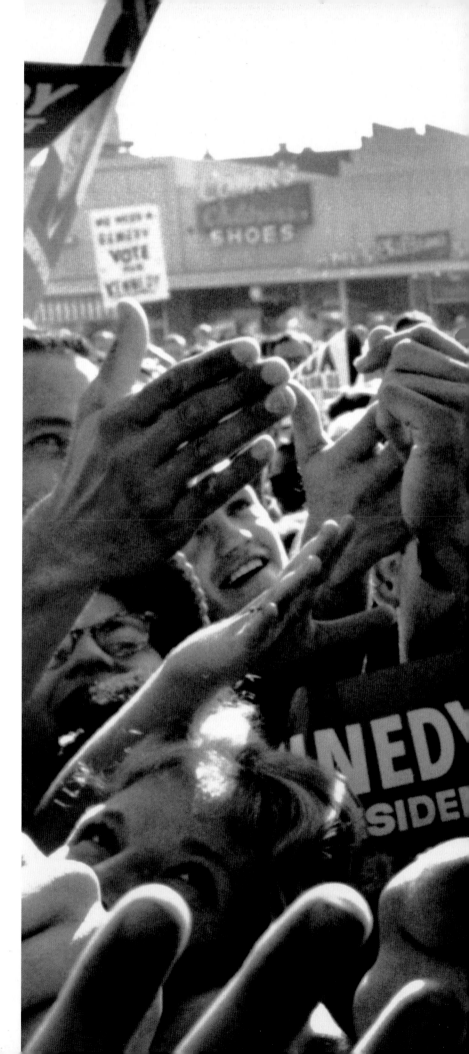

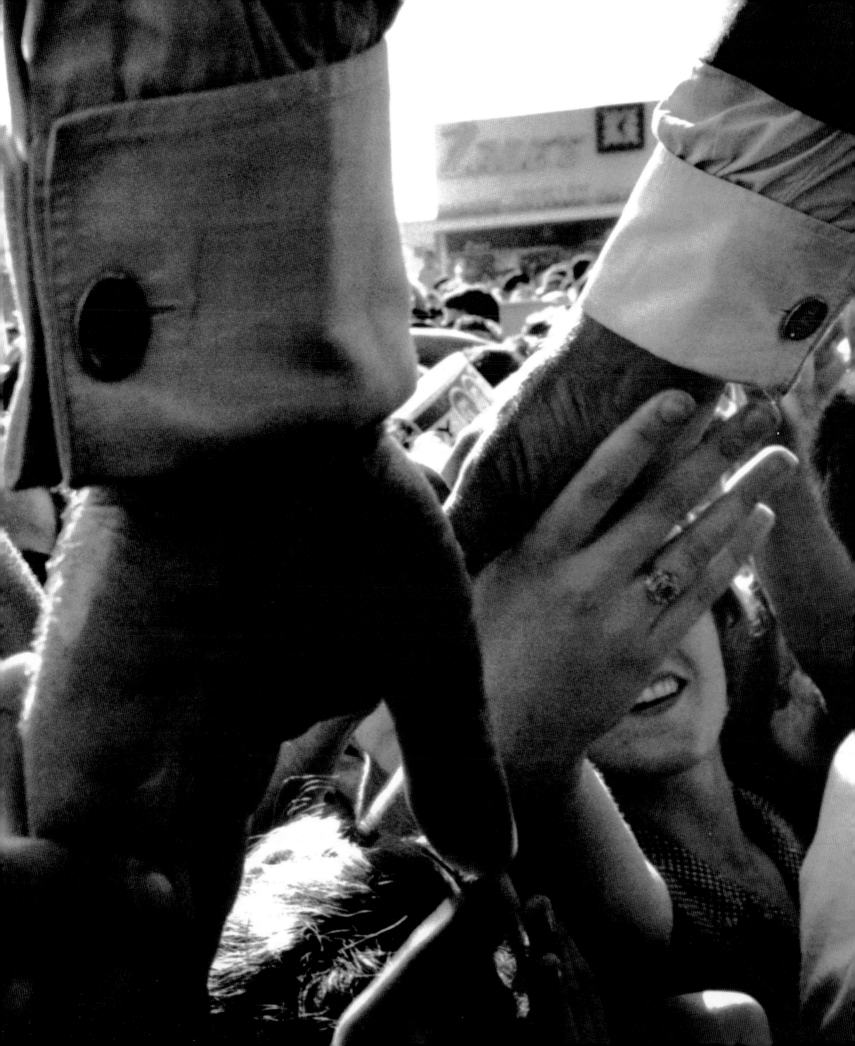

4 Dexter Hall Football Team Photograph (detail)
Unknown Photographer, *c*.1928

A detail from a group photograph shows Kennedy,
aged eleven.

5 Young John Kennedy
Unknown Photographer, *c*.1929

A small portrait of the young John Kennedy with his
dog, from the collection of the photographer Elliott Erwitt.
His frailty, which would plague him for life, was a closely
guarded family secret. In later years, he and his family
went to great lengths to suppress anything that might be
perceived as a personal sign of weakness and a threat
to the invincibility of the presidential image.

4

5

6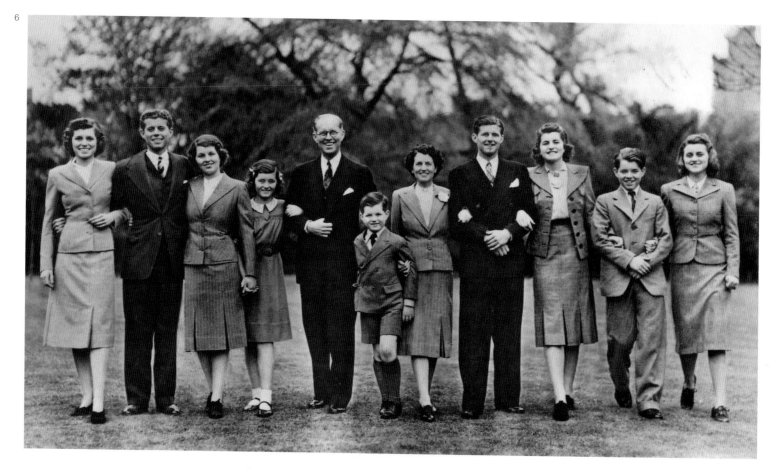

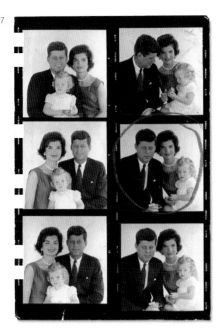

7

7 Senator Kennedy with Wife Jackie and Daughter
Caroline, Hyannis Port
Jacques Lowe, 1960

A contact sheet (with the photographer's annotations)
from a sitting for Lowe. Their first collaboration did not
augur well, for Kennedy was seeking re-election to the
Senate and, according to Lowe, was 'grumpy, awkward
and preoccupied. Still, his respect for his father and his
general good manners dictated civility. So after some
reluctance to cooperate, he acquiesced'.

Opposite
6 The Kennedy Family, London
Dorothy Wilding, 1939

Dorothy Wilding is best known for her meticulous studio
work. There she took many portraits of the Kennedy
family including the matriarch Rose and Jack's sister
Eunice as a debutante (Joseph Kennedy had been
appointed United States Ambassador to the Court of
St.James in 1937). On a rare excursion out of doors,
Wilding made this photograph in the grounds of the
ambassadorial residence in Kensington, London. 'Jack',
aged twenty-two, is shown second from the left. In order
to present everyone in the best possible light, the Wilding
studio occasionally montaged more flattering versions of
certain individuals into the final print. This partly explains
the ungainliness of the future president's right arm.

*You could be charmed by pictures of him at the tiller of a boat or strolling barefoot on
the beach. Wearing tails or with his shirttail hanging out ...*

Foremost among the many who documented the life of the thirty-fourth President was
the photographer Jacques Lowe, a young German-Jewish immigrant. At Kennedy's side
during the campaign trail to the White House and the years of his presidency, through
luck or foresight but most often by invitation, Lowe was there at crucial times, an almost
alchemical presence. He created one of the most comprehensive photographic records of
an American presidential term, albeit one cut cruelly short. In over 40,000 images, Lowe's
documentation has ensured that his name is firmly associated with the presidency, a part
of the fact – and the mythology. He would be there, too, in its final manifestation, taking a
picture at Arlington National Cemetery as Kennedy's coffin was lowered into the earth.

Lowe's photographs helped to create and sustain the myth of 'Camelot', a term coined
by the former First Lady Jackie Kennedy for the 1,000 days of her husband's presidency.
Kennedy may have appeared to embody an impulsive vitality, but in reality he had been –
and still was – chronically sick. It was not generally known, for example, that before taking
up office he had received the last rites on three separate occasions. Neither was it
generally known that his fragile health almost prevented him from serving his country
during World War II (he had failed his medical). It was certainly kept from the American
people that he was sexually promiscuous to the point of compulsion. Inevitably, Lowe
was caught up in the concealment of the President's frailties and complexities. As much
as he celebrated the man who offered a better future for his nation, he also protected,
knowingly or not, one of the foremost political mythologies of modern times.

Earlier photographs, kept unofficially from public scrutiny, revealed a frailty that Kennedy
tried hard to ignore. Snapshots show a young Jack at the age of twenty, almost palpably
unwell. His arms are painfully thin, his chest sunken and, despite a determined smile, his
face is cadaverous. Throughout his childhood (figs 4, 5) he had been in poor health and
was forced to abandon studies at both the London School of Economics and Princeton
due to repeated attacks of jaundice. However, his spirit was indomitable. At Harvard he
summoned the resilience to overcome his illness; and more importantly for his future,
he learned to conceal any manifestation of it.

Kennedy's medical problems, which would plague him throughout his life, were a
closely guarded secret. In later years, he and his family went to great lengths to suppress
anything that might be perceived as a sign of personal weakness and a threat to the
invincibility of the presidential image they had cultivated. A subsequent hindrance was a
back injury sustained in a university football match. In 1941, with America entering World
War II, it led to Kennedy's rejection from the US Army on medical grounds. After several
months of specialist exercises, he tried to enlist in the US Navy. Again he failed his
medical but family connections secured him a place. In 1943 he was involved in active
service in the South Pacific and in an act of personal heroism, he saved the life of a
comrade who was badly burned when their patrol boat was destroyed. But he was
invalided out. When undergoing surgery, it was discovered that he had an advanced
degenerative condition of the spine, the cause of which remained unclear. In the same
year, 1944, his older brother Joe, a bomber pilot, was killed over the English Channel.
The weight of the dynasty's expectations now passed over to Jack, who had neither
anticipated, nor was physically prepared for, this burden.

In 1946 Jack Kennedy ran in the national elections on a Democratic ticket and won a
seat in the House of Representatives. He was re-elected twice more. Spurred on by

8

8 Senator and Mrs John Kennedy, Georgetown
Orlando Suero, 1954

The news photographer Orlando Suero was sent to
Georgetown to photograph Senator and Mrs John
Kennedy eight months after their wedding. 'As a couple
they seemed to me like a hand in a glove, one fitted into
the other,' recalled Suero. They could not have been
more accommodating in front of the lens. After all, in
Suero's words, 'Jack had never seen a camera he didn't
like …' Suero's informal approach to taking pictures of a
political figure was new and proved extremely popular.
The couple personified the hopes and dreams of
postwar America.

Opposite
9 Ticker-tape Parade, Manhattan
Cornell Capa, 1960

As Kennedy's schedule became increasingly hectic,
so he became increasingly dependent on medication
to supplement his stamina. In September 1960, for
example, his whistle-stop tour took him to twenty-five
towns in five days concluding with this euphoric parade
in Manhattan. He was aided by a cocktail of drugs
including penicillin for infection, cortisone for Addison's
disease, testosterone to counterbalance weight loss,
Paregoric for colitis, Ritalin and Nembutal for sleep,
Lomotil, an anti-spasmodic, steroid-based painkillers,
and shots of amphetamine.

his father Joseph, he set his sights on the Senate, to which he was elected in 1952,
and thence ultimately, the presidency. In the run-up to his Senate victory, his illness
re-appeared and was so serious that his doctors feared for his survival. It was finally
diagnosed as Addison's disease, a debilitating adrenal complaint. It was also
discovered that drugs he had taken to control it had led to the degeneration of his spine.
He recovered and soon afterwards met the elegant, accomplished and socially
well-connected Jacqueline Bouvier. Their subsequent marriage was, for the 1,200
guests and a far wider newspaper audience, the social event of 1953. Cardinal Cushing,
Archbishop of Boston, conducted the nuptial mass (only, it was said jokingly, because
the Pope was unavailable). They made the perfect political couple.

Eight months after the wedding, Orlando Suero was despatched on his first major
assignment to photograph the Senator and Mrs Kennedy (figs 8, 10). 'Remember the
dignity of my office,' Kennedy had admonished him. Suero did more than that. He
presented them for the first time as the nation's gilded couple, the twin personification of
a new golden age. Contrary to outward appearances, Jack Kennedy was often physically
debilitated to the point of immobility without the aid of crutches. Yet for Suero's five-and-
a-half day visit, he was on such a high dosage of cortisone that Suero was able to
photograph him with his brother Bobby, playing football. Four months after Suero's
assignment, however, Kennedy underwent spinal surgery and his back ailment led to his
absence on a crucial vote to censure Senator McCarthy for his Communist 'witch-hunt'.

Suero's photo essay proved extremely popular. Its informal coverage of a political figure
was unusual for the time. Joseph Kennedy, the family patriarch, was quick to see the
potential benefits of this new, unceremonious approach to political reporting. He was
impressed further by a series of photographs of Bobby, his wife Ethel and their children
taken by Jacques Lowe. Harmonious, domestic vignettes, they reflected an idealised view
of all-American family life that could only help to consolidate the popularity of his other
son, the Senator.

Lowe, described by Arthur Schlesinger Jr as 'a spritelike presence, hovering on the
edge of historic scenes', felt he had made an inauspicious start with Jack Kennedy,
though he would be at his side until his assassination. Kennedy approached their first
photo session as though it was yet another obligation to his father. '[He] was grumpy,
awkward and preoccupied,' wrote Lowe. On the contact sheets, the Senator appeared
tense and stiff, his wife unnatural. But although Lowe was disappointed in the session,
the Kennedys liked the pictures immensely (fig.7). Recognising in Lowe's photographs the
freshness and immediacy that had intrigued his father, Kennedy granted Lowe increased
access. The results became the most definitive images of Kennedy as a family man,
endearing him and Jackie to the American people, as Joseph Kennedy had predicted.

Unlike Lowe's images, however, among the hundreds of thousands of photographs
taken of Kennedy there were many that he tried to suppress. A lone amateur
photographer, a middle-aged Irish Catholic woman called Florence Kater, came close to
wrecking the harmonious image Lowe's photographs had assiduously constructed.
Though Kennedy's womanising was well known in Washington's social and political
circles, it had been skilfully kept from a larger audience. A sex scandal involving a
prominent Catholic senator and family man would have fatally derailed any run for the
Democratic nomination. On 8 May 1958, in the early hours of the morning, Kater had
photographed Kennedy leaving the apartment above her own, which she had rented to
Pamela Turnure, a young member of Kennedy's office staff. She had discovered that the

10

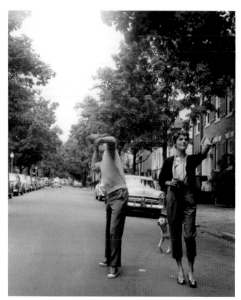

10 Playing Ball in a Georgetown Street
Orlando Suero, 1954

For his public appearances, no matter how informal,
Kennedy managed to ignore the almost constant pain
he suffered. For Suero's camera, accompanied by
Jackie, he passed the time playing ball with his brother
Robert. 'I had no idea,' wrote the photographer later,
'that Jack was in such agony with his back. I was
absolutely not aware he was in pain. It never showed
in anything he did.' Nevertheless, as Kennedy reached
for a high ball, Suero's exposures revealed beneath his
sweater the telltale outline of the back brace he now
wore to protect his disintegrating spine.

Opposite
11 Portrait of the President-Elect
Irving Penn, 1960

Penn took this portrait of the President-Elect for *Vogue* in
1960 (though it was actually published in its American
and British editions early the following year). Penn's
magisterial composition shows Kennedy seated in a
rocking chair, specially constructed to support his back
(to the unknowing public it was an antique, resonant with
reassuring American values, folksy and dependable). This
portrait endowed Kennedy with more gravitas than had
been customary for 'America's Golden Boy'. In a list of
'Great White Hopes', he was the greatest hope of all.

married Senator was conducting an affair with Turnure and, her sensibilities offended, she promptly sent a mailshot to fifty key members of Washington media and society, outlining his moral unsuitability for high office. She was dismissed, for the most part, as a crank. In May 1960, however, Kater confronted Kennedy on the campus of the University of Maryland, brandishing a placard bearing an enlarged image of her early morning encounter with the Senator (fig.13). The *Washington Star* printed a photograph of the confrontation but later dropped the story altogether, as did all the other newspapers.

Despite all that he had to hide, Kennedy ran a refreshingly open electoral campaign. Lowe was there to record its informality in series of unposed shots, which captured both the grinding tedium of the trail (see figs 2, 12) and the euphoria (see figs 3, 9) of his race against Richard Nixon to the White House. Lowe's handheld snapshot aesthetic – and his proximity to the candidate – were new to American political trailblazing and perfectly captured a new style of American politician. '[Kennedy was] mobbed by uncontrollable crowds,' recalled Lowe, 'and women would faint in the audience, a reaction more attuned to a rock star than a candidate for political office.'

Kennedy was the first American politician to seize upon the new medium of television, the more eagerly so after the first televised presidential candidate debate. Sixty million people, almost a third of America's population, had tuned in to hear or see the debate. Those who heard it on the radio were convinced Nixon had won outright; those who viewed the transmission were equally sure of Kennedy's supremacy. Kennedy proved himself a master of the medium. Although Nixon was an accomplished debater, he neglected the extent to which television emphasised personal demeanour. Viewers would recall not so much what the candidates said, but the way they presented themselves. Where Nixon looked gaunt and sweaty, Kennedy radiated health. Handsome and youthful, he ignored Nixon to speak directly to the camera and the American nation.

Kennedy appeared tireless, working from 6am until past midnight. In September 1960, for example, his whistle-stop tour took him to twenty-five towns in five days. In truth he was aided by a cocktail of drugs, administered by a medical practitioner known to a handful of Kennedy aides as 'Dr Feelgood'. Steroids bulked him up; others gave his complexion a glowing 'tan', all of which suggested, according to one commentator, that 'Kennedy's very "Kennedy-ness" was partly a side effect of his medication.' Robert Dallek, the most convincing analyst of his medical problems, has remarked that 'it is likely that he would have had a reasonably early death, that he might not have outlived his fifties … but he was extraordinarily courageous, single-minded and strong-willed'. Between 1955 and 1957 alone he had been hospitalised nine times.

Kennedy triumphed over his chronic illness and on 8 November 1960, he triumphed over his opponent too, though not by the landslide predicted. Jacques Lowe was at the Kennedy family compound at Hyannis Port, Massachusetts, to record the euphoria when Nixon finally conceded after one of the closest election results in American history. The Kennedys seemed to represent a break with the formality of the past, ushering in an age of optimism and progress at the White House (fig.15).

Shortly after his accession, Kennedy endorsed the appointment of an official photographer to record the presidency for posterity. Lowe turned down the role, believing it would focus on official functions and would deny him the degree of intimacy he had become accustomed to. In fact, Cecil Stoughton, to whom the honour went, was given almost full access to Kennedy, both officially and privately, but, in contrast to his relationship with Lowe, Kennedy retained full editorial control over Stoughton's output.

11

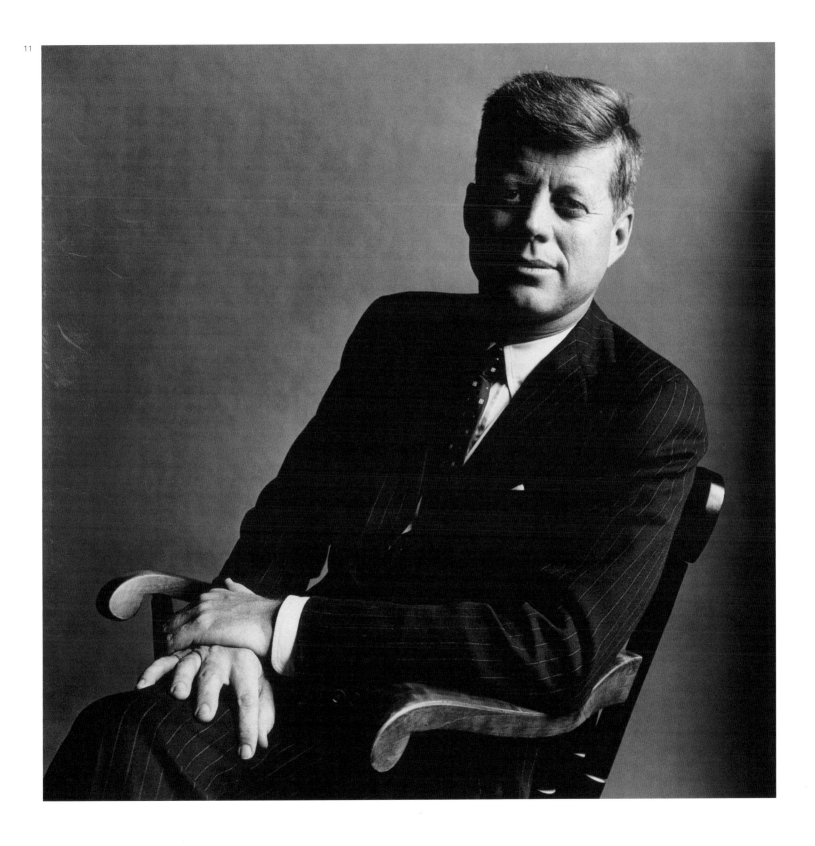

12

MASSACHUSETTS
SENATOR JOHN F. KENNEDY | JANET DAY
... advises: "Marry a politician—it's an interesting | ... lives in Massachusetts, goes to Hoos
life!" | Maryland, met her Senator in West Virg

12 'Marry a Politician!'
Milton Greene, 1960

It appeared that there was little that the Senator would not do to generate support. In this photo spread for *Glamour* (August 1960), a sister magazine to *Vogue*, taken in the run-up to the presidential election, Kennedy's prescient advice is quoted: 'Marry a politician – it's an interesting life!' Jackie Kennedy was also well versed in the artifice afforded by photography, having worked on American *Vogue*.

Opposite
13 Mrs Florence Kater Demonstrates Outside
the *Evening Star*
Unknown Photographer, c.1960

*Glamour*'s admonition (fig.12) might have satisfied Mrs Florence Kater, pictured here, had her tenant Pamela Turnure followed it and had Kennedy been a single man. But Kater had discovered that the Senator was conducting an affair with Turnure and, her sensibilities offended, she staked out the apartment until she got her proof. The *Washington Star* (sister publication of the *Evening Star*) printed her photograph but later dropped the story, treating her as a deranged housewife with an unnatural fixation.

Like his father, he realised the publicity value of featuring his children in carefully constructed photo opportunities recording domestic harmony. The First Lady often objected to the presence of photographers and elaborate, stage-managed public relations exercises. The other, more sustained source of tension between the Kennedys was Jack's extra-marital activity. His compulsive sexual behaviour appeared to gain momentum as he entered the White House though his many affairs were kept secret from the public. Kennedy was fully cognisant of his charisma, promoting it, and thereby his athleticism and youth, with staged photo opportunities that served to deflect the rumours about his private life.

Reinforced by a regime of medication and exercise, Kennedy was confident of a second term in office. But by now he was being lifted onto the presidential plane, Air Force One, as he could not negotiate the steps and, away from the public gaze, he was using crutches to walk.

On 22 November 1963, Jacques Lowe, after seven years still the President's favourite photographer, was walking through Manhattan. He was aware of an unnatural silence on streets that were customarily chaotic:

*I sensed that something was wrong, yet I couldn't identify it. I suddenly realized that traffic had come to a near standstill and people were crowded around cars parked at the curb. I walked over to one group, asking what was the matter. 'The President has been shot,' a man said. 'What President?' I asked uncomprehendingly. 'President Kennedy!' he said. I can still feel the chill running down my back. I started running ...*

The presidential open-topped car had been proceeding in a motorcade through Dallas. Though the circumstances would remain forever a source of speculation, Lee Harvey Oswald had fired three shots from the Texas School Book Depository. The first shot went wide but the second struck Kennedy in the nape of the neck. Anyone else might have slumped forward with the impact but Kennedy remained erect. Momentarily, his back brace of canvas, with its metal stays and padded bandage, held him up. The third bullet entered the back of his head. The back brace, which had for years helped to conceal the extent of his infirmity, was now implicated in his death. Three years into his presidency, Jack Kennedy's promise of a brighter future for his nation was over, unfulfilled (fig.14).

Lowe's images of the President became of immense importance – and considerable worth. No insurer was prepared to underwrite the risk and Lowe deposited his negatives in the vaults of the Chase Manhattan Bank. He died in May 2001. Four months later, on 11 September, they vaporised in the destruction of the World Trade Center. Only his prints and contact sheets remain.

The presidency of John F. Kennedy was the most photographed of the early postwar era. The youngest president elected to office, he was the youngest to die in office. He did not allow photography to expose his secrets, nor did he live long enough for it to damage him. He remains for the most part frozen in amber, the embodiment of youth, promise and hope. The press, sympathetic for the most part, chose during Kennedy's lifetime to place his policies ahead of intrusion into his private life. But in the eighteen months before his assassination, it had begun to question his health and his ability to govern.

As the era of Camelot starts to slip from contemporary memory, there is every likelihood that photography, as much as the written word and oral testimony, will continue to reveal the reality behind the fantasy. In a short political career, John Fitzgerald Kennedy struggled against his ailments to make a dynamic impression on the international stage. 'The Great Enemy of the Truth,' he said a year before his death, 'is very often not the Lie but the Myth.'

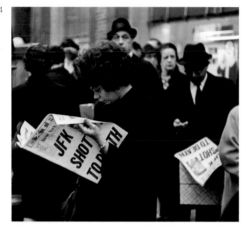

14 'JFK Shot to Death'
Wayne Miller, 1963

New York, 22 November 1963. A rushed-out newspaper
reports the unthinkable. Three years into his presidency,
Jack Kennedy's promise of a brighter future for his nation
was over and, for the most part, unfulfilled.

Opposite
15 President Kennedy in the Oval Office
Jacques Lowe, 1961

At the White House, the Kennedys broke with the rules
and procedures of the past. Kennedy was, in many
ways, the first American president of the modern age.
He gave photographers unprecedented access to the
corridors of power. Although the inference was
occasionally deceptive (standing up to work gave
Kennedy relief from his back problem), Jacques Lowe
found Kennedy at his most statesmanlike when standing
at his desk in the Oval Office, the full weight of national
and international responsibility on his shoulders. Lowe's
photographs represent Kennedy at his most iconic, and
are all the more resonant for their informality and the
photographer's lack of a self-aggrandising 'style'.
The 'thousand days' of Kennedy's presidency is almost
indelibly seared on the consciousness of the American
nation and, more than any other photographer, Lowe
shaped its memories of the golden years of 'Camelot'.

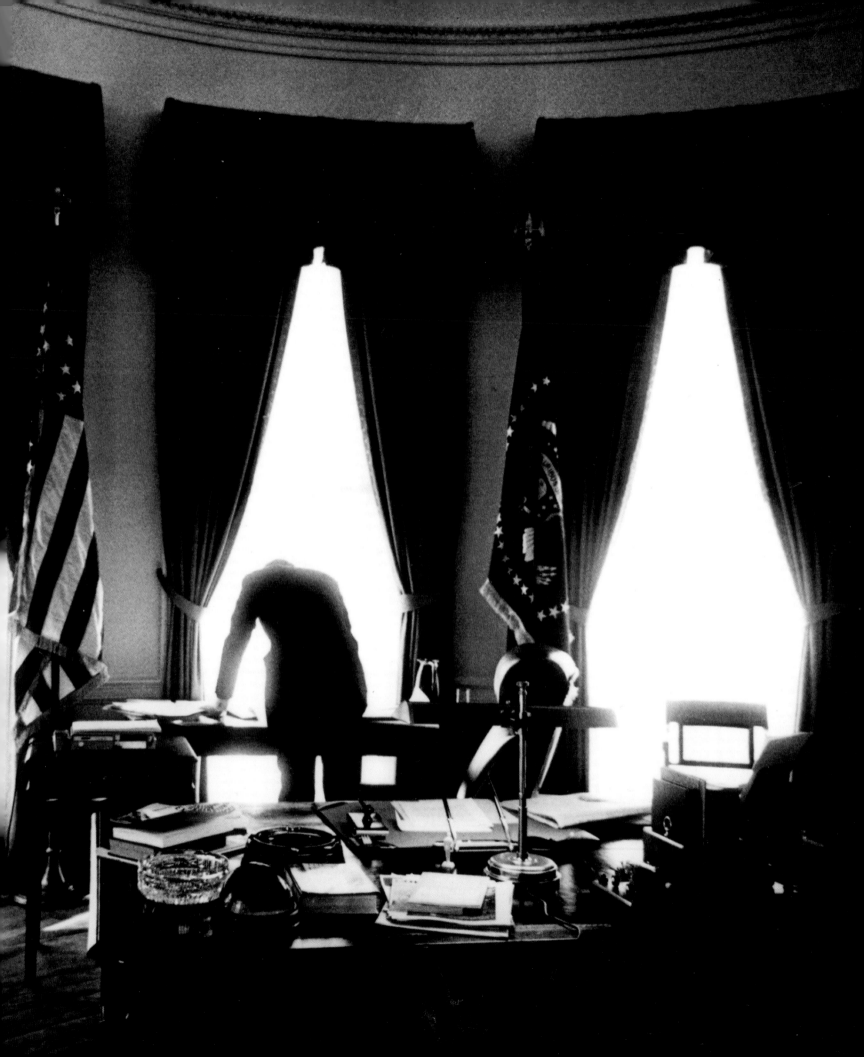

# 6  Marilyn Monroe

**Marilyn Monroe (1926-62)**

1926 Born Norma Jean Mortensen on 1 June
to a single mother, Gladys Pearl Baker,
in Los Angeles

1942 Aged sixteen, marries neighbour
Jimmy Dougherty but divorces four years later

1944 Spotted by photographer at work for the
war effort

1946 Signs first studio contract with
Twentieth Century Fox

1952 Wins first major role in *Niagara*

1953 Early glamour shot published in *Playboy*

1954 Marries baseball hero Joe DiMaggio in
San Francisco

1955 Moves to New York to study with
Lee Strasberg at the Actor's Studio

1956 Marries playwright Arthur Miller

1959 Wins a Golden Globe for *Some Like It Hot*

1961 Miller writes the script for Monroe's
last film, *The Misfits*

1962 Monroe is found dead on 5 August in her
Brentwood home

Opposite
1 Marilyn Monroe, Beverly Hills
Baron, 1954

Photographs of Monroe by the British photographer
Baron remain little known, despite his claim that they
were 'among the best pictures I have ever taken'. She
was less than an hour late for their session, which Baron
understood to be something of a record, and he was
able to photograph her in the fading Californian light. He
recalled that she was one of the most appealing people
he had ever met and that 'she fell automatically into a
liquid position which no photographer could possibly
invent for her'.

Henri Cartier-Bresson, cited as the greatest photographer of his age, was a taciturn and
serious man to whom the grand statement did not come naturally. He made an exception
– as did so many great minds, from Edith Sitwell to Willem de Kooning, Aldous Huxley to
Saul Bellow, Carl Sandburg to Isak Dinesen – for Marilyn Monroe (fig.1) : 'She is,' he said
simply, 'the Great American Phenomenon'. He could have gone a little further. She was
certainly the most famous American woman of the twentieth century, perhaps the most
famous woman of the twentieth century. She was a sex symbol without rival and, as more
than one commentator has observed, a cultural heroine without parallel. Bert Stern,
whose elegiac photo essay *The Last Sitting* was completed six weeks before her death,
did go a little further and expressed what Monroe meant for a generation:

*Marilyn Monroe is the first American goddess – our goddess of love. We created her*
*just as much as she created herself. She arose in response to our sexual yearning and*
*our spiritual awakening. She is gone but she is everywhere. Stars die but the light goes*
*on forever. Through the magic of photography the light from Marilyn Monroe is still*
*reaching us, still drawing us on, like the moths to a flame …*

His observations were prescient. Since her early death by her own hand in 1962, aged
thirty-six, hundreds of magazine features, newspaper articles and books have been
written about her, all telling and retelling her story and embellishing further the myths
surrounding her brief life. Eve Arnold, a colleague of Cartier-Bresson and herself a stranger
to overstatement, attempted to articulate the allure, both complex and obvious, which
Monroe presented to the camera. She was drawn inescapably to a subjective conclusion:

*I never knew anyone who came even close to Marilyn in natural ability to use both*
*photographer and still camera. She was special in this, and for me there has been*
*no-one like her before or after. She has remained the measuring rod by which I have*
*– unconsciously – judged other subjects … I am still haunted by her as she appeared*
*before my lens.*

Monroe herself could not pin down what it was that made her come alive for the camera,
but when one photographer asked her what it was that occurred between her and the
lens she replied, 'It's like being screwed by a thousand guys and you can't get pregnant.'

Monroe worked hard to achieve the status of phenomenon and love goddess. She
appeared on more magazine covers during her short life than any other screen star, and
on many more after her death. In one month alone she was featured on fifteen front
covers. By 1946 she was the Advertising Association's 'Most Advertised Girl in the
World!'. At the height of her fame her studio fan mail, one source claimed, exceeded that
of all other actresses in Hollywood put together. She sang 'Happy Birthday' to a
president, curtsied to a reigning British monarch and shook hands with Nikita Khrushchev,
after which the Cold War thawed a little. She married two high-profile American legends:
the first a baseball player, the second the greatest playwright of modern times. She was

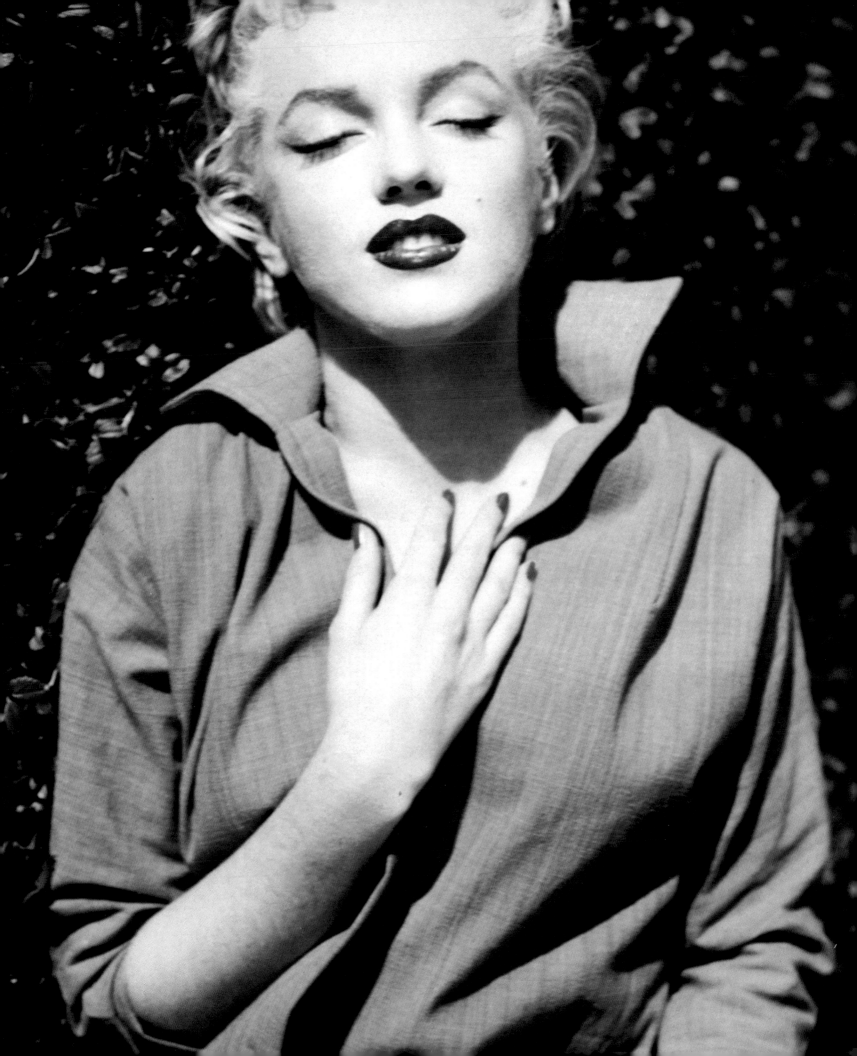

3

3 Monroe at Press Conference for
*The Prince and the Showgirl*, London
Unknown Photographer, 1956

Opposite
2 Transparency Taken During *The Last Sitting*
Bert Stern, 1962

The *Evening Standard*, which published this photograph of Monroe attending a press conference for *The Prince and the Showgirl* in London in 1956 (fig.3), clearly found the greatest American playwright of his generation, Arthur Miller, to be an irritating peripheral; so too the back of Vivien Leigh's head. Bert Stern's marathon photo session with Monroe (fig.2, opposite) reaped over 2,600 images for his publication *The Last Sitting* (1962). Monroe was herself very much a part of the selection process. As Stern recalled: 'On the contact sheets she had made x's in magic marker. That was all right, although I didn't agree with her – I thought some of the ones she'd crossed out were beautiful. But she had x-ed out the colour transparencies with a hairpin, right on the film. The ones she had x-ed out were mutilated. Destroyed.'

4

5

4, 5 Norma Jean, California
André de Dienes, 1945

Opposite
6 'Miss Golden Dreams'
Tom Kelley, 1949

Impoverished and as yet undiscovered, Monroe posed nude for glamour photographer Tom Kelley for $50. This image was to become 'Miss Golden Dreams' in a popular calendar. Later, when her star was in the ascendant, it returned to haunt her. But her honesty gained her public sympathy and far from destroying her career, the scandal made her 'the hottest property in Hollywood'. It was with this photograph that Monroe became *Playboy*'s first centrefold in 1953.

the first *Playboy* centrefold. She brought New York City to a standstill with a promotional image, four-storeys high, of her billowing skirt. Further upstate, the town of Monroe declared itself, just for a day, 'Marilyn Monroe'.

In a professional career of only fourteen years, she made some twenty-nine films (the thirtieth, *Something's Got To Give*, 1962, remained uncompleted). In these she frequently and effortlessly sidelined those billed above her including Bette Davis, Laurence Olivier, Cary Grant, Clark Gable, Barbara Stanwyck and Groucho Marx. Every moment she was in shot, whether speaking or motionless, all eyes in every theatre across the world, whether male or female, were on Marilyn Monroe. On the set of her last completed film, *The Misfits* (1961), an unprecedented corpus of photographers was in attendance, documenting her every move on- and off-set: Ernst Haas, Bruce Davidson, Elliott Erwitt, Cornell Capa, Inge Morath, Erich Hartmann, Dennis Stock, as well as Eve Arnold and Henri Cartier-Bresson.

Undoubtedly a star, only occasionally an actress of depth, she frequently experienced difficulties performing for the movie camera, always preferring the medium of stills photography to promote the persona of Marilyn Monroe. The film set was a chaotic milieu in which she was one part of a gradually coalescing whole. But in front of a photographer's lens, one-to-one, she was in control (fig.16). When the incessant pressures of the Hollywood system threatened to overwhelm her, she turned, time and again, to her photographers for the intimacy, encouragement and reassurance she seemed persistently to crave. It is telling that her directors – among them John Huston, Billy Wilder and George Cukor – consistently made observations about her lack of ability and her insecurities, while her photographers spoke only of her metamorphosis for the lens. Wilder damned her with faint praise, commenting, 'she does two things beautifully – she walks and she stands still', while Richard Avedon remarked that 'she gave more to the still camera than any actress – any woman – I've ever photographed'.

Norma Jean Baker, named after the silent film actress Norma Talmadge and the Hollywood star Jean Harlow, made the transition to Marilyn Monroe in the full glare of the photographer's gaze, always a willing accomplice. She was from the start 'a photographer's dream'. Bert Stern recalled for *Vogue* her participation and intercession:

*She was much more of a partner than I'd expected. The first hour or two I had an idea of what I was after. I had all kinds of imagery floating around, and she was picking up on it, performing it all. I didn't have to tell her what to do. We hardly talked to each other. We just worked it out … She'd move into an idea, I'd see it, quick lock it in and my strobes would go off like a lightning flash – PKCHEWW!! – and get it with a zillionth of a second.*

In June 1944, *Yank*, a forces magazine, commissioned army photographer David Conover to take a series of documentary photographs of women at work for the war effort. In an aircraft plant in Los Angeles he came across a girl fixing propellers. 'I raised the camera to my eye. I snapped her picture and walked on. Then I stopped, stunned. Half child, half woman her eyes held something that touched and intrigued me.' He photographed her several times that summer and returned the following year, still mesmerised. She was eighteen years old and had been married since her sixteenth birthday to the first of her three husbands, James Dougherty, then on active duty in the Pacific. She possessed, declared Conover, 'natural talent', and he offered to introduce her to the Blue Book modelling agency. She accepted.

Monroe had had a turbulent childhood, her schooling had been fractured both by circumstance and her mother's fragile mental health, and she would spend much of her

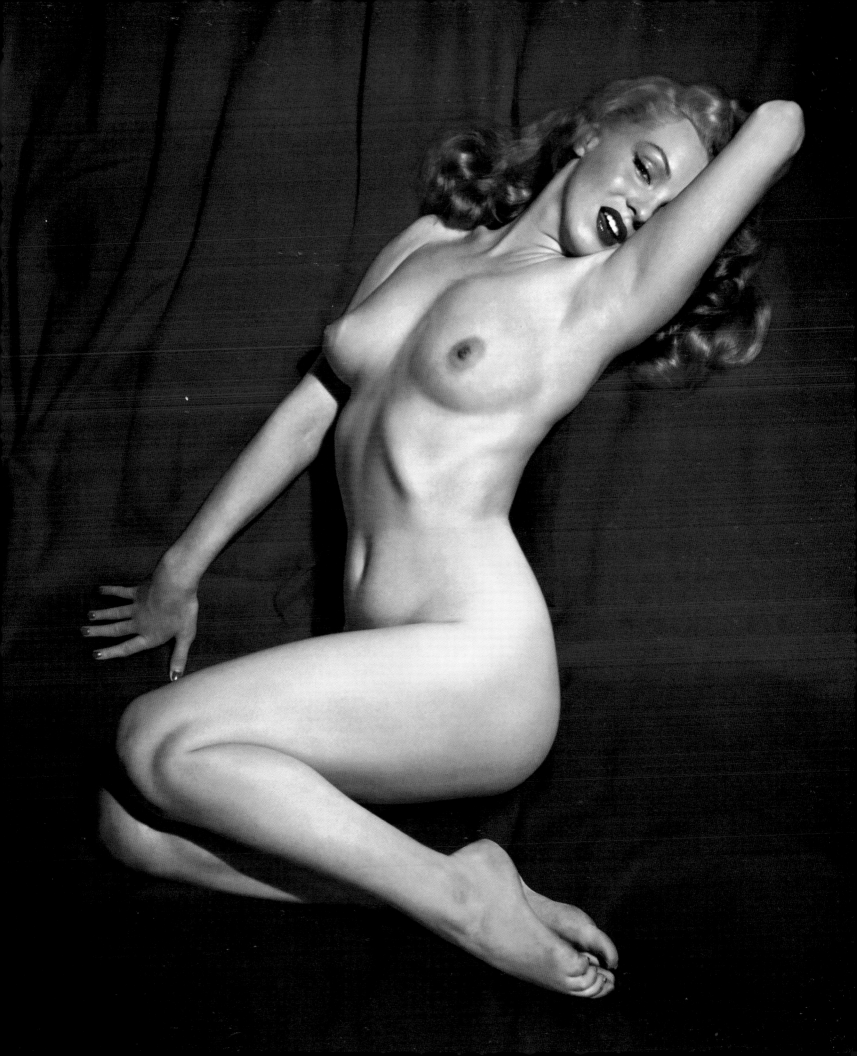

7

7 Monroe as Glamour Model
Unknown Photographer, c.1945/46

By spring 1946, Norma Jean had appeared on the cover
of over thirty men's magazines, of which she was clearly
proud. That summer she became 'Marilyn Monroe' and
started turning her new persona into a concept. Within
a few short years she had reinvented herself out of
all recognition.

Opposite
8 'The Talk of Hollywood'
Philippe Halsmann, 1952

Monroe's appearance on the cover of Life magazine
(7 April 1952), an endorsement for any ascendant star,
was nearly aborted by the re-emergence of Tom Kelley's
calendar pictures (fig.6). Philippe Halsmann had wanted
to photograph Monroe for an earlier issue of Life as one
of eight up-and-coming starlets. He asked her to mimic
being 'kissed by the most fabulous invisible lover'.
He recalled that she gave such a 'performance of realism
and dramatic intensity that not only she but I was utterly
exhausted'. A year later, in 1952, Life wanted Halsmann
and Monroe again, this time for the cover.

adult life compensating for a perceived lack of learning. After spells in an orphanage and
with foster parents, she sought security and an escape route from a marriage that had
failed to provide it (she memorably described her first marriage as 'a sort of friendship with
sexual privileges'). Photography and modelling, with the twin probabilities of attention and
approval, at least offered her a way out. Even at this early stage in her career, she had a
critical eye and scrutinised endlessly the contact sheets and transparencies Conover had
provided. She admitted to enjoying the frisson of delight in recognising exposures that
'worked' and the satisfaction in identifying those that did not. This attention to, and
control over, the presentation of herself to the world would be a lifelong preoccupation.
Part of the process of completing Bert Stern's *The Last Sitting* (fig.2), at 2,600 images an
epic production, belonged with its subject who pored intently over the results.

In late 1945, shortly before her husband returned from his tour of duty, Norma Jean had
met André de Dienes, a young Hungarian photographer, who was already a name in New
York but was new in Hollywood. She enchanted him. He said she reminded him of a
'pretty Easter bunny' and he conceived of a men's magazine with a rabbit as its logo, filled
with pictures of a naked Norma Jean Dougherty. Eight years later, Hugh Hefner produced
exactly that – and his first *Playboy* centrefold was Norma Jean, by then Marilyn Monroe.
De Dienes had been determined to escape New York and the artificiality of the studio
setting and was in search of the freedom the monumental landscape of the American
West might afford. He took Norma Jean on a three-week road trip through the California
desert and into Arizona and Nevada. The photographs he took, mostly in colour, reflected
in an almost heightened fashion the reality of the natural surroundings (figs 4, 5). They
remain in sharp contrast to the later iconography of Marilyn Monroe – she told Eve Arnold
that she always thought of herself in 'blonde monochrome'. De Dienes sold his portraits in
Los Angeles and Norma Jean Dougherty secured her first front cover.

By spring 1946, she had appeared on the cover of over thirty men's magazines, albeit
with titles such as *See*, *Laff*, *Peep* and *Swank* (fig.7); by the summer she had been signed
up by Twentieth Century Fox; and from 24 August she became 'Marilyn Monroe'.
De Dienes observed her coming to terms with her new persona, turning it none-too-subtly
into a concept. She practised her signature, 'two large, curly romantic "M"s on a notepad.
She was getting acquainted with her new identity, saying "Marilyn Monroe" as if tasting a
piece of candy.' A month later she divorced James Dougherty. She completed the
transformation with some minor cosmetic surgery, the heightening of her hairline and the
bleaching of her hair with hydrogen peroxide and ammonia. Her emblematic platinum
shimmer obliterated Norma Jean forever. 'Suddenly,' noticed Eve Arnold, 'there was a
glow about her: skin, fingernails, toenails are all translucently silvery. Everything about her
becomes exaggerated.' Andy Warhol observed her as this stereotype, pared down to its
essential elements: a platinum-blonde hair-do, a beauty spot, a come-on smile and
arched eyebrows. His coloured Marilyn series of 1962, taken from a Gene Korman
publicity still for *Niagara* (1953), her first role of substance, established her as the
quintessential American icon. As the commentator Sarah Churchwell has shrewdly written,
'[Warhol] painted bright colours over the face that suggested cosmetics, the garish fakery
of Hollywood, and cartoons.'

Her break came in 1950 with John Huston's *The Asphalt Jungle* and her career gained
momentum. In March 1952, *Life* wanted Philippe Halsmann to photograph Monroe for the
cover (fig.8). But on the eve of the shoot for one of America's biggest mass-circulation
magazines, an early career move came back to haunt her, threatening to overshadow all

9

9 Monroe in a Class at the Actor's Studio, New York
Roy Schatt, 1955

Opposite
10 Still Photographs from *Some Like It Hot*
Unknown Photographer, 1959

Monroe was captivated by New York. Intent on reinventing herself as a serious actress, in 1955 she enrolled at the Actor's Studio, where Lee Strasberg, known for his teaching of 'the Method', was Artistic Director. Roy Schatt photographed Monroe in class looking all but anonymous amongst the other actors, her face devoid of make-up and listening in rapt attention (fig.9). This photograph is stamped 'Not for Reproduction' on the reverse. But Monroe would be frustrated by the lightweight nature of the parts offered to her, and it was perhaps her misfortune that she proved so accomplished in them. In this unpublished contact sheet of photographs taken during the filming of *Some Like It Hot* (1959), she displays perhaps a little of the radiance (and ditziness) that she brought to it (fig.10). As Sugar Kane Kowalczyk, ukulele player in an all-girl troupe, she turned in one of her finest comic performances.

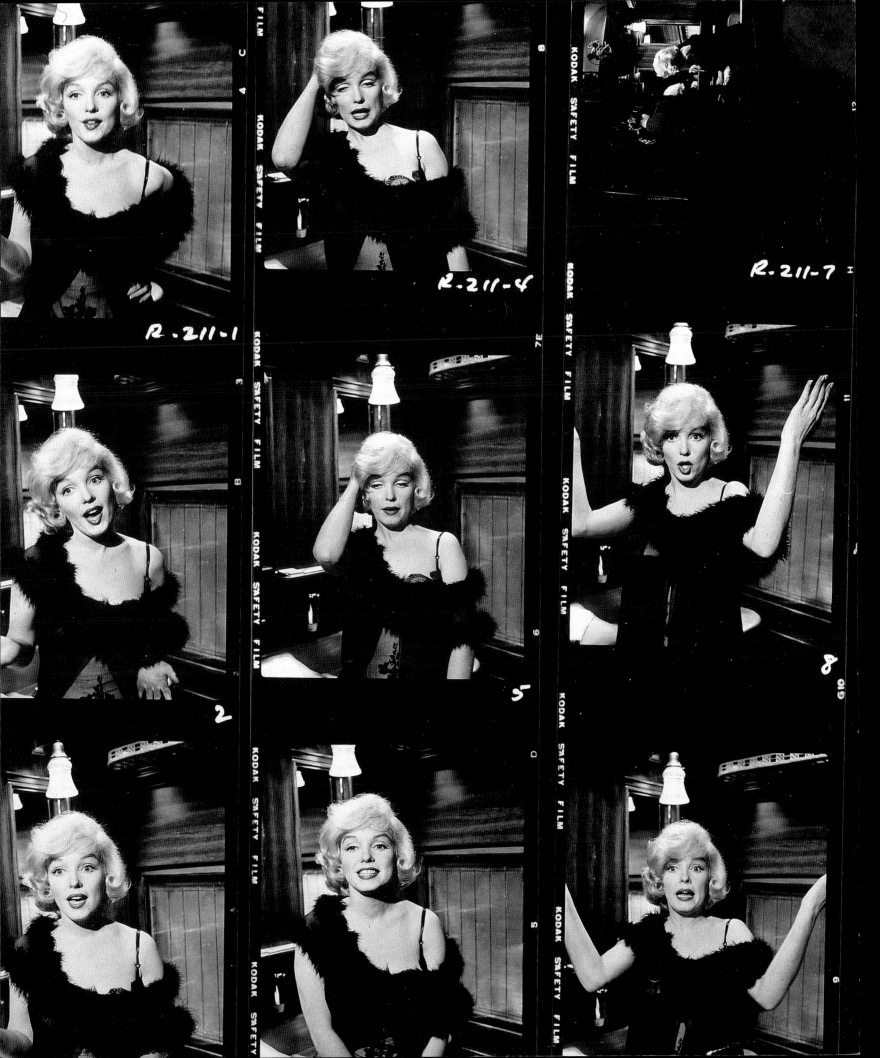

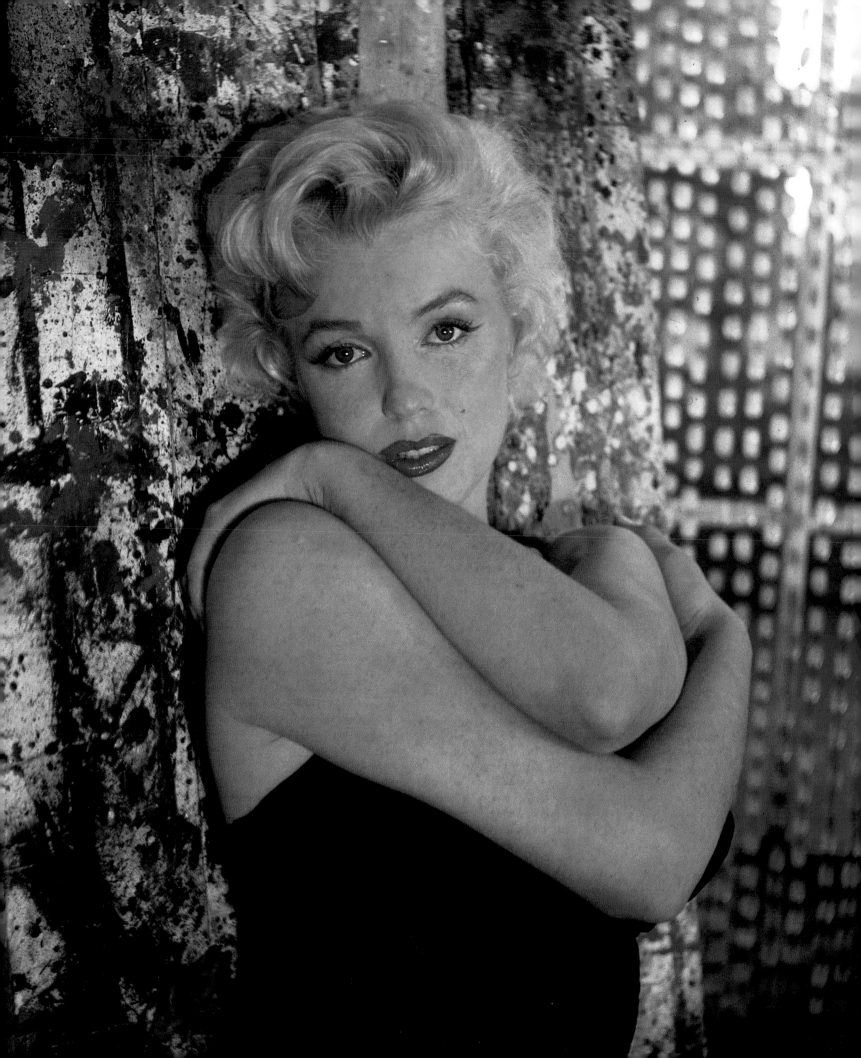

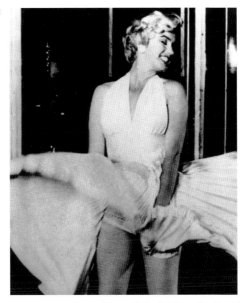

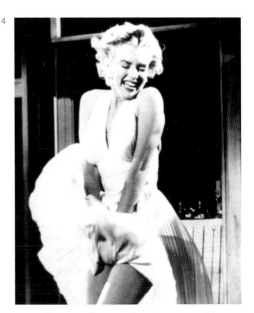

12, 13, 14 Monroe Filming *The Seven Year Itch*
Sam Shaw, 1954

Two thousand New Yorkers, among them the photographer Sam Shaw, turned up to watch the filming of *The Seven Year Itch* but more particularly to see Monroe's skirt billowing over her thighs as she stood astride a subway vent. Twentieth Century Fox decided to use this image to market the film. Shaw had positioned himself next to the movie cameras and it was one of his stills that was blown up for a Times Square billboard. It was considered to be the most provocative image ever displayed in a public place.

Opposite
11 Monroe at the Ambassador Hotel, New York
Cecil Beaton, 1956

Monroe sat for Cecil Beaton in his New York hotel suite in 1956. This session remained one of her favourites. Beaton was characteristically fulsome in his praise: 'Miss Monroe calls to mind the bouquet of a fireworks display, eliciting from her awed spectators an open-mouthed chorus of "Ohs" and "Ahs". She is as spectacular as the silvery shower of a Vesuvius fountain.' He enjoyed watching her perform for his lens but he was also intuitive, catching something of the vulnerability that lay beneath her outer shell. 'It is an artless, impromptu, high-spirited, infectiously gay performance,' he wrote later. 'It will probably end in tears.'

she had so far achieved. In 1949, she had been penniless and struggling for recognition. A glamour photographer, Tom Kelley, offered her $50 for a nude session and she complied (conditional on Kelley's wife being present). One photograph finished up on a calendar. She was 'Miss Golden Dreams', lying naked on a strip of red velvet (fig.6). Though she was not credited by name, rumours of the model's identity focused on the young starlet. MGM panicked but Monroe rose to the occasion. She gave an interview confirming the identity of the model and presenting herself as an impoverished and blameless victim with nothing to be ashamed of. Her defiance earned her public sympathy, her initiative saved her career. In 1953 the session was used to launch *Playboy*, its headline indicative of Monroe's sensational rise to the top: 'First time in any magazine FULL COLOR the famous MARILYN MONROE NUDE'. Far from destroying her, the scandal established her as Hollywood's hottest property. The success of *Niagara*, *Gentlemen Prefer Blondes* and *How To Marry A Millionaire*, all released in that same year, confirmed her status. By 1963, eight million copies of the infamous calendar had been sold. *Life* magazine kept her on the cover of their 7 April 1952 issue, trumpeting her as 'Marilyn Monroe: The Talk of Hollywood', which by then she certainly was. The magazine subverted Monroe's misfortune to its, and her, own ends:

> Because her movie role is always that of the dumb blonde, Hollywood generally supposes she is dumb herself. This is a delusion. Marilyn is naïve and guileless.
> But she is smart enough to have known how to make a success in the cutthroat world of glamor … being as wholly natural as the world will allow.

Monroe's celebrity was consolidated in January 1954 when she married Joe DiMaggio, one of the nation's greatest sporting heroes. A baseball legend, his stardom was of a far greater magnitude than Monroe's. 'Sitting next to him,' she said later, 'was like sitting next to a peacock with its tail spread … No woman has ever put me so much in the shade.' It was a glamorous but explosive pairing, a union that would last barely nine months. It had an inauspicious start. While on their honeymoon in the Far East, Monroe had accepted an invitation to visit American forces in Korea. As 60,000 servicemen clicked their shutters at what would be her biggest ever public exposure, DiMaggio seethed. He fulminated further when Joan Crawford, Monroe's childhood heroine, railed against her vulgarity – she had appeared at a gala in a dress so tight that it was claimed she had to be sewn into it. His

15

15 Monroe at the Première of *The Prince and
the Showgirl*, New York
Unknown Photographer, 1957

This photograph shows how even the most hurried
of paparazzi shots invested Monroe with an allure that
few others possessed. In *The Prince and the Showgirl*,
starring and directed by Laurence Olivier, she played
an American showgirl Elsie Marino. This image was used
extensively in the British press to announce Monroe's
death five years later.

Opposite
16 Monroe with Photographers, New York
Sam Shaw, 1956

Monroe preferred the medium of still photography to
that of moving film when promoting the persona of
'Marilyn Monroe'. In the chaotic environment of the film
set she was one part of a gradually coalescing whole,
but in front of a photographer's lens, one-to-one, she
was in control.

fury was barely repressed when he accompanied his new wife to New York to film
*The Seven Year Itch* (1955). The scene that unfolded before his eyes and those of 2,000
onlookers in Lexington Avenue at midnight on 15 September 1954 was that of Monroe's
skirt billowing up over her thighs as she stood astride the subway's hot-air vent (figs 12-
14). Billy Wilder remarked later that he had caught DiMaggio's eye and the look returned
was a 'look of death'. Monroe filed for divorced shortly after filming was completed.

Monroe remained in New York after filming. Sam Shaw, now a friend as well as an
amanuensis, was there to show her the city, which she thought was the most exciting
place on earth. In an effort once again to reinvent herself, this time as a serious actress,
she enrolled in Lee Strasberg's Actor's Studio (fig.9). Strasberg's unconventional teaching
– 'the Method' – demanded that participants search deep into their psyche to trigger
responses drawn from their own emotional depths. Monroe laid bare her emotional scars
willingly, but still seemed unable, or reluctant, to put them to constructive use. She had
begun to establish an independence from the Hollywood system. With the photographer
Milton Greene, she formed her own short-lived production company, which led to her
temporary suspension by Twentieth Century Fox, a decision not taken lightly. It was said
that Fox's two greatest assets were CinemaScope and Marilyn Monroe – and not
necessarily in that order.

In 1956 she married the playwright Arthur Miller and entered what she later described
as the happiest time of her life. They had met five years earlier on the set of *As Young As
You Feel* (1951). Miller had written to her with prescience: 'Bewitch them with this image
they ask for, but I hope and almost pray that you won't be hurt in this game nor ever
change.' It was an unexpected liaison. She was famous for her beauty and her flagrant
displays of sexuality; he was renowned for his challenging intellect and liberal principles.
Sam Shaw was there to document the early months of their marriage, an intimate record
of a couple in love (fig.18). Though doomed to end in acrimony, it gave Monroe for a time
the security and happiness she craved. In addition, she found success with films such as
*The Prince and the Showgirl* (figs 3, 15) and was sought by leading photographers
including Richard Avedon and Cecil Beaton (fig.11).

Before their marriage dissolved, Miller provided his wife with a role that confirmed her
reputation as serious actress – Roslyn Tabor in the elegiac Western *The Misfits*. Miller's
character was based upon observations and vignettes of Monroe's own life: a sensitive
and confused woman at the mercy of the men around her but who changes their lives
ineluctably. Released in 1961, this was the last film she made. Later that year, back in
Hollywood, she began work on *Something's Got To Give*, a film from which she was fired.
She had begun to suffer panic attacks and her behaviour on set was erratic. Inevitably she
sought refuge in photography. George Barris took her to the ocean at Santa Monica for
what would be one of her last sessions (fig.17). The location had a special resonance for
Monroe – as a child, she had sought solitude there from her troubled home life.

On 5 August 1962 her housekeeper found Marilyn Monroe dead. The autopsy
concluded that she had taken her own life with an overdose of barbiturates. The
circumstances surrounding her sudden death confirmed her reputation as a victim of
Hollywood, beautiful and tragic. 'God gave her everything,' commented Billy Wilder.
'The first day a photographer took a picture of her, she was a genius.' These
photographs continue to exercise their peculiar hold, allowing her, as Sammy Davis Jr
put it – apparently in admiration – to 'hang around like a bat in our minds'.

17 Monroe on the Beach at Santa Monica
George Barris, 1962

In 1962 George Barris, a photographer and personal
friend of Monroe's, took her to the ocean at Santa
Monica for what would be one of her last photo
sessions. The location had a particular resonance.
As a child, Norma Jean had sought solitude there from
her troubled home life. Barris recalled, 'the sun had
gone down. It was windy and cold and Marilyn said
"Can't we stop? I'm getting cold," and I said, there
is only one frame left in the camera and she said
"But George, you're always saying that," and I said no,
honestly it's the last picture … So we took the towel and
put it over her legs and she said, "I'll blow a kiss to you".
This was the last picture we took.'

Opposite
18 Monroe in New York
Sam Shaw, 1956

Despite periods of introspection and despair, the most
photographed woman of the immediate postwar era
also knew moments of great happiness. In autumn 1956,
Sam Shaw spent a day in New York with Monroe and
Arthur Miller, her husband of only a few months. Miller
enthralled her. 'It was like running into a tree,' she said
of their first meeting. 'You know, like a cool drink when
you've got a fever.' The full frame of this photograph,
only recently re-discovered, shows Miller in the driver's
seat. Here, Shaw's preferred version shows just Monroe
at her most naturally radiant.

17

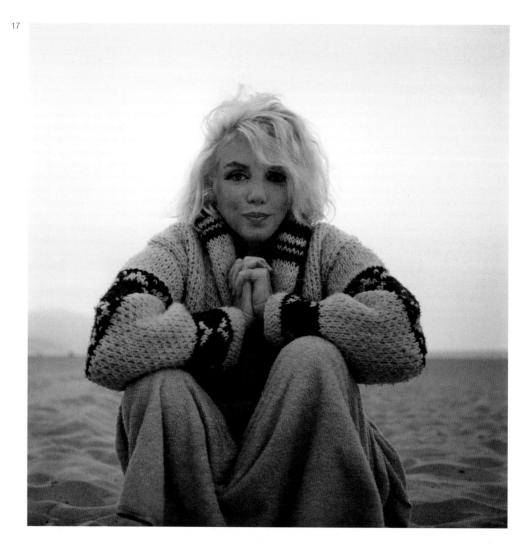

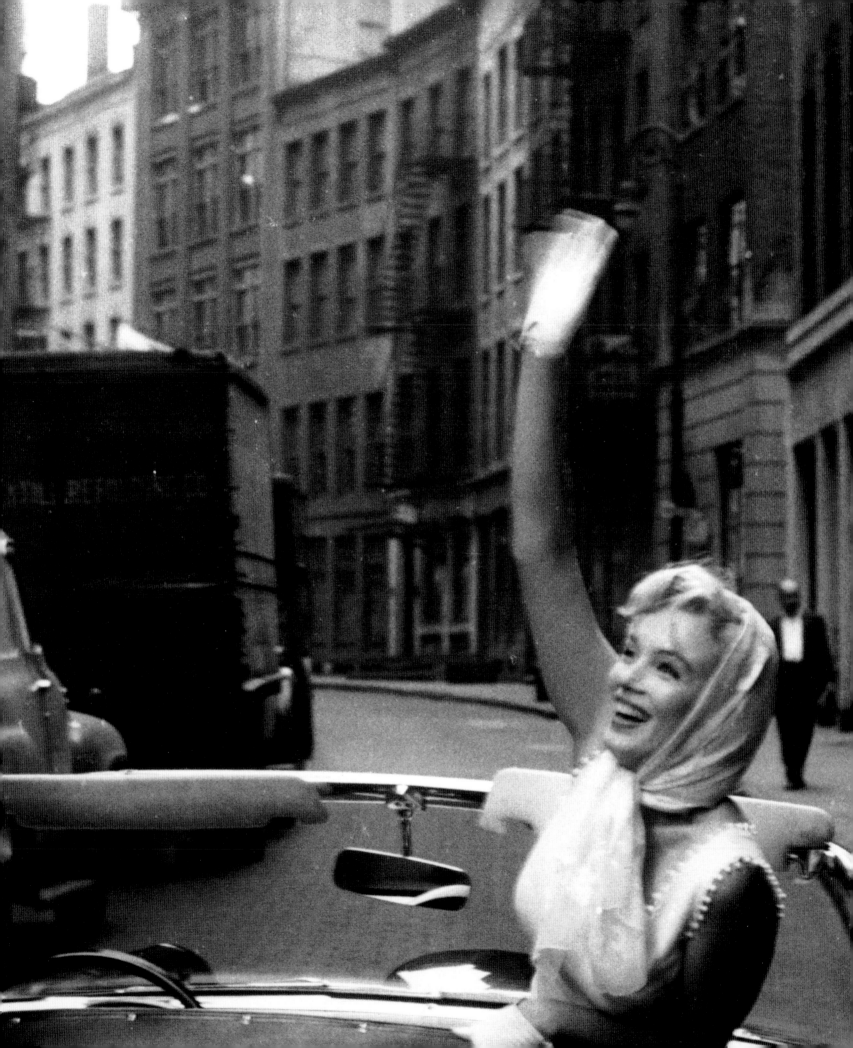

# 7  Audrey Hepburn

**Audrey Hepburn (1929-93)**

1929   Audrey Kathleen Ruston is born
       on 4 May in Ixelles, Brussels
1939   Moves to Holland after father abandons
       family; helps the Dutch Resistance
       during World War II
1947   Wins scholarship to Ballet Rambert, London
1949   Makes her London stage debut in the chorus
       line of the musical *High Button Shoes*
1951   Spotted by French novelist Colette to star
       in Broadway adaptation of her book *Gigi*
1953   Stars in *Roman Holiday* with Gregory
       Peck and receives Academy Award as best actress
1954-61 Award launches successful film career including
       *Sabrina, War and Peace, Funny Face* and
       *Breakfast at Tiffany's*
1954   Marries actor Mel Ferrer in Switzerland; six years
       later their son Sean is born
1964   Reconciled with her father the same year she
       makes *My Fair Lady*
1969   Marries Italian psychiatrist Andrea Dotti (their son
       Luca is born the following year) and makes her
       home in Rome and Switzerland
1988   Becomes special ambassador for UNICEF
1993   Dies of cancer on 20 January

Opposite
1 Portrait of Audrey Hepburn
Cecil Beaton, 1954

Cecil Beaton would photograph Hepburn on many
occasions, most famously for the film *My Fair Lady*
(1964). She had, he declared, 'enormous heron's eyes
and dark eyebrows slanted towards the Far East. Her
facial features show character rather than prettiness.'

The pages of *Vogue* in London, Paris and New York are a significant barometer of the social and cultural changes of the twentieth century or, as its British edition put it, it is 'a Geiger-counter to changing fashions in looks, style and beauty'. If ever you appeared there, you could be sure it was at the right moment, when your star was in its ascendancy, and in the brightest of contexts. In March 1951, the magazine duly introduced its readers to its latest find, the 22-year-old actress who was dazzling Broadway in *Gigi*: 'She has big, slanted dark eyes, a rich slightly clotted voice, and long-legged young grace.'

For the next three decades Audrey Hepburn dominated its pages, both as an Oscar-winning actress of undeniable charm and as a glittering fashion icon, whose association with the couturier Hubert de Givenchy was to last for thirty years. For her first *Vogue* fashion sitting, however, she wore 'a romantic ball gown of Bianchini flowered silk taffeta, designed by Adrian'. In 1954 she was, for *Vogue*, 'the world's darling'. By 1964, on the eve of *My Fair Lady*, the magazine marvelled that almost single-handedly Audrey Hepburn had established a new standard of beauty: 'Every other face now approximates to the "Hepburn Look".' By 1974 *Vogue* had not yet expended its superlatives: 'Audrey Hepburn has looked all her life as if every minute and every new fashion were born just for her ...'

During the course of nearly forty years, she sat for the magazine's star photographers, all heroes of twentieth-century fashion photography, and her elusive charm beguiled every one of them: Richard Avedon, Irving Penn, William Klein, Norman Parkinson (figs 11, 12), Henry Clarke, Bert Stern and Cecil Beaton (figs 1, 14). Many more took her picture, their portraits of the photogenic young actress the highpoints of brief careers. Her last published set of photographs, taken by Steven Meisel, appeared in Italian *Vogue* in 1991. But perhaps Avedon's hyperbole spoke for them all: 'I cannot lift her to greater heights. She is already there. I can only record, I cannot interpret her. There is no going further than who she is. She paralyses me. She has achieved in herself the ultimate portrait.'

Of all film stars, Hepburn remains the most photographed in British *Vogue*'s ninety-year history. Indeed, of all the twentieth-century figures who graced its pages, she runs third only to the Queen and her late daughter-in-law, Diana, Princess of Wales. Audrey Hepburn was simply, as the magazine put it, 'today's and tomorrow's wonder-girl'. She had, of course, seduced the fashion world early on. In the musical parody *Funny Face* (1957) (fig.9) – forerunner to *My Fair Lady* (1964) (fig.13) and the successor to *Sabrina* (1954) (fig.8), both ugly-duckling-to-swan roles in which she would specialise – she was transformed from awkward bookshop assistant to enchanting fashion model.

Hepburn's *Vogue* debut (and probably her debut in print) may well have been three years earlier, when Clifford Coffin photographed the uncredited fashion mannequin for the Paris Collections of spring 1948 (fig.5). Later in life, he bragged to all who would listen that he had 'discovered' Hepburn, but had passed her over at first as she was a little

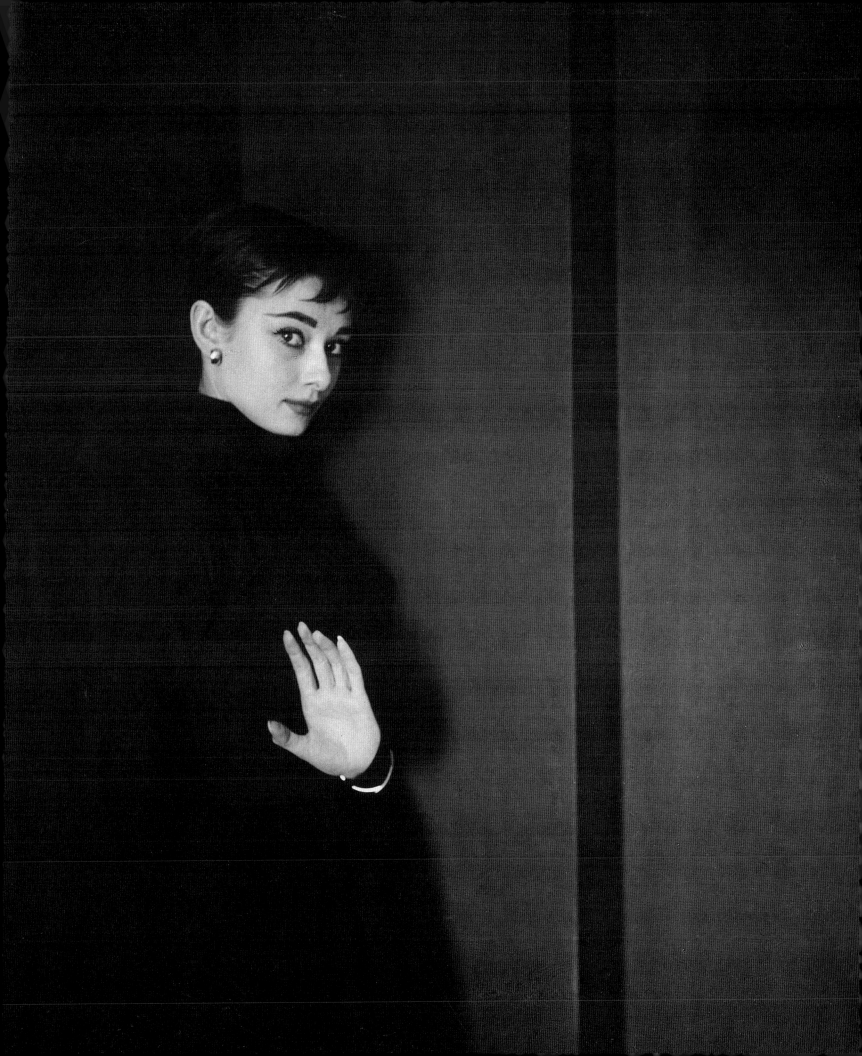

RETIRED

2

RETIRED

3

4

3 Family Charades
Unknown Photographer, 1938

Many myths have sprung up around Audrey Hepburn's ancestry, nationality, given name and surname. She was born Audrey Kathleen Ruston to Anglo-Irish businessman Joseph Ruston and Dutch baroness Ella van Heemstra. Researching the genealogy of his family, Joseph Ruston discovered that some of his forebears were named 'Hepburn', which he added to his surname. Here, playing charades with her brothers, she gives an early indication of the career she would pursue.

4 Fashion Shoot for *Picture Post*
Bert Hardy, 1950

This fashion story for *Picture Post*, entitled 'We Take a Girl to Look for Spring', was probably Hepburn's first magazine appearance. It was photographed in Kew Gardens, London.

Opposite
2 Still Photograph from *Secret People*
Unknown Photographer, 1952

Hepburn's much-admired slimness derived from the hardship of German occupation during World War II, which helped to define her film career but destroyed her childhood ambition: to be a ballet dancer. Her wartime experiences helped bring an authenticity to her first important film role – that of a young ballerina enmeshed in wartime resistance work in *Secret People*. This print from the Kobal Collection, London, bears a reminder that after half a century of use by magazines and newspapers, its working life has come to a close.

overweight. Coffin was always treated with caution, not least because of his volatile temper, excitable behaviour and a propensity for embroidering the truth. But even his detractors (and there were many) recognised his eye for a new face and his perseverance once he had found it. Several of his discoveries became the marque names that dominated fashion pages in the postwar era: Barbara Goalen, Wenda Rogerson, Wilhelmina, Elsa Martinelli and Carmen dell'Orefice. And, seen by him on the London stage, Audrey Hepburn. No negatives exist to substantiate his claim but a print from that Collections issue, nearly sixty years ago, still remains at *Vogue*. It shows a slight, waif-like girl, far from overweight, her hair tied back to expose fine cheekbones. Though the glare of reflected sunlight casts a shadow over her face, the discernible features look delicate and curiously familiar. If the photograph was not of her (Hepburn herself denied it), then it was the precursor of a look that, more than any other, defined the postwar years.

Angus McBean, based in London's West End and known for his extravagant surrealist-inspired tableaux, also claimed to have found Audrey Hepburn first (fig.6). She was considered ideal for the face of a new beauty preparation, Lacto Calomile. On the reverse of a surviving print from the shoot, he scrawled in ink: 'London, 1951. Aged 18, picked out of the chorus line of a Revue & chosen by me for one of my very rare commercial shots – "A beauty which dares not come close". It was her first published photograph.'

McBean was wrong on two counts, however. By 1951 she was twenty-two and it was not her first published photograph. Another London photographer – Anthony Beauchamp – saw the unknown actress in a cabaret line-up, beating McBean by six months. He grabbed the opportunity to photograph her for a series of magazine profiles in *Tatler* and *The Bystander*. He recalled in his memoirs that he could not quite fathom that she was real: 'There were so many paradoxes in that face. Darkness and purity; depth and youth; stillness and animation.' Yet another British photographer, Noël Mayne, took several shots of Hepburn around 1949 but it remains unclear if he ever disseminated them and they now appear, like much of Beauchamp's *oeuvre*, to be lost.

Perhaps *Picture Post*'s readers glimpsed the actress first, in a fashion shoot taken by Bert Hardy (fig.4). A confirmed documentary photographer of cheerful urban vignettes, he was an unlikely choice for 'We Take a Girl to Look for Spring', a series of fashion pictures that appeared in May 1950. Hepburn transcended Hardy's unimaginative direction and the

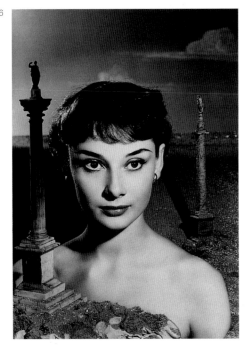

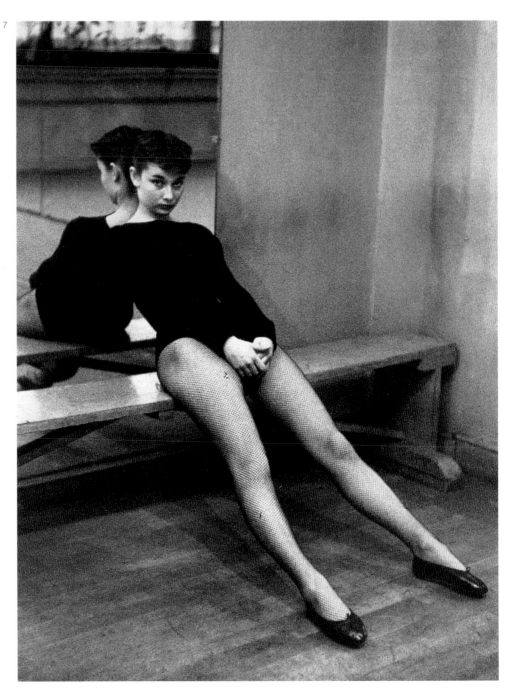

5 Photo Shoot for British *Vogue*
Clifford Coffin, 1948

6 Photo Shoot for a Beauty Preparation
Angus McBean, 1951

7 After a Dance Rehearsal
Ben Ross, 1952

8 Hepburn during Filming of *Sabrina*
Dennis Stock, 1954

Audrey Hepburn as seen by four markedly different photographers. The American fashion photographer Clifford Coffin claimed to have 'discovered' Hepburn and photographed her for *Vogue*. Nothing but this vintage print from the magazine's archives backs up his claim (fig.5). There is nothing to indicate it is of Audrey Hepburn other than the remarkably similar cheekbones. British theatrical photographer Angus McBean composed a typically surrealist tableau as the backdrop to a photo session for the beauty preparation Lacto Calomile, for which he considered the young revue artist ideal (fig.6). The American photojournalist Ben Ross shows Hepburn in repose after a dance rehearsal (fig.7). Though her early promise as a ballerina was cut short, energetic dance played a large part in her film roles, most notably perhaps the left-bank jazz club routine from *Funny Face* (1957). American photographer Dennis Stock captured Hepburn's gamine look in this reflective portrait taken during the filming of *Sabrina* (1954), which showcased the ugly-duckling-to-swan role in which Hepburn specialised and would reprise in *Funny Face* and *My Fair Lady* (1964) (fig.8).

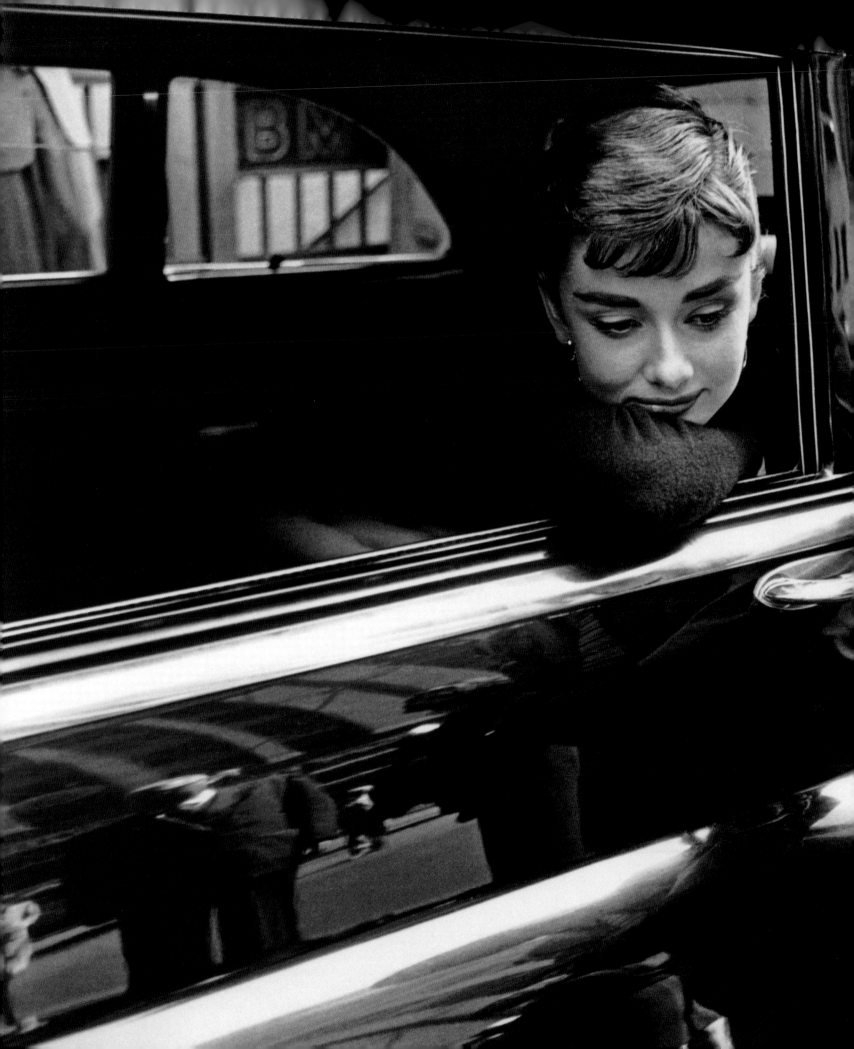

9

9 Hepburn with Fred Astaire in *Funny Face*
Unknown Photographer, 1957

A gentle satire on the world of the fashion magazine, whose pages featured Hepburn inordinately. The character of Dick Avery, the photographer played by Fred Astaire, was based partly on Richard Avedon, whose photographs appear briefly in the film and who acted as technical adviser.

Opposite
10 Hepburn as Holly Golightly in *Breakfast at Tiffany's*
Unknown Photographer, 1961

Hepburn transformed Truman Capote's amoral prostitute Holly Golightly – a role originally conceived for Marilyn Monroe – into an image of doe-eyed innocence. This was perhaps Hepburn's most defining role. And the image of her in the little black dress, designed by Givenchy and featured in *Life* magazine (8 September 1961), is perhaps the one that fixed her romantic appeal most indelibly in the public imagination.

dowdiness of a wintry, harlequin-patterned dress. 'After her singing-dancing part in *Sauce Piquante*,' considered *Picture Post*, 'the green grass and tulips make a pleasant change from stage scenery and curtain-calls …'

That so many photographers spotted Audrey Hepburn in chorus-line roles and fought over the distinction of introducing her to the world is indicative of her conspicuous grace – and the international renown she would later achieve. The comedian Bob Monkhouse, also in *Sauce Piquante* (1950), recalled her with affection but thought her by far the poorest dancer. While she may not have excelled as either dancer or actress, Hepburn, a subsidiary cast member, radiated an offbeat glamour that transfixed audiences. The magazine *Picturegoer* claimed with commendable prescience that she was 'God's gift to publicity men, a heart-shattering young woman with a style all of her own'. Further, in these early photographs she projected for the lens an openness and a curious physicality that was at odds with the role models of the era – customarily buxom and blonde, like Marilyn Monroe, or buxom and brunette, like Elizabeth Taylor or Gina Lollobrigida. 'She keeps escaping the camera,' the photographer Philippe Halsmann later observed. 'Her face has such facets, such changes of expression, you're always afraid you'll be too late.' In the postwar era, more than any other figure she changed the way men looked at women and the way women looked at themselves. Until given an imprimatur by the cinema of the *nouvelle vague*, film stars were not gamine or boyish with limpid eyes; nor did they possess, as one observer put it, 'rat-nibbled hair and a moon-pale face', nor were they unconventionally flat-chested. Billy Wilder, who directed her in *Sabrina* and *Love in the Afternoon* (1957) reckoned, with regret as well as admiration, that Audrey Hepburn might 'make the bosom a thing of the past'. Cecil Beaton compared her – favourably – to 'a lost Barnado boy'.

Though many of these early portraits show her, as the critic Walter Kerr once remarked, looking as 'fresh and frisky as a puppy out of a tub', several reveal what Hepburn considered a defect: a determined jaw and a face slightly square when viewed frontally. She learned, mainly from her sessions in 1951 with Richard Avedon at *Harper's Bazaar*, to 'slim' the lower part of her face by turning her head to a three-quarter profile. Beaton, who photographed her in his costumes for *My Fair Lady*, studied her endlessly and found, at length, a harmonious whole: 'She is like a portrait by Modigliani where the various distortions are not only interesting in themselves but make a completely satisfying composite.' But her smile, which could be a little 'fixed', continued to betray a hint of enigma and vulnerability, which, in view of her wartime privations and her fragmented, uncertain upbringing, is scarcely surprising. That she was able to reach London at all and the 'purgatory of cabaret', as her son Sean has put it, was nothing short of miraculous. Her early years marked her both physically and emotionally for life, but left her ultimately without rancour, one of the best known – and most loved – screen figures of her century.

She was born in Brussels in 1929 to Ella van Heemstra, a Dutch baroness who had fallen on hard times, and Joseph Ruston, an Anglo-Irish entrepreneur (he was later to add 'Hepburn' to his surname). Though their backgrounds were markedly different, they shared similar extremist political beliefs. Both were actively involved in fund-raising activities for Oswald Mosley's British Union of Fascists. In May 1935, they met Adolf Hitler in the Führerbau, Munich. Within one month Joseph Hepburn-Ruston had abandoned his young family. With the onset of war, Ella van Heemstra's right-wing enthusiasms dissipated and, for the safety of her three children (fig.3), she returned with them to Holland. On 10 May 1940 the German army advanced to the Dutch border. After five days

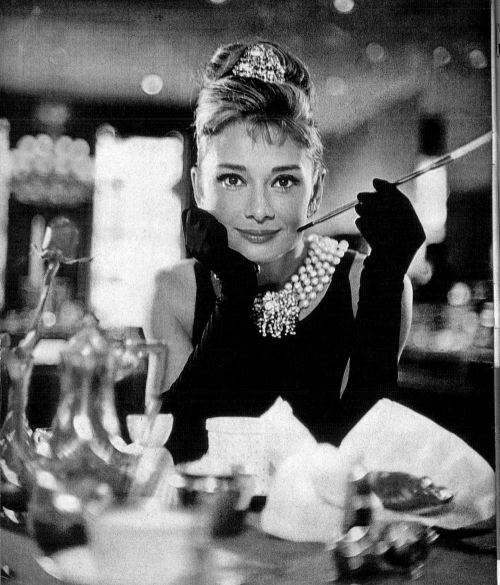

Holly dreamed of a breakfast at Tiffany's elegant jewelry store and here Audrey, her eyes agleam with hoyden joy, shows how—if dreams came true—she might have had her meal there. The menu: Danish and a container of coffee.

CONTINUED

Get the
made
with t

11

11 Hepburn during the Filming of *War and Peace*
Norman Parkinson, 1955

*Vogue*'s star photographer of the 1950s, Norman
Parkinson, photographed Hepburn on many occasions.
This small, creased contact print, initialled as his first
choice for publication, was taken on location in Rome
during the filming of King Vidor's *War and Peace* (1956).
Hepburn played Natasha and Mel Ferrer (whom she had
married the previous year) played Prince Andrei.

Opposite
12 Fashion Shoot for British *Vogue*
Norman Parkinson, 1955

The contact sheet of a projected fashion story, taken
by Parkinson, that never reached the printed page.

Holland capitulated. Ella van Heemstra, after her ideological volte-face, threw herself into
the struggle to free her homeland. Her 11-year-old daughter Audrey found ways to help,
too. She delivered messages for the Resistance, hidden in her shoes, and was an active
participant in musical revues, which the German occupiers permitted for their uplifting
value to the Dutch people. Other performances had no such sanction and were held in
secret, the funds raised going directly to the Resistance. Several years later, Hepburn
recalled that the performances she had loved the most, and which remained with her all
her life, were those given in basements, in the dark, under the noses of the invading
forces and greeted, for obvious reasons, with no applause. But perhaps the greatest
performance of her juvenile years occurred at Arnhem in September 1944. Ferrying
information to a stranded British paratrooper, she was stopped on her return by a group
of German soldiers and asked for her papers. Had they even a suspicion of her role, her
youth would have been no bar to detention and possible execution. But she held her
nerve and played innocent. Her mask did not slip, as it rarely did throughout her life, and
she emerged from the incident unscathed.

Hepburn also survived the winter of 1944, the 'Winter of Hunger' during which the
German occupiers all but starved the Dutch population. Thousands died of malnutrition
and associated illnesses. Hepburn herself suffered jaundice, yellow fever and acute
anaemia and she was reduced, she recalled later, to eating tulip bulbs and grass. The
effects of starvation permanently impaired her metabolism. At 5 feet 6 inches, by
Liberation she weighed barely 6 stone. Her much-admired slimness, which inspired a
generation of fashion designers, and which arguably contributed as much to her iconic
status as her acting abilities, derived directly from the hardship of German occupation.
What helped to define her look also destroyed her childhood ambition: her muscular
strength had been devastated to the extent that a promising career in ballet was cut
short. Yet it was these personal experiences that helped to bring an authenticity to her
first important film role – that of a young ballerina enmeshed in wartime resistance in
*Secret People* (1952) (fig.2).

Hepburn's vulnerability was to be a lure to filmmakers as well as photographers, but
she resisted any further roles that tapped so clearly into her harrowing early life.
Subsequently she refused the role of Anne Frank in the film version of her eponymous
Amsterdam wartime diaries, despite entreaties from Frank's father Otto, which she found
painful to decline. She was exactly the same age as Anne Frank. She said that reading
the diaries 'destroyed me … I was reading what was inside me and is still there.' She had
found an entry that read: 'Five hostages shot today.' It was the date her uncle was
executed by a Nazi firing squad for his role in the Dutch Resistance.

By contrast – and by design – she escaped her past by accepting a series of
lightweight roles, which made much of her irrepressible *joie de vivre*. Her innocent charm
was never far from the surface and during her audition for *Roman Holiday* (1953), its
director William Wyler was convinced he had discovered a star. So, too, was the
production's stills photographer Bob Willoughby. Of all her photographers, it was
Willoughby who, at its inception, contributed more than anyone else to defining her
legend. Her beauty, he remarked, was 'uncorrupted', her nature was like the 'innocence
of a child'. His portraits of her are poignant documents of their time and unexpectedly
informal, the effortless achievements, perhaps, of a prescient stills man. MGM's
cinematographers would find Willoughby's photographs waved at them as examples of
how Hepburn's close-ups should be shot.

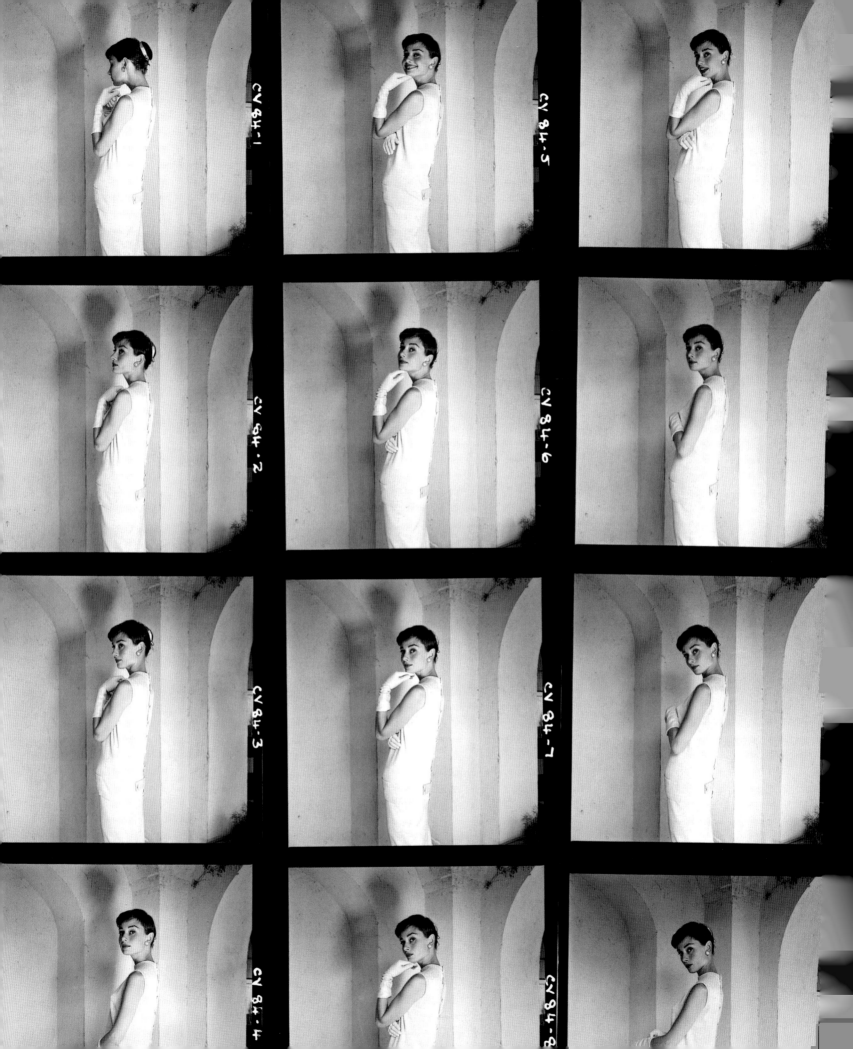

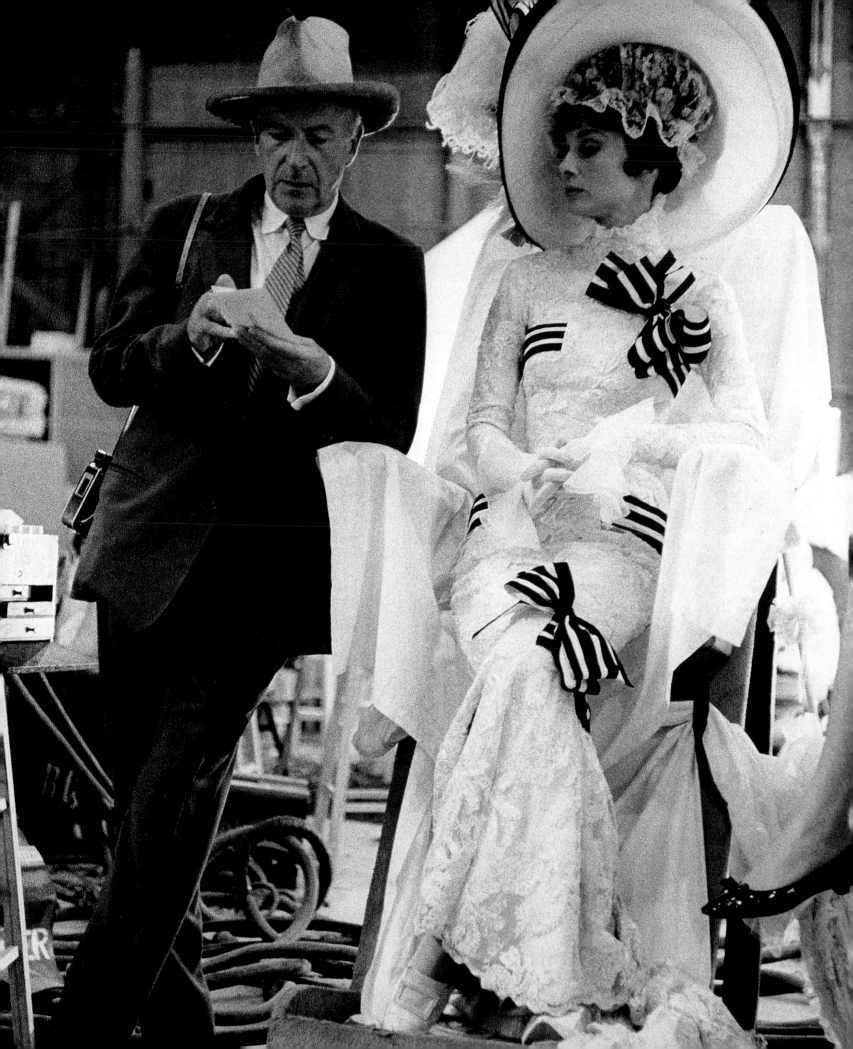

14

14 At the Hepburn Dotti Family Home, Switzerland
Henry Clarke, 1971

A pastoral vignette in the form of a contact strip for
British *Vogue* (April 1971), taken in the garden at the
Hepburn Dotti family home, Le Paisible, near Lake
Geneva, Switzerland. 'The more man flies to the moon,'
she told the magazine, 'the more I want to sit and look
at a tree.'

Opposite
13 Hepburn and Beaton on the Set of *My Fair Lady*
Cecil Beaton, 1963

As set and costume designer for the film of *My Fair Lady*,
Beaton was struck by its star almost to the point of
obsession. Once Beaton had completed his work,
George Cukor, the director, tried to ban him from the set.
Beaton photographed Hepburn in every creation he had
made for the film, from her own costumes to those of the
elaborately dressed extras. So transfixed was he that their
photographic sessions ran for nearly forty-eight hours
with hardly a break. In his forty-year career Beaton would
never make so many exposures of a single sitter.

Barely ten years after she had surfaced from war-ravaged Europe, Audrey Hepburn's
Hollywood debut in *Roman Holiday* had earned her an Oscar (she would be nominated on
four further occasions). Within two months she made the cover of *Time* magazine and
*Life*, which devoted six pages to the newcomer. Her unconventional elfin looks together
with her physical frailty were, for Hollywood, a startling proposition – and a powerful one.
From 1956 she had power of veto over all her photographs and production stills, unheard
of for a star of only three Hollywood films. When she pulled out of Alfred Hitchcock's *No
Bail for the Judge* over a questionable rape scene, he abandoned it rather than seek
another actress. And she could turn Truman Capote's hustling, amoral prostitute Holly
Golightly in *Breakfast at Tiffany's* (1961) – conceived by its author for Marilyn Monroe –
into an image of sweet-natured innocence, a doe-eyed waif who yearns for love and
misses home (fig.10).

Hepburn brought similar qualities of wide-eyed naivety to the role of Eliza Doolitle, the
Covent Garden flower-seller who transcends class and culture in *My Fair Lady*, a musical
version of George Bernard Shaw's *Pygmalion*. She was unfairly involved in a Hollywood
public relations debacle that marked this production. The lobby for Julie Andrews to play
the part of Eliza had gathered pace. Andrews had earned the film role, it was claimed, by
dint of her magical stage portrayal and her unique singing voice (which Hepburn did not
possess). But the film's set and costume designer, Cecil Beaton, was enraptured by the
choice of star almost to the point of obsession and he photographed Hepburn in every
creation he had made for the film, from the star's costumes to those of the elaborately
dressed extras (fig.13). He was able to scrutinise her appeal in detail:

> [She] has enormous heron's eyes and dark eyebrows slanted towards the Far East. Her
> facial features show character rather than prettiness: the bridge of the nose seems
> almost too narrow to carry its length, which flares into a globular tip with nostril's [sic]
> startlingly like a duck's bill. Her mouth is wide, with a cleft under the lower lip too deep
> for classical beauty, and the delicate chin appears even smaller by contrast with the
> exaggerated width of her jawbones …

In *My Fair Lady* Hepburn gave one of her best comedic performances – she was as
'dangerously beautiful' as the Eliza of its Shavian origins. But the world knew that her
singing voice had been dubbed. The film was an outstanding success and won Oscar
nominations in almost every category – except best actress. Beaton won two Oscars.
The award for best actress went to the lead in *Mary Poppins* – Julie Andrews.

By 1965 Hepburn had made twenty-two films. The hard work began to take its toll on
her slender physique. She had already collapsed from nervous exhaustion in 1954,
curtailing the Broadway run of *Ondine*. Close-ups were occasionally re-scheduled, as her
fragility showed most markedly in her face. By 1968 her thirteen-year marriage to the
Princeton-educated actor-director Mel Ferrer had begun to disintegrate. The following year
she married Italian psychiatrist Andrea Dotti after which, as a devoted mother to two sons,
she attempted retirement in Switzerland (fig.14) but remained a fixture in *Vogue*, at least.
Henry Clarke photographed her on several occasions with her second husband in Rome,
where, as she had done since the 1960s, she often modelled the collections of Hubert de
Givenchy (fig.15).

Givenchy and Hepburn had met when she was despatched to select outfits for
*Sabrina* in 1954. Givenchy was thrilled that Miss Hepburn herself would be coming to
his atelier, but was unimpressed when it turned out to be Audrey and not Katharine.
His disappointment did not last. The grey woollen suit she chose transformed her and,

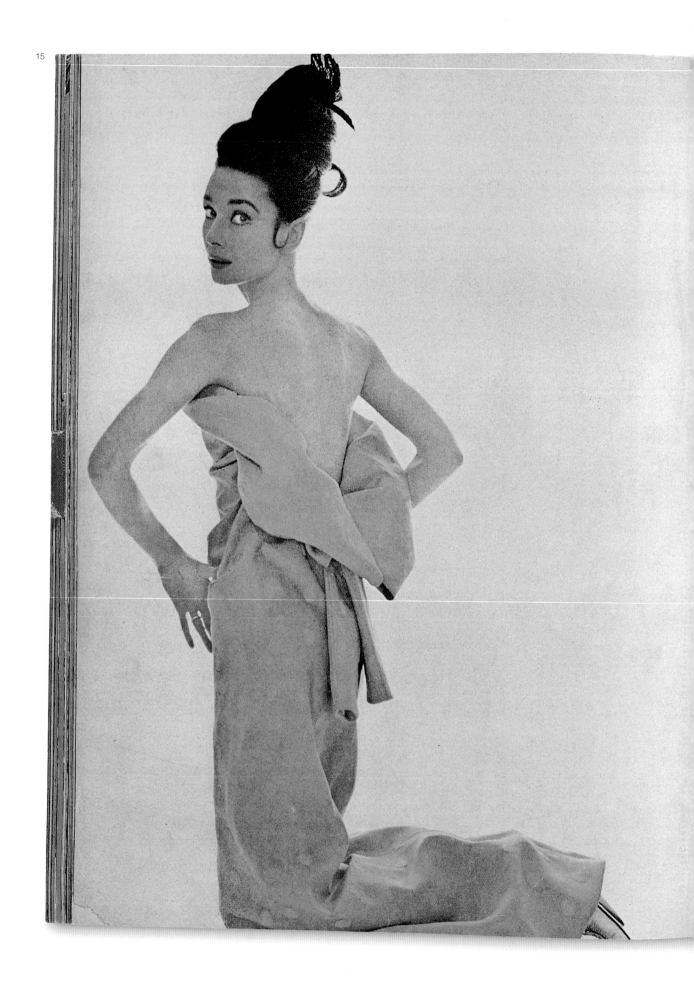

Vivid silk evening dress, left, narrowly curved to the body, with a décolletage like a night-blooming flower. (Made of gauzy dotted shantung. At I. Magnin.)

*"Very teahouse," said Miss Hepburn. "It's like a tiger lily—a wonderful colour at night, radiant and life-giving. And it's tremendous when a dress can make you take on a different personality."*

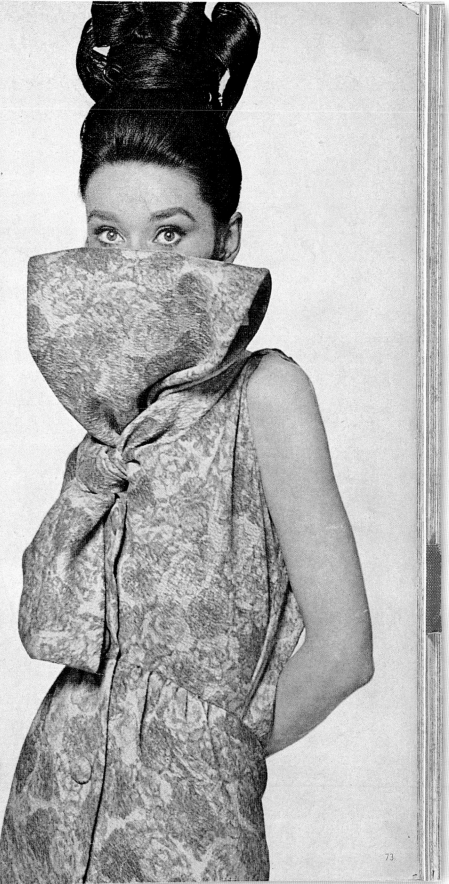

Cloqué silk déshabillé, right, printed in shades of china blue. At the front, a slightly lifted waist; at the back, loose folds falling to a miniature train.

*"I love that long, narrow string-bean-with-a-bow look designed completely around the body with so much line it's almost as if you had nothing on. Very feminine. Very natural."*

# DRESSING AT GIVENCHY

73

Preceding pages
15 Modelling Givenchy for US *Vogue*
Bert Stern, 1963

From the 1960s onwards, Hepburn frequently modelled the collections of Givenchy, who became her friend and she his 'muse'. They first met when Hepburn was despatched to select outfits for *Sabrina* in 1954. During the course of her career, Hepburn sat for all *Vogue*'s star photographers, including Bert Stern, who shot this fashion feature for US *Vogue* (April 1963).

perhaps more importantly for Givenchy, she transformed the garment. She became his muse and their close friendship and collaboration lasted for almost thirty years. In public she wore his creations to the exclusion of all other fashion designers. Perhaps the most famous image of her ever taken, the one that fixes the romantic appeal of Audrey Hepburn most indelibly in the public mind, is that of Holly Golightly in the little black cocktail dress designed by Givenchy, forever fashion shorthand for glamour: 'Just think,' remarked one fashion observer, 'what Givenchy has done for Audrey Hepburn!' 'No,' came the reply, 'just think what Audrey Hepburn has done for Givenchy.' She worked with the fashion designer to develop a silhouette that emphasised her thinness, and in turn, it brought him unheard-of press attention.

In 1984 Hepburn embarked on a late-flowering career as a Goodwill Ambassador for UNICEF (fig.16). She had never forgotten the part played by the charity when, as the war drew to a close, Holland was liberated. She travelled the world with UNICEF for nearly ten years, taking part in arduous and prolonged relief work, highlighting the plight of starving children. The awareness she raised was considerable, a role she described as 'talking my head off', which she did most effectively. She remembered a visit to a remote region of Sudan, where she came across a 14-year-old boy lying desperately ill. The doctor's diagnosis sounded familiar: anaemia, respiratory problems and oedema – the effects of malnutrition. She recollected that at the end of World War II she was the same age, with those same three illnesses. And then, she recalled, a large UNICEF truck roared up with food and medicine. 'I was one of the thousands of hungry youngsters and not all that well through many years of malnutrition and it was UNICEF that came in with food packages … I opened up a can of condensed milk and ate the lot.'

The war years shaped her look and that, in turn, shaped fashion history. Her upbringing had taught her to be self-reliant and instilled a work ethic that moulded her acting career. Yet the vagaries of stardom and fashion magazines could never camouflage her true nature. Abandoned by her father (they met only a handful of times after 1935), a certain vulnerability and resilience underpinned both facets of her work. She was not flawless but she was careful to allow that to be thought of her. She conducted herself in public with dignity, restraint and elegance. 'She has authentic charm,' remarked the great American stage actor Alfred Lunt, 'whereas most people simply have nice manners.' Her biographer Barry Paris put it even better: 'She left no lurid secrets or closet cruelties to be exposed. Beneath her kind, warm surface lay more kindness and warmth to the core.'

Opposite
16 Hepburn as Ambassador for UNICEF, Somalia
Betty Press, 1992

Hepburn embarked on a second career as an ambassador for UNICEF in 1984. Her hectic schedules took her to Sudan, Kenya, Ethiopia and Somalia by way of the US Congress, which, after her impassioned speech, augmented its funds for Ethiopia by some $60 million. This photograph was taken the year before she died, on her last tour of duty to Somalia, which affected her greatly. She told her son on her return, 'I have been to hell and back.'

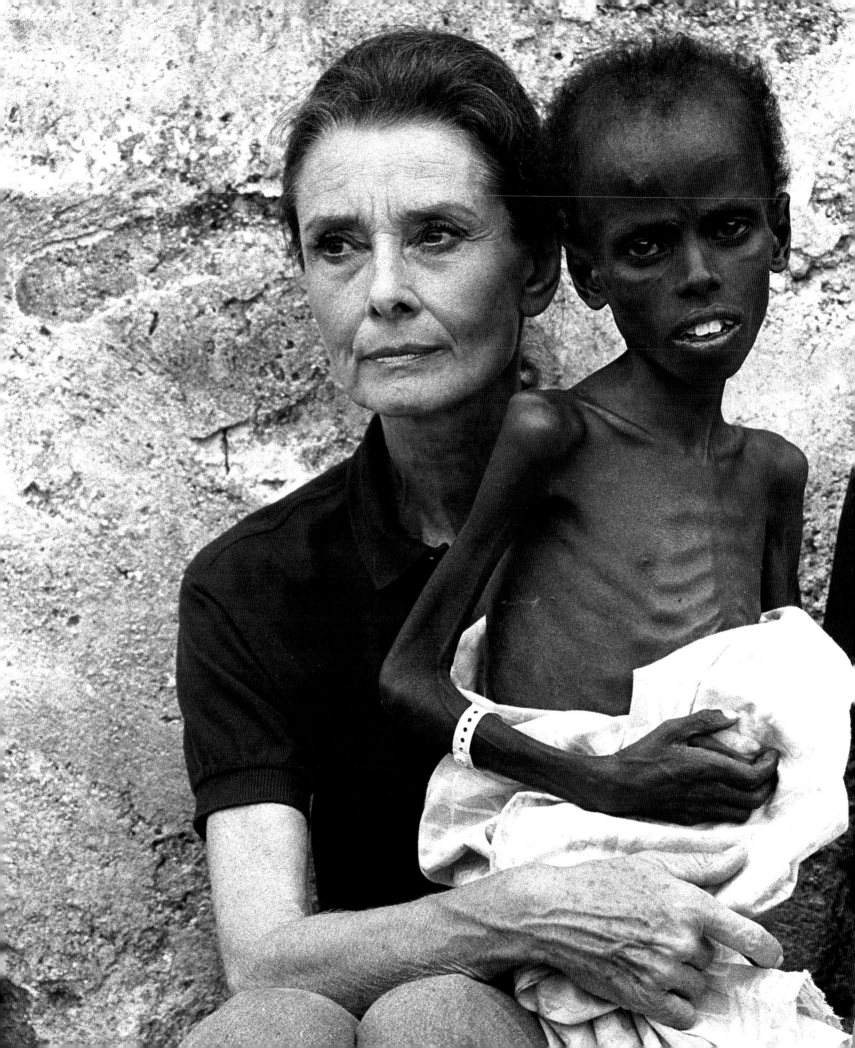

8  James Dean

**James Dean (1931-55)**

1931   James Byron Dean is born on
8 February in Marion, Indiana

1940   Sent to live on his uncle's farm
after his mother dies

1949   Moves to California and studies
theatre at UCLA

1950   Wins first role in a Pepsi commercial

1951   Moves to New York to pursue
serious roles

1952   Enters the Actor's Studio as one of
its youngest pupils

1954   Director Elia Kazan spots Dean and
casts him in *East of Eden*

1954–5   *Rebel Without a Cause* and *Giant* are
filmed within months of each other

1955   Killed 30 September in a road accident
driving Porsche Spyder 550;
*Rebel Without a Cause* is released in
New York a month after his death

Opposite
1 Portrait of James Dean
Phil Stern, 1955

This enigmatic portrait of James Dean became one of
the most iconic of the doomed star. Stern encountered
Dean in Los Angeles six months before his death and in
circumstances that presaged it. 'Coming down Laurel
Canyon,' Stern recalled, 'was a crazy motorcyclist who
was driving through a red light. We both braked and
careened through the intersection. I came close to killing
him – just a few inches saved his life.'

In early 1955, between his last performance in New York (in *The Thief* with Mary Astor)
and the start of filming in Los Angeles for *Rebel Without a Cause*, James Dean made a
trip back to the farm where he had grown up in Fairmount, Indiana. He was accompanied
by Dennis Stock, a young photographer with an escalating reputation in Hollywood, on
assignment for *Life* magazine. In common with many photojournalists of the time, Stock, a
member of the elite Magnum photo agency since 1951, was eager to strip his pictures of
the artifice, pretence and glamour that lingered on in the work of contemporaries, as if a
world war hadn't happened. Magnum was renowned for its uncompromising analysis of
social themes and Stock brought a gritty honesty to celebrity photography that was at
odds with the era, at least on the West Coast of America.

Dean was acutely aware that close friendships with photographers would be vital to the
development of his image (fig.1). As more than one biographer has noted, photographers
were almost as important to Dean as the directors of his three key movies – Elia Kazan,
Nicholas Ray and George Stevens. Accordingly, Stock's time with Dean in Indiana lasted
not the projected few days but nearly two months and was, as a result, extraordinarily
productive. Dean had been despatched from Los Angeles to his uncle's farm in Fairmount
by his father, when aged nine and an only child, on his mother's death. His father seemed
unconcerned about the emotional damage such dereliction of duty might cause. A sense
of abandonment and a quest for identity would colour both Dean's personal life and, as
observed by *Life*, underpin his individualistic style of acting. After Fairmount, tiny, remote
and Midwestern, Stock trailed Dean to New York. Here the young actor had studied
Method acting, polishing a technique of delivery that would be described, in admiration,
as 'slurred and uncommunicative' and honing off-set behaviour best summed up as
'militantly independent'. His acting coach Mildred Dunnock alleged that 'he was constantly
at war with his own temperament, torn between the desire to be theatrical and the desire
to be truthful'.

The collaboration between Stock and Dean was intimate and revealing and would
produce the most enduring images of a Hollywood idol, whose star blazed brightly if
briefly. And perhaps none was more lasting than a snapshot of Dean walking a bleak
Times Square (figs 2, 3), the actor hunched into the folds of a great coat with its collar
turned up to the rain, each sodden step sending eddies of water along the sidewalk. Like
a still from a movie, it was a picture that defined Dean for the generation to come.

James Dean starred in three films and thirty-two television plays. He had something of a
reputation on stage, too, though latterly it veered between 'gently awkward' to 'believable'
to 'an extraordinary performance'. He also featured in a musical comedy (fig.5), a genre
that he did not repeat, and made two commercials. The first, for Pepsi-Cola, which aired
just before Christmas 1950, marked his debut on screen. The second, made as his last
film *Giant* was completed, would be his valediction. By this time, 17 September 1955,

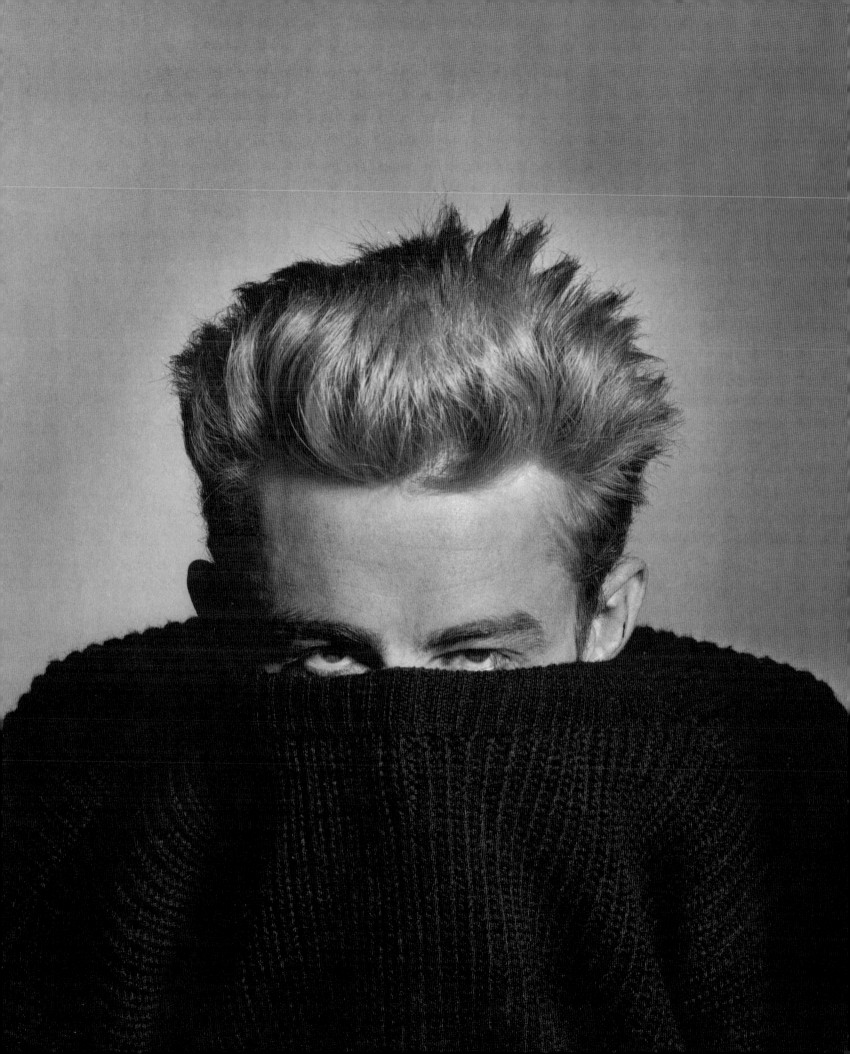

2, 3 Dean in Times Square, New York
Dennis Stock, 1955

A vintage print (fig.3) together with Stock's annotated
contact sheet (fig.2) puts the frame in its context.
Though the moment belongs to Stock, Dean could not
resist his own idiosyncratic contribution: the cigarette
dangling from his open mouth parodied the jacket
photograph to a paperback he was then reading, a
portrait of the existentialist author Albert Camus. In the
1990s Stock's masterful portrait hung in Times Square
in a form scarcely imaginable to its subject, a giant-sized
multi-storey billboard dominating the mid-town skyline.
When it first appeared in *Life* magazine (7 March 1955),
the accompanying caption was insightful: 'His top floor
garret on Manhattan's West Side is no more home to
him than the farm in Indiana. But he feels his continuing
attempt to find out just where he belongs is the source
of his strength as an actor.'

3

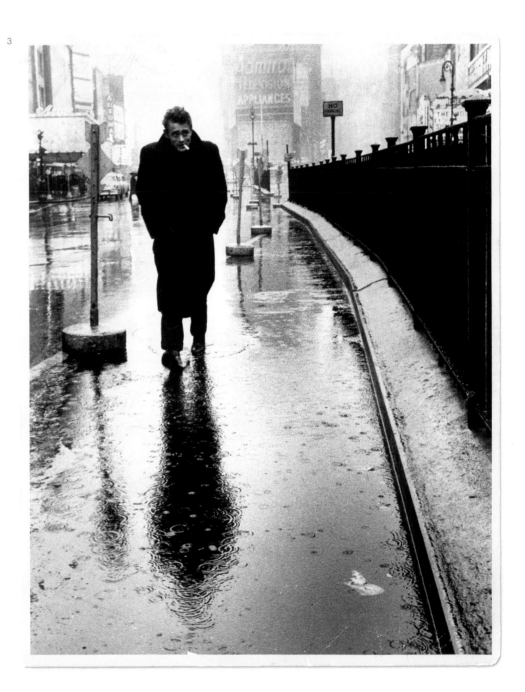

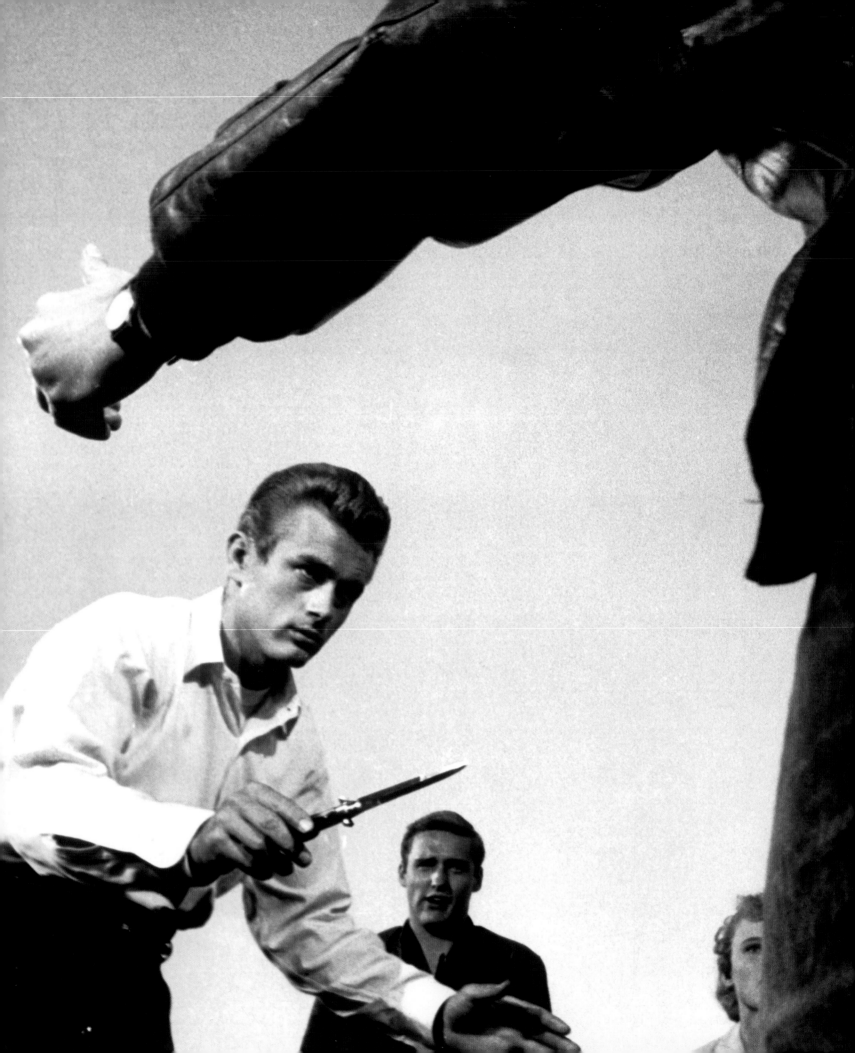

James Dean's career was in its ascendancy. Advance publicity for *East of Eden*, his first starring role, billed him as the most exciting actor to hit Hollywood since Marlon Brando. When the film opened in March 1955 he was the focus of attention that had become hysterical. Marilyn Monroe, Marlene Dietrich and Eva Marie Saint attended the première in Los Angeles. Its star, who found the acclaim and adoration disturbing, did not.

The director of *East of Eden* was Elia Kazan, of whom it was claimed there was no finer director in Hollywood and, as important, no surer eye for talent. Having secured the reputations of Brando and Montgomery Clift, he now singled out James Dean. As he would tell any studio executive who would listen, 'You're going to meet a boy; he's going to be very strange to you and he's going to be different. No matter what you see or what you think of him, when you see him on the screen, he's gonna be pure gold ...'

Warner Brothers, to whom Dean was under contract, leaked to the press that he would appear in *Somebody Up There Likes Me*, the biopic of boxing legend Rocky Graziano made by Metro-Goldwyn-Mayer. To insiders this was firm evidence of a quid pro quo, as MGM had allowed Elizabeth Taylor to appear in the forthcoming Warner feature *Giant*. These insiders would not have been slow to recognise that Dean, unheard of a year previously, was now considered the equal – at least in trade-off terms – of one of Hollywood's biggest draws. In the meantime, Dean had started principal filming on *Rebel Without a Cause* in Los Angeles (fig.4), which continued until the summer of 1955. Back-to-back with that came *Giant*.

He found time for two off-set diversions, one more distracting than the other. He started a romance with a young Swiss-German actress, Ursula Andress, which flickered briefly, and continued a passion for racing in a Porsche Speedster, acquired in March. He had come second in a road race in Palm Springs and during the filming of *Rebel* came third at Bakersfield, California. Before *Giant* he had time for one more race, at Santa Barbara, and came from nowhere to fourth when his engine seized and he withdrew. Insurance conditions strictly excluded him from race participation during filming, but in anticipation of the completion of *Giant*, he ordered a Lotus. While awaiting delivery, Dean came across and bought a Porsche 550 Spyder, one of only five in the United States, part-exchanging the Speedster. He nicknamed it 'Little Bastard'. Two days beforehand, he made his last screen appearance, a public service broadcast commissioned by The National Safety Council in an effort to promote road safety to the young.

Dean had entered the Spyder in a race at Salinas, 350 miles north of Los Angeles, due to take place two weeks later on 1 October 1955. Intending to tow the car to the race track, at the last minute he changed his mind and decided to drive it there himself. His mechanic, Rolf Wuetherich, joined him in the passenger seat. Following them in a station wagon would be two friends, Bill Hickman and Sanford Roth, a talented photographer. Roth was in the final stages of completing a photo-essay on Dean for *Collier's* magazine. It began on the set of *Giant*; the race at Salinas would be its high point. As dusk closed in on the eve of the race, the silver Porsche had a near miss with a Pontiac on the outskirts of the town of Cholame (earlier in the day Dean had been issued with a speeding ticket). Perhaps as much as a minute later, a Ford Tudor turned into Dean's lane and the two cars collided. Wuetherich was thrown clear but Dean died of multiple injuries at the scene. As Hickman, ambulance men and the Pontiac driver all absorbed what lay before them, Sanford Roth instinctively stepped back and began to take pictures of the carnage. For most of his short adult life, James Dean was subject to the scrutiny of the camera. It seemed somehow fitting that it should be present to record his abrupt death (fig.15).

5

5 Dean on the Set of *Has Anybody Seen My Gal?*
Unknown Photographer, 1951

Douglas Sirk's lightweight musical comedy featured Dean in an eye-catching bit part as an irritating soda fountain customer. Enough Dean trademarks were in place to prompt one critic to claim, 'For a moment it was as if the Wild One had invaded Toytown.' It was not a genre Dean revisited.

Opposite
4 Still Photograph from Filming of
*Rebel Without a Cause* (detail)
Dennis Stock, 1955

Much of the knife fight scene in *Rebel Without a Cause* was cut from the final version. The film itself was released after its star's death, which gave rise to an unpalatable, if unique, situation for Warner Brothers: the actor playing the character with whom the target audience was intended to empathise was, by then, dead.

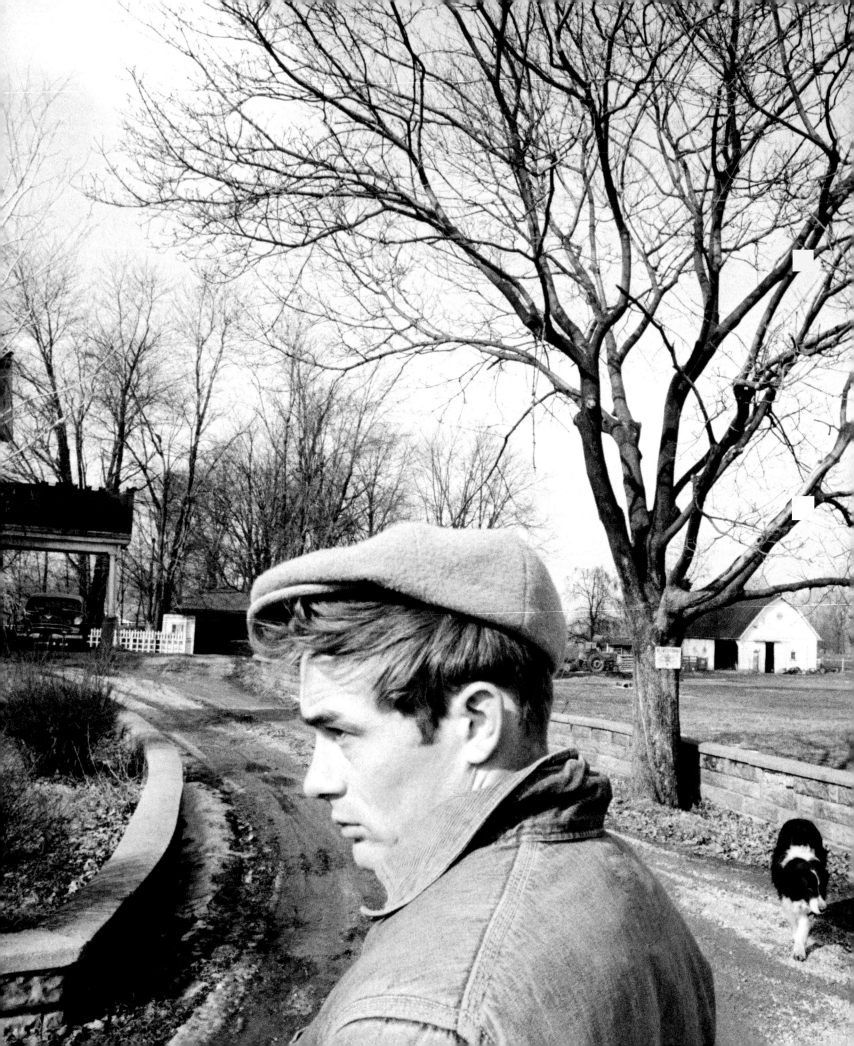

7 Dean in the High School Baseball Team Photograph
Unknown Photographer, c.1946

By the time Dean reached high school he was an
athlete of considerable ability, excelling in basketball
and baseball (here pictured front row, centre).
He confided to friends that his strong competitive drive
was fostered by his mother's death, a desire to prove
that he was a son worthy of her and that she had been
wrong to 'leave' him. His abilities were tempered by poor
eyesight, contributing to a failed schoolboy stunt with a
trapeze, which removed his front teeth.

Opposite
6 Dean Revisits his Uncle's Farm, Fairmount, Indiana
Dennis Stock, 1955

In 1955, having finished *East of Eden*, Dean returned
to Fairmount, Indiana and the farm of his uncle
Marcus Winslow where he had been brought up.
Dean had been despatched to the farm from Los
Angeles, as an only child, by his father on his mother's
death. The collaboration between Stock and Dean
for *Life* magazine (March 1955) was intimate and
revealing. This trip to Fairmount, where he felt he had
been happiest, would be Dean's last journey to what
passed for 'home'.

8, 9, 10, 11 Dean in Hunt's Funeral Parlor,
Fairmount, Indiana
Dennis Stock, 1955

Stock kept back from *Life* several snapshots taken on
the Indiana road trip. There was one location Dean
appeared particularly drawn to: Hunt's Funeral Parlor in
Fairmount. Here, in a series that might conceivably have
been construed as tasteless, Dean clambers in and out
of a casket. All the more *guignol* in the light of events a
few months away.

Stock and Dean had left for Fairmount on their assignment for *Life* magazine in early
February 1955 (fig.6). As Stock recalled:

*For Jimmy it was going home. But it was also the realisation that the meteoric rise to
fame that had already begun … had cut him off forever from his small-town Midwestern
origins, and that he could never really go home again. Still in those bitter-cold, late-
winter days, as Jimmy and I roamed the town and farm and fields of Fairmount, visiting
family and friends, I came to know, or at least glimpse, the real James Dean.*

But Dean's insistence that he should be on the cover of the magazine nearly curtailed the
assignment. Stock considered the stipulations 'foolhardy' and 'egocentric' but persevered.
Though *Eden* was predicted to be a huge hit, Dean was still as good as unknown to *Life*'s
considerable readership. When Stock's photo essay appeared in the magazine in March
1955, the cover image was instead a giant golden Buddha.

In roll after roll of 35mm film, Stock captured with a studied lack of formality the
vulnerability that lay at the heart of a contradictory figure. They visited a motorcycle repair
shop and the local cemetery, finding the tombstone of his great-grandfather engraved 'Cal
Dean' (Cal Trask was his *East of Eden* character). They visited Dean's grandfather, fed the
cattle, and walked the length of muddy fields where, to an audience of farmyard animals,
Dean played his bongo drums. Later, at the Sweetheart's Ball held on Valentine's Day at
his former high school, he signed autographs, amazed that his reputation had preceded
him. He sat in his old classroom, now deserted, and mounted the school stage where he
had made his first entrance. He had been an accomplished athlete, a member of the
baseball team (fig.7) and, for a time, he held the school's pole-vaulting record. These
vignettes from a rural life, taken *en plein air* in natural light, were in striking contrast to
what habitually passed for a celebrity lifestyle. Stock's two-month odyssey set a
benchmark in the depiction of Hollywood film stars. As Dean articulated it:

*I don't think people should be subservient to movie idols … I would like to be a star
in my own sense. I mean to be a very consummate actor, to have more difficult roles
and to fill them to my satisfaction. But not to be a star on the basis of gold plating.
A real star carries its own illumination, an inward brightness.*

One series of tableaux, in a location to which Dean was particularly drawn, remained unpublished for over thirty years. Stock did not reveal them at the time to *Life*, in case they were construed as morbid, disrespectful or tasteless. In Hunt's Funeral Parlor, Stock photographed Dean climbing into, and then recumbent in an open casket (figs 8-11). The idea was entirely Dean's and survives as an example, perhaps, of his recognition that with careful manipulation, photography could preserve the image he wished to present to the world, no matter how eccentric or misjudged. He was as keen as Stock to create a different canon of film star imagery. In striving to break away from the conventional ideals of masculinity, he intended to be a new kind of Hollywood hero. And inevitably this set of pictures, when eventually released, assumed an even greater resonance. But at the time they had a more personal significance. The first time Dean travelled from Los Angeles to Fairmount, a journey of some 2,000 miles, was as a child in traumatic circumstances in 1940. He accompanied his mother's coffin on her final journey back to Indiana. With each stop the train made, he leaped out of his seat to ensure that the coffin was still aboard. Her death was a loss he never quite overcame. On 8 October 1955 he was buried beside her, his body having lain for a short while in a closed casket in Hunt's Funeral Parlor.

Stock's assignment represented the culmination of years Dean spent nurturing a new persona. To him an appearance in *Life* was proof that he had 'arrived'. *Life* had America's largest magazine readership and highest circulation. Bigger even than television, an appearance in its pages would establish Dean with a mass audience. To this end, in New York in February 1954 (the year before Stock's commission), he had asked Roy Schatt, a photographer well known to *Life*, to take some shots of him and submit them to the magazine: vignettes of his domestic life, in and around the streets of Manhattan, in bars and diners, playing his bongos. *Life*'s editors liked them but not enough to publish them. Instead they told Schatt to return with pictures that showed 'a more masculine side' to the young unknown (figs 12-14). On the day of the retakes, 29 December 1954, Dean had neither shaved nor, it would appear, slept much. Dark circles ringed his eyes and he had calculatedly worn an old and fraying sweater. The photographs Schatt took, known from then on as the 'Torn Sweater' series, showed Dean exactly as he had wanted to be

12

13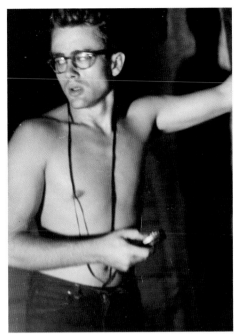

14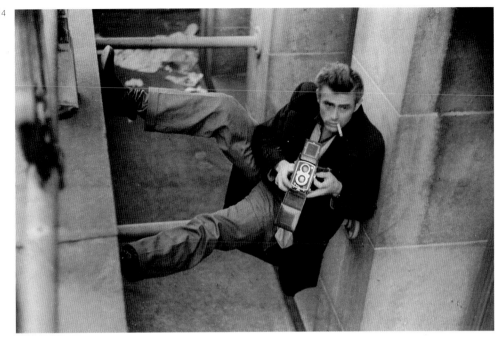

12, 13, 14 James Dean in New York
Roy Schatt, 1954

Roy Schatt's photographs of Dean – he tried to interest
*Life* magazine in a photo story – revealed the actor
precisely as he wished to be seen, almost as if he was
directing his own *mise-en-scène*: by turns heroic,
brooding, reflective and sexually alluring. With Schatt
and Dennis Stock as tutors, Dean attempted to take
his own often highly idiosyncratic photographs, the
camera angled off-kilter for a more dramatic effect.
His friend (and frequent subject) Martin Landau recalled,
'It was as if he was directing little pieces of theatre'.

represented: brooding, oddly heroic and unavoidably sexual. They appeared as
spontaneous snapshots, but, in truth, were artful arrangements by the subject himself.
As Roy Schatt recalled: 'We were doing this series of portraits and suddenly Jimmy said,
"Wait a minute, I want to try something". He turned his head to the left and looked down.
I asked him what the Hell he was doing … it was such a strange pose. And he said:
"Don't you see, I'm Michelangelo's David".' *Life* refused the pictures. The attempts of
Dean and Schatt at a more masculine representation resulted in an unpalatable amalgam
of the aggressive, the reflective and the suspiciously homoerotic.

With Roy Schatt and Dennis Stock, Dean had refined the essentials of photographic
technique. Dean's own photographs, often oddly composed and taken at a low level for
greater impact, revealed a keen sense of the dramatic. His favourite theme was himself.
Elia Kazan recalled that during the filming of *East of Eden*, Dean had acquired a camera
and could be glimpsed standing in front of a mirror endlessly taking self-portraits, one
exposure barely different from the next. The photographer Frank Worth, who memorably
observed that Dean 'never had the time to destroy his image', also noticed that when
presented with a selection of shots, Dean took great care to suppress those that
conflicted with his desired self-image.

The most apposite valediction to James Dean is not the Porsche Spyder, damaged
almost beyond identification and recorded by Roth's coldly observant lens just one year
later. Instead, it belongs to Roy Schatt and Dennis Stock, whose photographs more than
any others fixed the features of James Dean in the minds of his generation and those to
come. Dean did not allow himself the time to grow old, lose his looks or make a
disastrous box office impression. In just three major films he had managed to entrance a
generation and, when *Rebel Without a Cause* opened a month after his fatal crash, his
following was greater in death than that of any living contemporary actor. He never made
the cover of *Life*, though in 1956 he appeared in its pages three months in succession.
The second feature reported the 'Delirium over a Dead Star'. The delirium has continued
for half a century and the image of James Dean remains a shorthand motif for alienation,
disenchantment and a rebellious independent spirit.

15 The Wreckage of 'Little Bastard'
Sanford Roth, 1955

Dean died from multiple injuries at the scene of a
collision with a station wagon, near Cholame. His friend,
the mechanic Rolf Wuetherich, was thrown from the
passenger seat and survived. Following Dean's Porsche
550 Spyder, nicknamed 'Little Bastard', were two other
friends, Sanford Roth and Bill Hickman. The former,
a photographer, was trailing Dean to a road race at
Salinas on a commission from *Collier's* magazine.
As the tragedy of 30 September 1955 unfolded, Roth's
professional instincts took over. James Dean, in his
short life, had become used to the attention of
photographers and had encouraged their presence
on numerous occasions. It seemed fitting, if shocking,
that one should be there to record his final moments.

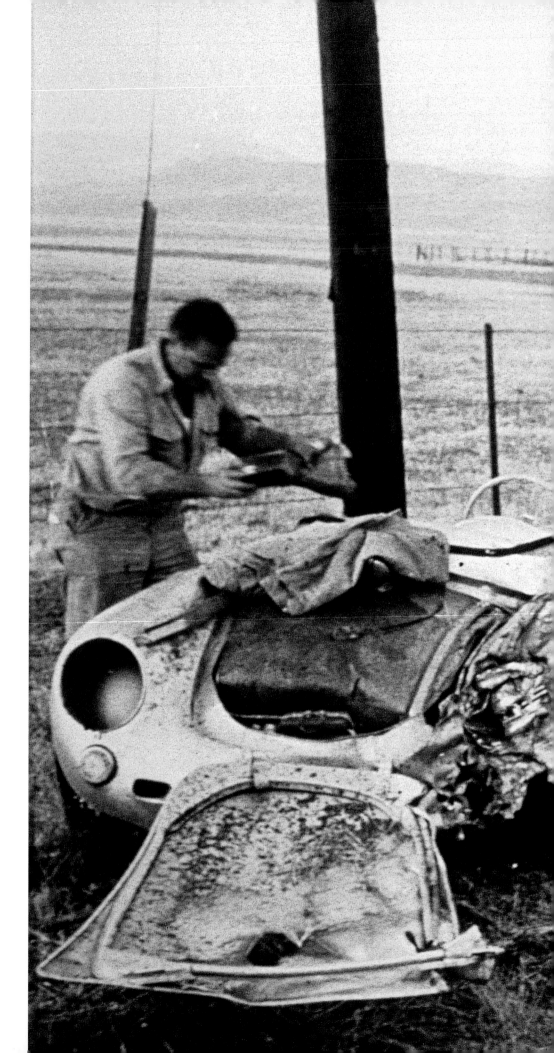

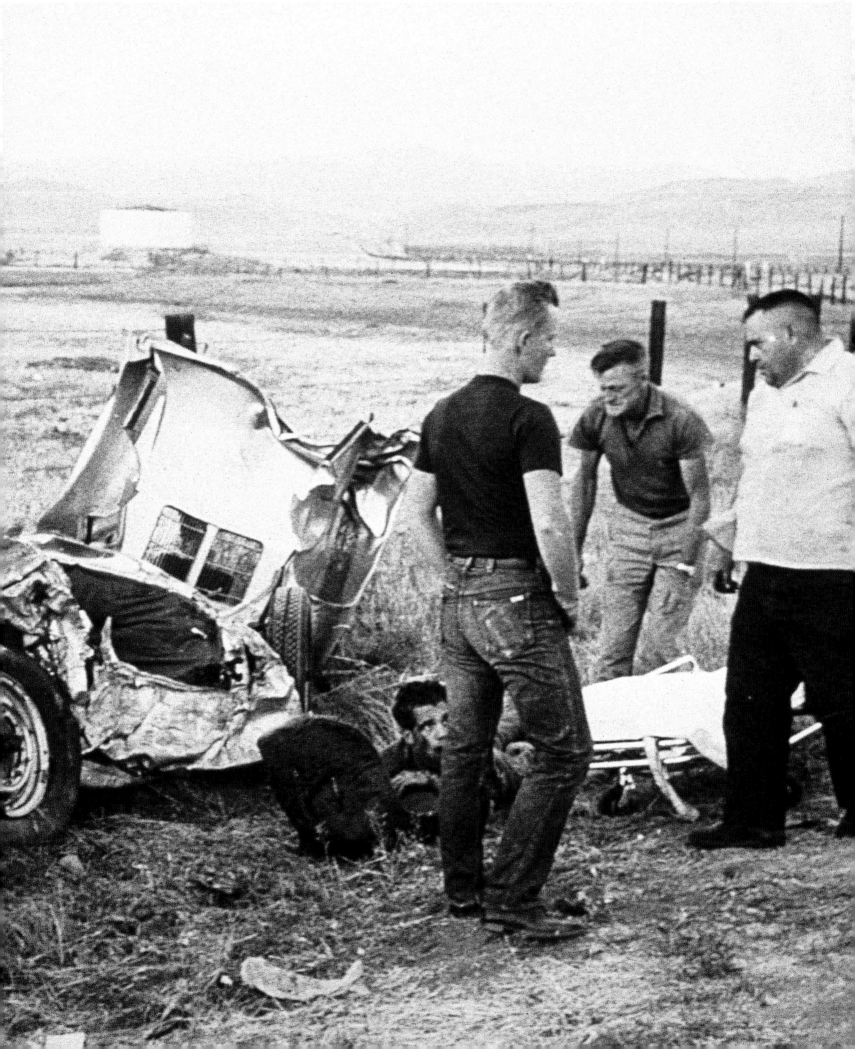

9  Elvis Presley

## Elvis Presley (1935–77)

1935  Born Elvis Aaron Presley on 8 January
      in Tupelo, Mississippi

1955  Signs recording contract with RCA Victor

1956  His provocative dancing on the
      *Milton Berle Show* causes scandal;
      his first film *Love Me Tender* opens and
      Elvis becomes a household name

1957  Buys the plantation house Graceland,
      which becomes his Memphis home

1958  Receives draft notice into US Army but
      returns home upon his mother's death

1967  Marries 21-year-old Priscilla Beaulieu

1969  Daughter Lisa Marie is born

1971  Receives Lifetime Achievement Award
      from the American music industry

1973  Television special *Aloha from Hawaii* is
      viewed by one billion people worldwide

1977  Dies of heart failure on 16 August
      at Graceland

Opposite
1 Elvis Presley at the Warwick Hotel, New York
Alfred Wertheimer, 1956

In 1956, aged twenty-one, Presley had reached what
would be the halfway point in his short life. That year also
represented the last time that Colonel Tom Parker,
Presley's manager, would allow him to be photographed
without supervision. Alfred Wertheimer, who took almost
4,000 photographs of Presley, was able in the space of
those twelve months to photograph him with a degree of
intimacy that would be henceforth denied. He found
Presley the perfect subject, oblivious to the camera and
possessing an intuitive belief in his own importance.

On the evening of 4 March 1959, Elvis Presley walked into uncharted territory: a low-rent strip joint in Munich, the Moulin Rouge. Had his manager known, he would have forbidden it unquestionably, but he was back home in America and powerless to prevent his charge from doing whatever he pleased – including destroying his carefully crafted public image. Elvis Presley was undeniably photogenic, but no unapproved photographs had been taken of him since 1956 and his meteoric rise to fame. In a few short years his image had been assiduously invented, re-invented, refined and promulgated by an efficient publicity machine. His manager had thrown a ring of steel around him, personally granting and withdrawing access to the star with a hawk-like intensity. The real Elvis Presley was as remote to his adoring public as the constellations of the solar system and he twinkled back to them from another world, which, as official photographs showed, became increasingly populated by teddy bears, puppy dogs and colourful Hawaiian shirts.

But in 1959 Presley was a draftee in the care of the United States Army. Its rules may have been only mildly stricter than those the 24-year-old singer had come to know under his manager, the self-styled 'Colonel Tom Parker' (both name and rank were spurious). The Colonel, who had by now ensured that he was Presley's sole representative, was a former carnival huckster turned small-time show business promoter. While Presley was born and bred in America, a scion of the Deep South, and had never left his homeland until his induction, America was not technically home to the Colonel. As an illegal immigrant, born in one of the Low Countries of Europe (his birth certificate gives Breda, 1909 as his place and date of birth), he could never have followed his protégé from America to Germany, even if it had been sanctioned, as he would not have been allowed back into the country.

The Colonel would have been apoplectic had he known that the Moulin Rouge had its own in-house photographer, Rudolf Paulini, whose snapshots of its principal clientèle – strippers, dancers, prostitutes and drunks – lined the club's walls. That night Paulini's lens captured an unguarded and increasingly uninhibited Presley. Actresses, showgirls and lavatory attendants queued to have their picture taken in the arms of the greatest rock 'n' roll star in the world. In the unflattering glare of Paulini's flashgun, Presley's slicked back hair and self-confident grin were gone. He stood in the midst of his new circle of winking, leering friends like a rabbit caught in the headlights, unsure of his next move, unmistakably 'real'. These snapshots of Presley in a sleazy club in southern Germany were a million miles away from the Colonel's artfully constructed image. It was, perhaps, a glimpse of an all-American hero that Middle America was not yet ready for.

Elvis Aaron Presley, born in Tupelo, Mississippi and raised in Memphis, Tennessee on gospel and black rhythm and blues, was an overnight success with his first single, 'That's All Right', for Sun Records. In June 1954, it was played in a seemingly endless rotation on radio stations all over the Southern states. The following month, photographer James

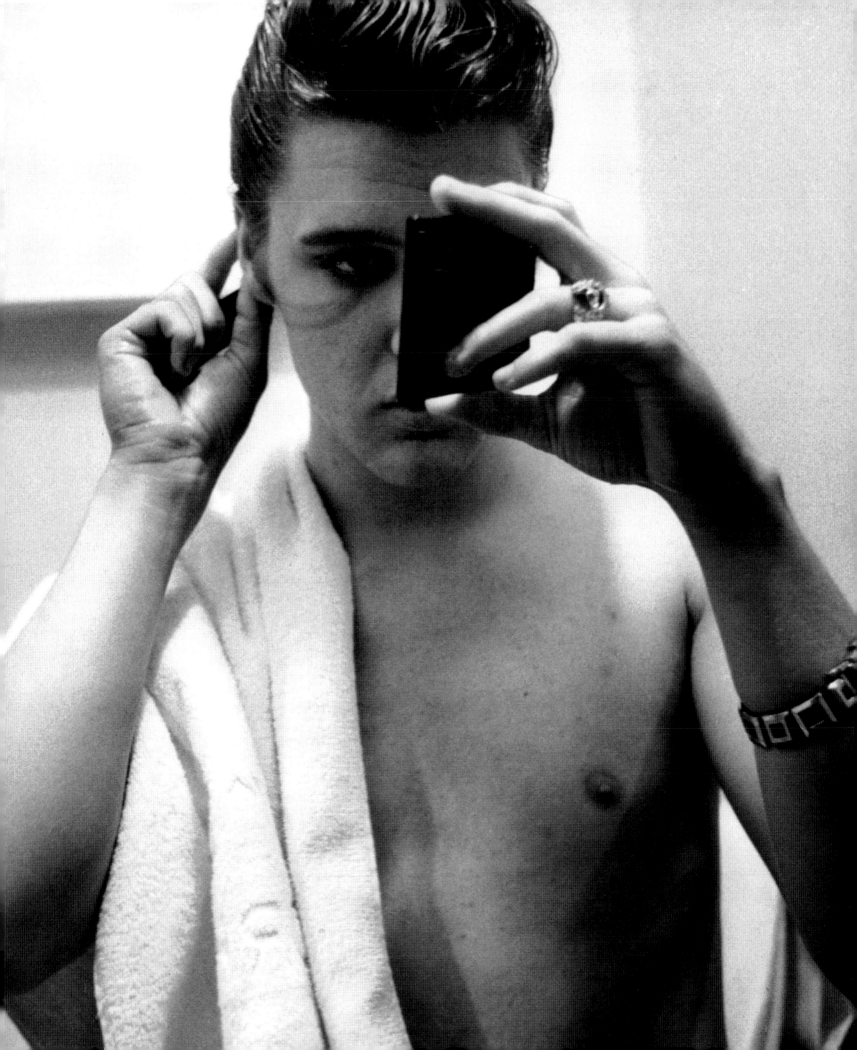

2 'Who the Hell is Elvis Presley?'
Main photograph attributed to William V. Robertson, 1955

The question posed by *Cabaret* magazine in August 1955 was answered by the end of the year, a momentous one for the singer. His records spent half the year at number one, selling 12.5 million singles. Pre-orders of 'Love Me Tender' reached a record 900,000. By Christmas he had ten songs in the Billboard Top 100 and his first film (also entitled *Love Me Tender*) was released. By May he had become RCA's biggest-selling act. The summer had seen a whistle-stop tour of the Midwest, California, and the Southern states of the Carolinas, Georgia and Virginia – and a furore over interpretations of his body movements on the *Milton Berle Show*.

Reid was assigned to trail the local star for a Memphis newspaper, taking photographs of the as yet unrefined 'Hillbilly Cat':

> When I first set eyes upon Elvis I thought what a pitiful looking fella. His face was pockmarked, his hair was in some sort of 'ducktail' and his clothes were ill-matched and scruffy. I had photographed a number of budding young singers and was expecting someone more properly attired … Elvis was so shy he wouldn't even look at the camera.

Presley's popularity grew throughout the following year, his idiosyncratic singing voice all but drowned out by the screaming of febrile teenagers in response to his bodily gyrations. By the end of 1955, he had met the Colonel (fig.10), who would in a similarly short time manoeuvre himself from hustling bearded ladies to sitting around the boardroom tables of record companies and film studios. He was the consummate entrepreneur, a brilliant strategist, marketer and scam artist. In the raw and undisciplined Elvis Presley he saw a malleable commodity and a gold mine. For the unprecedented sum of $35,000 he arranged for RCA Victor to buy out Presley's deal with Sun Records. Apart from his financial acumen, the Colonel was far-sighted in his attention to publicity. He understood perfectly the part photography would play in the creation of Presley's stardom. A 'hillbilly' primitivism slowly but irrevocably yielded to a scrubbed-clean, colour-saturated image. In his early publicity stills Presley was moulded for all tastes: saint and sinner, snarl-lipped outlaw, Byronic dreamer, choirboy, romantic prince, animal lover, little-boy-lost and older brother (figs 11-14).

A mass of clichés, the unpin-down-able look of Elvis Presley was designed to take him as far as possible from his small-town roots. In 1956 he left it all behind in what was by any stretch of the imagination a remarkable year. He spent twenty-six weeks at number one in the charts, selling 12.5 million singles and nearly 3 million albums in the United States alone. His first RCA session yielded the seminal 'Heartbreak Hotel' and in March his first album was released. In April the Colonel bound him to a film contract with Paramount Pictures. By May he was RCA's biggest-selling act. In June he caused a

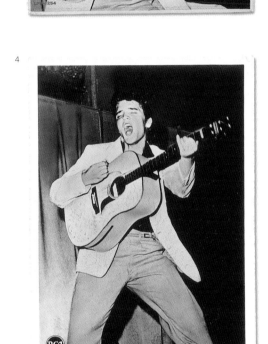

Elvis Presley

Foto: Teldec                    Rudel-Verlag

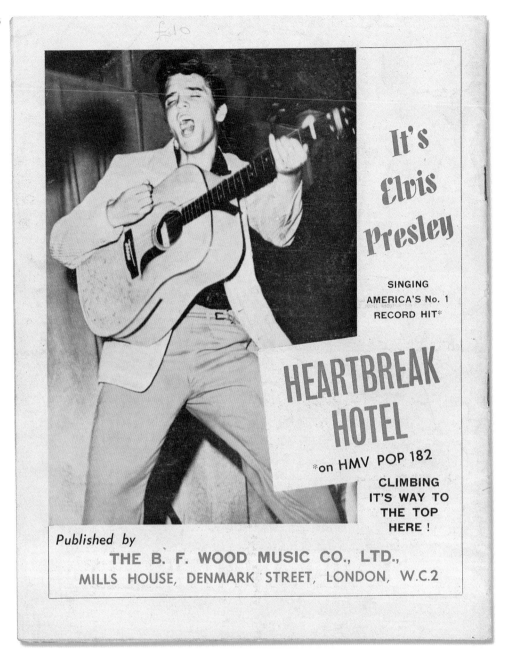

3 *Elvis Presley* Album Cover
Attributed to William V. Robertson, 1955

4 Postcard
Attributed to William V. Robertson, 1955

5 Back Cover of *Hit Parade*, June 1956
Attributed to William V. Robertson, 1956

One of the most famous images of Presley (and one of the most widely disseminated) remains shrouded in mystery, its origins, according to the writer Greg Williams, 'as fuzzy as the green shag carpet in the Jungle Room of Graceland' (figs 2-5). It is now believed to have been taken in Tampa, Florida in July 1955 during a concert at the city's Fort Homer Hesterly Armory by William V. 'Red' Robertson of the local firm Robertson and Fresh. Presley had appeared there before, as the finale to a Hank Snow concert, where he nearly caused a riot and confirmed Colonel Parker's prediction that he would become 'the biggest thing in showbusiness'. Robertson's image, selected by the Colonel for one of the most iconic album covers in music history, Presley's first album *Elvis Presley* (fig.3), was wrongly credited on the back to William 'Popsie' Randolph.

7 Presley before a Show at the Fieldhouse,
University of Dayton, Ohio
Marvin Israel, 1956

In spring 1956, on assignment for *Seventeen* magazine,
the writer Edwin Miller and the photographer Marvin
Israel reached Dayton, one of the last dates in a gruelling
tour for Presley and his band. They had travelled from
Little Rock to Kansas City to Detroit to Los Angeles
and Las Vegas to Waco, Amarillo, San Antonio and
many other towns and cities in between. Israel seemed
more conscious than many of the graphic possibilities
that a more considered approach to the Presley
phenomenon might bring.

7

Opposite
6 Elvis Presley in a Motel Room, Las Vegas
Unknown Photographer, 1956

Photographers followed Presley's every move, on
occasions even back to his motel room, capturing
unguarded moments that the Colonel would not have
sanctioned. This contact sheet remains unattributed
but it is evidence of a proximity to the star that would
scarcely be possible even a few years later.

media frenzy with his suggestive body movements on the *Milton Berle Show*. The
summer saw a whistle-stop tour of the Midwest, California, and the Southern states of
the Carolinas, Georgia and Virginia. At the year end RCA released the single 'Love Me
Tender', pre-orders of which reached nearly 900,000. A 40-foot-tall figure of Elvis was
unveiled at New York's Paramount Theater at 8am on 15 November to mark the opening
of Presley's first film of the same name. It was the biggest stunt Broadway had yet seen.
By Christmas, Elvis Presley had made history with ten songs in Billboard's Top 100.

The halfway point in Presley's life – 1956 – also represents the last time, at least in
mainland America, that he would be photographed without the permission of his manager
(fig.6). The Colonel spent much of January negotiating Presley's first national television
appearances, leaving promotional details in the hands of his record company's publicity
department. On the eve of Presley's debut – on CBS Television's *Stage Show*, compèred
by the Dorsey brothers – RCA hired the photographer Alfred Wertheimer. It was his first
professional assignment for the company. Never having heard of the singer, Wertheimer
was indifferent but intrigued enough to accept. He found Presley backstage at the CBS
studios: 'The guy I'd never heard of was leaning back in a chair with his feet on the
make-up table, sporting argyle socks, silk shantung pants and jacket, black shirt, freshly
combed black hair and a sneer.'

Despite his early misgivings he found Presley a compelling subject and spent the day
with him, following him back to his hotel room and capturing unguarded moments that
the Colonel would never have sanctioned: asleep, half-dressed in front of a mirror, eating
(figs 1, 20, 21). He was the perfect sitter, oblivious to the camera and possessed of an
almost intuitive belief in his own importance and the need for these moments to be
recorded. And then, in front of a live audience and Wertheimer's lens, he sang, snarling
and gyrating in paroxysms of sexual energy. The reaction of the audience was unlike
anything the photographer had ever witnessed before (fig.8).

In time, Wertheimer would take almost 4,000 photographs of Presley, a remarkable
portfolio, the more so for its candidness and the fact that the Colonel did nothing to halt it
(Wertheimer was also surprised by the Colonel's perfect pronunciation of his Germanic
surname). His images were technically accomplished, taken in what he termed 'available

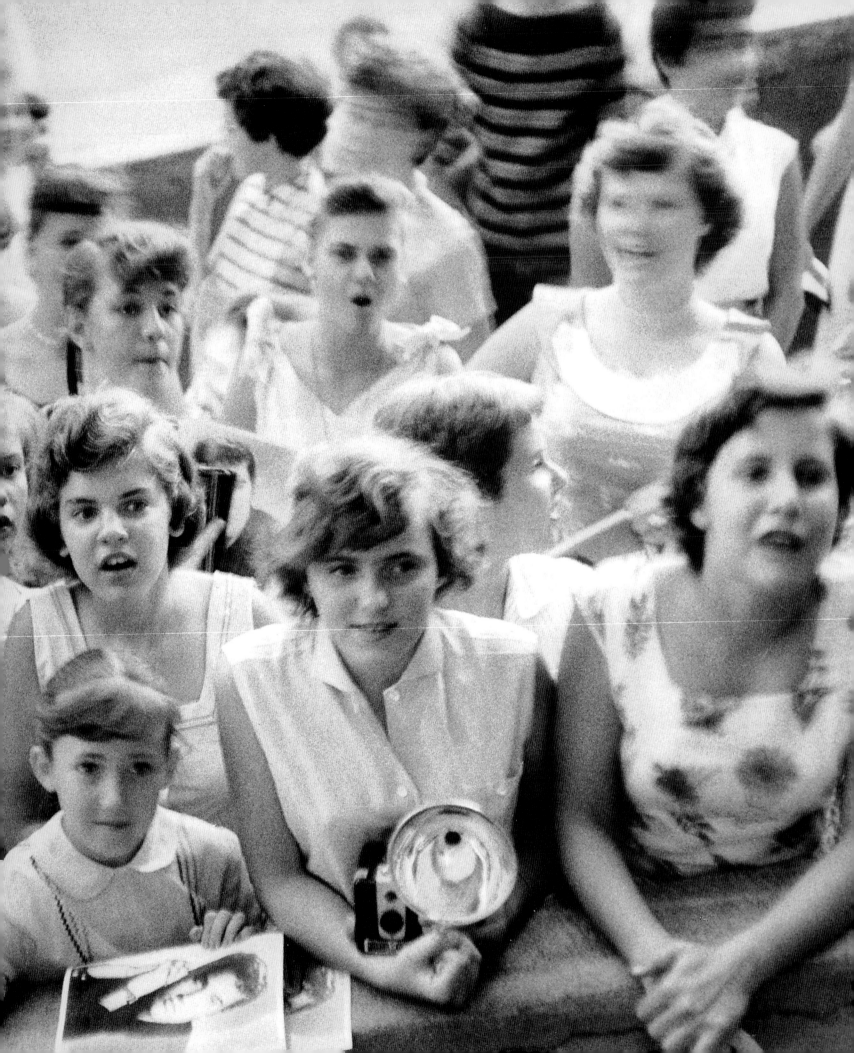

Opposite

8 Elvis Fans outside the Mosque Theater,
Richmond, Virginia
Alfred Wertheimer, 1956

Wertheimer recalled a Presley concert: 'The screaming came in waves, breaking at the extreme motion of his body. Someone shouted "Sing it boy!" and he did, unleashing such a convulsive reaction that I thought the ushers were going to have to carry people away. I had never seen anything like it before.'

9

9 Elvis during Rehearsal for a Show, Cleveland, Ohio
Lew Allen, 1956

Presley played Cleveland, Ohio in November 1956, two days after his first film *Love Me Tender* had opened. It was a sensation, outperforming the much-hyped *Giant*, a vehicle for James Dean, Elizabeth Taylor and Rock Hudson, and Dean's last film (he had died shortly after shooting it). In Cleveland, Lew Allen, a 17-year-old schoolboy, had hoped to take a few pictures of the star for his school yearbook. He had expected to be dwarfed by the throng of photographers eager to capture the now unstoppable Presley, whose gyrating stage movements had shocked the parents of teenagers from coast to coast. But Allen found that there were no other photographers there to record Presley's sound checks: Cleveland's newspapers were on strike and their photographers had simply not shown up. The schoolboy's snapshots, a few of which he sold on to classmates, were, like much of Alfred Wertheimer's *oeuvre*, rediscovered after Presley's death. Like Wertheimer just a few months before, Allen was present to capture the final moments of the 'real' Elvis Presley, appearing spontaneous and irrepressible for the camera.

10

10 'Colonel' Tom Parker and Elvis Presley
James Reid, 1956

Presley's sole representative was a former carnival
huckster turned small-time show business promoter
who styled himself 'Colonel Tom Parker'. By the end
of 1955, he had manoeuvred himself from hustling
bearded ladies to sitting around the boardroom tables
of record companies and film studios with one of
the great products of all time: Elvis Presley. In Presley's
unrefined state, he saw a goldmine. And he understood
perfectly the part that photography would play in
Presley's ascendancy.

Opposite
11 MGM Promotional Postcard
Unknown Photographer, c.1957

12, 13 MGM Promotional Postcards
Attributed to Virgil Apger, 1957

14 MGM Promotional Postcard
Unknown Photographer, c.1962

The Colonel ensured that after 1956 Presley's 'hillbilly'
sensibilities gave way to a new scrubbed-clean image.
The publicity machine of the Hollywood studios, first
Paramount and then MGM, consolidated the
transformation. The colour-tinted postcard image (fig.11,
top left) is from a session welcoming Presley to MGM;
the publicity stills (fig.12, top right; fig.13 below left) were
taken for 'Jailhouse Rock'; and in fig.14 (below right), his
hair is newly brushed forward for 'It Happened at the
World's Fair', released in 1963.

darkness', which invested them with an intimacy that would not be repeated by other
photographers. But in the autumn of 1956 the Colonel commandeered the RCA picture
archive. The majority of Wertheimer's images slipped his grasp as the photographer had
submitted only the token headshots required by the record company, the rest lying
undisturbed until Presley's death some twenty years later. By the end of 1956, with
Presley's sexual frankness at its most potent and overt, the Colonel's influence was at its
most pervasive and the access Wertheimer had enjoyed was now unthinkable. He had
captured moments perceived as indelicate, and from that point on the Colonel would be
present at all times.

One of the last assignments offered to Wertheimer was the recording of Presley's
triumphant homecoming to Memphis and his family. Here was unguardedness and
intimacy of a different kind: Presley collecting his clean washing from his ever attentive
mother, Gladys; splashing about in the pool with his father, Vernon (fig.20); tinkering with
his motorbike and playing records, mostly his own (fig.21).

Marvin Israel, who would become famous for his collaborations with Diane Arbus and
Richard Avedon, was also allowed to accompany the entourage on a self-motivated
assignment for *Seventeen* magazine. He had first photographed Presley on the singer's
mammoth spring tour, which he joined at Dayton, Ohio in May 1956. His photographs,
more polished and more consciously observational than most, revealed Presley with a wry
detachment. That they also possess pace and a graphic harmony is unsurprising as Israel
would later become an influential art director of *Harper's Bazaar*. Of his 500 carefully
contrived photographs, *Seventeen* published just two (fig.7). However, as the Colonel
started to open up commercial possibilities for Presley in other areas, simultaneously he
began to foreclose to the press. The gold mine had started to yield prodigiously. The
Colonel was working Presley's career like a million-dollar carnival sideshow. He had, for
example, assigned the singer's image to a toy manufacturer for seventy-two different
products from dolls to bubblegum wrappers. An appearance on the *Ed Sullivan Show*
attracted a barely computable 54 million viewers – around one in three Americans. In
something of a valediction, and with an irony that time would shortly reveal, Presley told a
home crowd of 14,000: 'Those people in New York are not gonna change me nothing –
I'm gonna show you what the real Elvis Presley is like tonight.'

After the Memphis homecoming Wertheimer was dispensed with. He was not alone.
The Colonel contrived to exclude all press photographers from Elvis Presley's life. There
would be no unsupervised access. One unanticipated exception was a 17-year-old
schoolboy with a large half-plate camera, who happened to be at the right place at the
right time: Cleveland Arena, on 26 November 1956, one of the final dates of Presley's tour
of Ohio and Kentucky. Lew Allen had hoped to take a few snapshots for his high school
yearbook with a camera given to him by a friend and working photographer. He had
expected to be shoved to the back of a seething pack of photojournalists, but to his
surprise not one had shown up due to a newspaper strike in Cleveland. He was not
intimidated by his unsought status (which led to lunch with the King of Rock 'n' Roll) and
produced vignettes that belied his tentative abilities. 'They seemed,' he recalled, 'to take
me seriously.' Backstage, he photographed Elvis clowning around (fig.9) and was later
allowed to photograph the concert from a vantage point on the stage itself. Like
Wertheimer, Allen was there to record the final moments of the 'real' Elvis Presley,
spontaneous and irrepressible, before his reconstruction by Colonel Parker and the
arguably mightier publicity machine of Paramount Pictures, Hollywood.

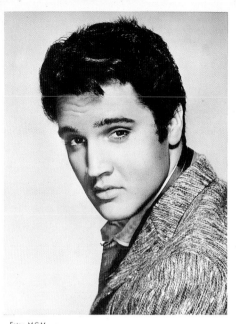

Foto: MGM

Elvis Presley

Ufa/Film-Foto                    Reproduktion verboten

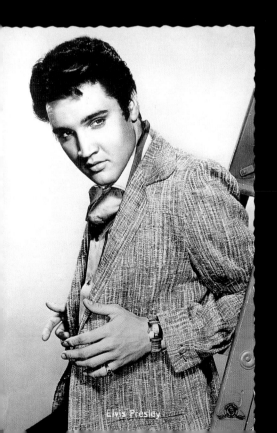

Elvis Presley

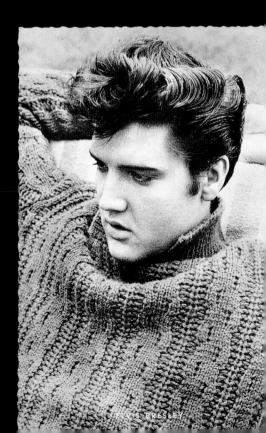

ELVIS PRESLEY

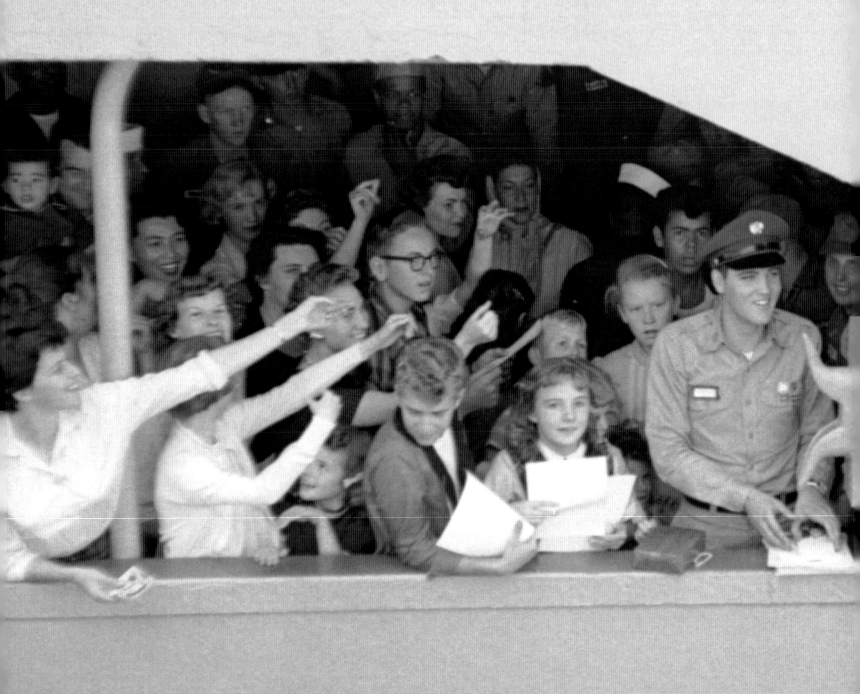

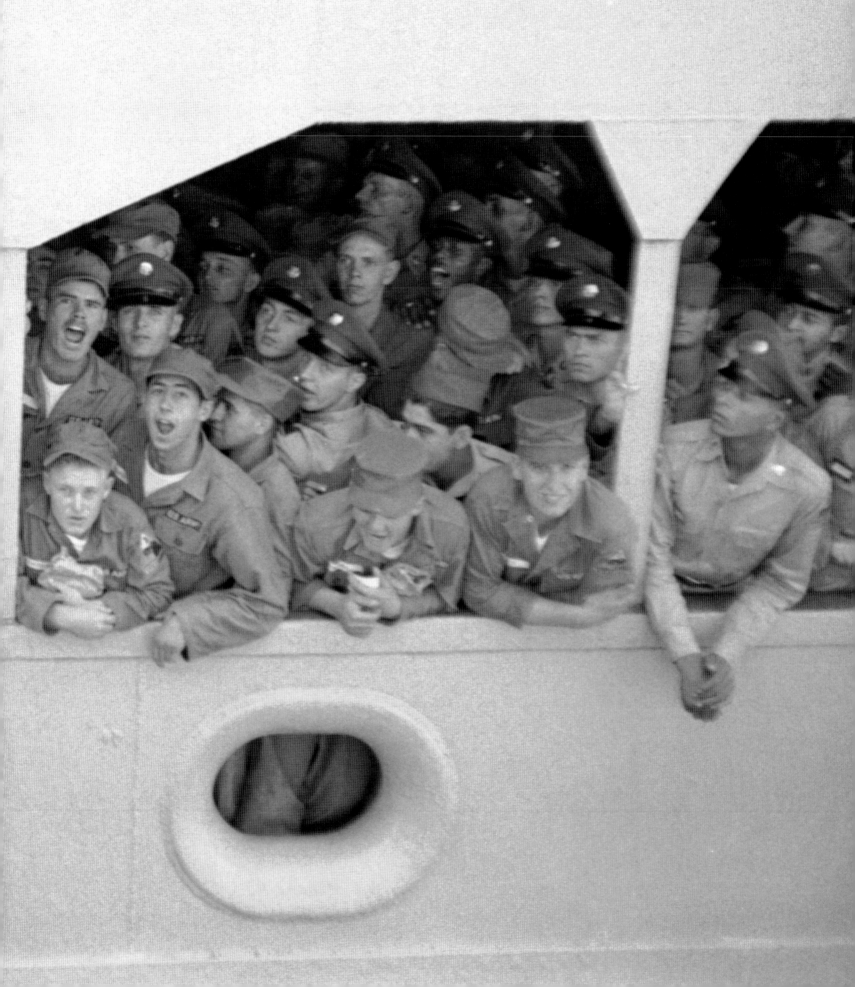

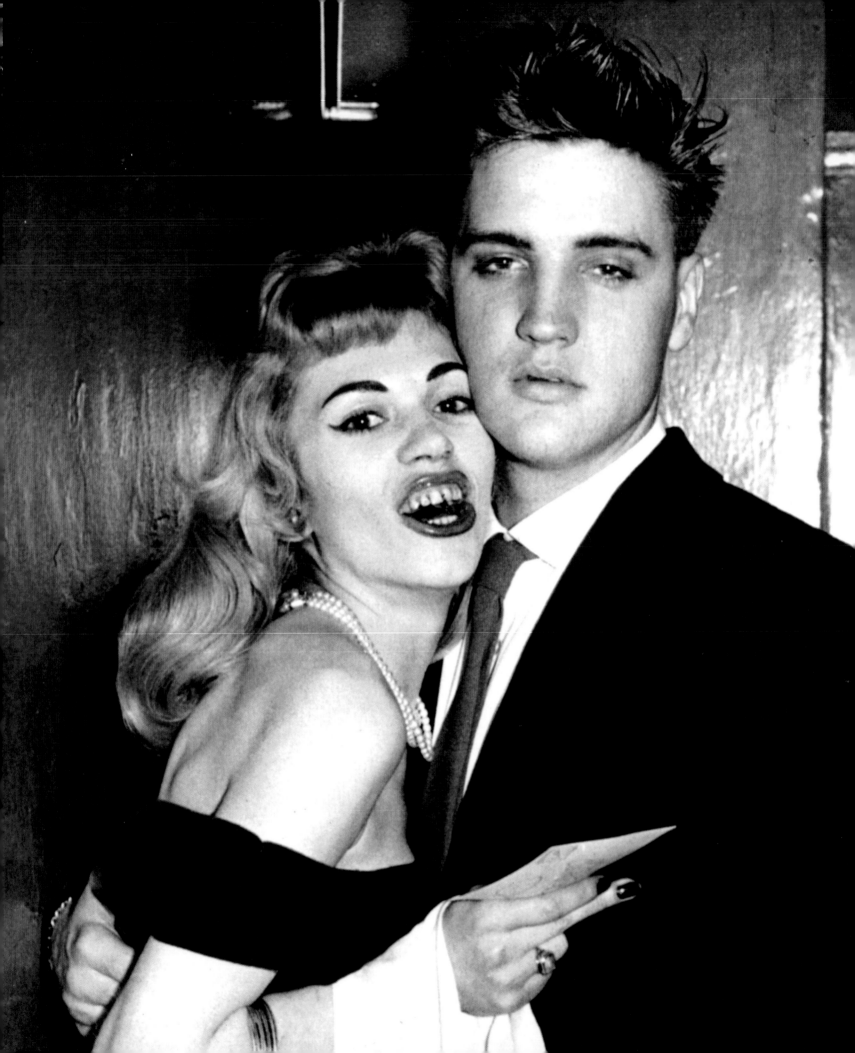

17 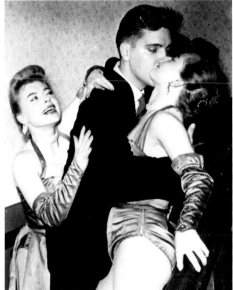 18 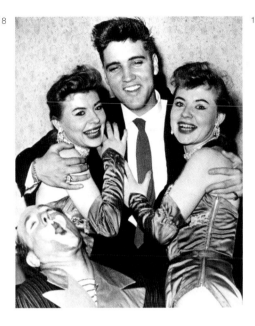 19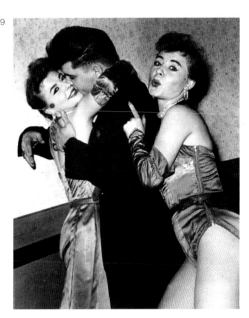

Preceding pages
15 Elvis Presley Leaving for Germany
Alfred Wertheimer, 1958

Presley's draft notice for National Service had been
served in 1958, but the Colonel stalled its full effect for
a year until film publicity and recording commitments
had been honoured. Presley's tour of duty would be
spent in Germany. It was his first trip abroad (he is seen
here at the point of embarkation in Brooklyn).

Opposite
16 Elvis Presley at the Moulin Rouge Nightclub, Munich
Rudolf Paulini, 1959

17, 18, 19 Elvis Presley at the Moulin Rouge Nightclub,
Munich
Rudolf Paulini, 1959

In the care of the United States Army, Elvis Presley was
returning to his unreformed state. In March 1959 he was
photographed in a Munich nightclub-cum-strip joint, the
Moulin Rouge. As he posed for the club's in-house
photographer, actresses, showgirls and lavatory
attendants queued up to have their picture taken with the
greatest rock 'n' roll star in the world. In the unflattering
glare of Paulini's flashgun, the Colonel's artfully
constructed image of 'Elvis Presley' seemed far away.

By the end of 1956 and the beginning of 1957, the more recognisable iconography of
Elvis Presley had begun to be formed. The new year augured an era of pink Cadillacs,
gold lamé suits, a jet-black luminescent hairstyle (dyed in order to photograph better) and
the memorabilia of toy hound dogs, perfumes and jewellery. After five more number one
singles, another multi-million selling album and two further box office hits, Presley
acquired his Memphis plantation house, Graceland. But barely a year later, Gladys Presley
died at the age of forty-six and was to lie in state within its increasingly grandiose walls.
The photographer James Reid, who had become a friend, was unaware of what had
occurred and had gone to Graceland with his camera, expecting a day of 'Elvis hanging
around and me taking some goofy shots'. Instead he found Elvis and his father on the
steps, inconsolable with grief. He took some photographs before being aware of a crowd
behind him. As might have been predicted, the Colonel had leaked the news of Gladys's
death to the press and had encouraged a number of photographers to assemble.

In January 1958 Presley's draft notice for National Service was served. The Colonel
contrived to stall its execution for a year until public relations and recording commitments
had been honoured. But to be seen to block it for much longer might have had a
calamitous effect on Presley's popularity. Parker therefore wound down Presley's live
appearances and public exposure in preparation for a break of two years. Presley's tour
of duty would be spent in Germany (fig.15) and he would return fitter and even more
clean-cut (the ducktail and quiff were early casualties). In return for Presley's word that his
conduct would be exemplary, the Colonel vowed that he would come back to America an
even bigger star than before. It was Presley's first trip abroad and the first time for more
than three years that he had been beyond the Colonel's direct sphere of influence.

In March 1959 he walked into the Moulin Rouge nightclub and promptly swapped
puppy dogs on his knees for showgirls, his airbrushed features for a harsh and dissolute
mask. As Presley's biographer Albert Goldman put it forcefully:

*A big baby-faced boy with short, unruly hair, dressed in ugly ill-fitting clothes, he allows
himself to be taken with every ugly hussy in torn net-stockings and sleazy sateen
leotard. As the dancers and hookers of this upholstered sewer entwine themselves
about him, flashing manic grins, Elvis offers himself up like a life-sized dummy …*

20

20 Elvis Presley with his Father, Vernon, Memphis
Alfred Wertheimer, 1956

Wertheimer captured an innocence in Presley before
everything started to unravel. His domestic vignettes
included shots of Presley splashing about in the pool
with his father Vernon, with whom he did not enjoy
a close relationship.

In defiance of the Colonel's wishes, Presley was returning to his unreformed state.
The reckless country boy was never far from the surface of the clean-cut American idol.
His minders had dissuaded him from singing along to the house band and had managed
to stop him signing autographs. But Presley did pose for Rudolf Paulini in over thirty
photographs with the flimsiest of promises that they would not be seen outside the club
(figs 16-19). Had they been released, this visual evidence of Presley's visit to a Munich
strip joint would have unravelled the Colonel's careful plans. Against all odds, the promise
was kept and a few of Paulini's photographs remained on the club's notice board, curling
and unremarked upon, for nearly twenty years.

On his return to America in 1960, Private Elvis Presley was officially and honourably
discharged. From then on, his career gained rapid momentum. Yet as John Lennon
famously remarked, 'Elvis died when he joined the army.' Throughout the rest of his life
the Colonel hustled him into a continuous cycle of bad movies, gruelling coast-to-coast
tours and residencies at Las Vegas, the huckster's Shangri-la. The movies became ever
more colourful and implausible, the concerts more elaborate and orchestral and the
attendant promotional activities – with midgets, elephants, cheerleaders and marching
bands – more absurd. His costumes began to parody, in gaudy rhinestones and sequins,
the country-and-western music of his Dixie home state (figs 22, 23), which, along with

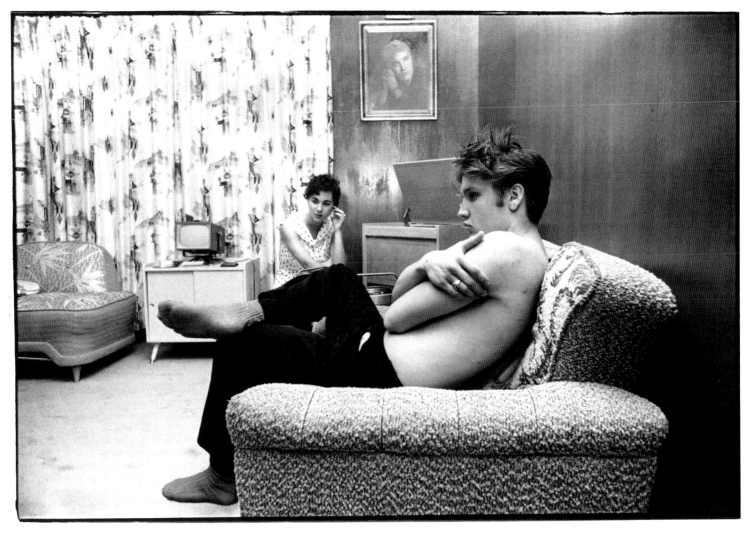

21 Elvis Presley and Barbara Hearn, Memphis
Alfred Wertheimer, 1956

One of Wertheimer's last sessions with Presley was back
home in Memphis, Tennessee. Here he listens to an early
pressing of 'Don't Be Cruel' with his high-school
sweetheart Barbara Hearn.

gospel and the Delta blues, he appeared rapidly to have left behind. The Colonel had
managed Presley's lucrative rise with panache but had in the process removed any
vestige of authenticity, naturalness or spontaneity. By the 1970s Presley was bored,
bloated, reclusive and unrecognisable to his public. By this time, it has been claimed, the
figure of Elvis Presley was the second most commonly reproduced image in the world
(the first being Mickey Mouse).

At his death of a heart attack on his bathroom floor in August 1977, aged forty-two, he
weighed over twenty-two stone and his bloodstream contained fourteen different types of
prescription drug. The end of the Presley story was as pitiful and tragic as its opening
was exhilarating. More than any other postwar American figure, he signified for too brief a
time that anything might be possible, that music suddenly mattered and that to be young
was to be in a state of grace. Wertheimer, Israel, Allen and Paulini had caught the truth
behind the legend, the exuberance and energy of Elvis Presley at his most touchingly
'real', when he was still within reach to the world and when life seemed full of the
intoxicating possibilities offered by a haunting snarl of a voice and a barely containable
sexual allure. As Thom Gunn memorably put it in 'Elvis Presley', a poem written in 1957:

> *He turns revolt into style, prolongs*
> *The impulse to the habit of a lifetime.*

22 Record Cover of *50,000,000 Elvis Fans*
*Can't Be Wrong*
Unknown Photographer, 1958

23 Elvis Presley's Gold Lamé Suit
Albert Watson, 1991

Presley's film and music career had earned him millions of dollars and his Southern lifestyle became increasingly opulent (two private jets, several pink Cadillacs and diamond-encrusted jewellery). His wardrobe, both personal and for live appearances, became increasingly gaudy from high-collared jumpsuits to gold lamé-threaded skin-tight stage wear. The gold suit, made by Nudie in 1957 for the cover of *50,000,000 Elvis Fans Can't Be Wrong*, is one of the earliest incarnations of a luridness that would in time become commonplace. His costumes began to parody, in rhinestones and sequins, the country-and-western music of his Dixie home state, which, along with gospel and the Delta blues, he so quickly left behind.

22

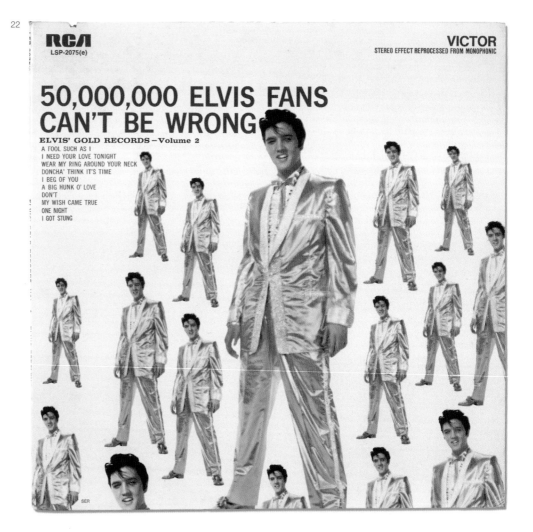

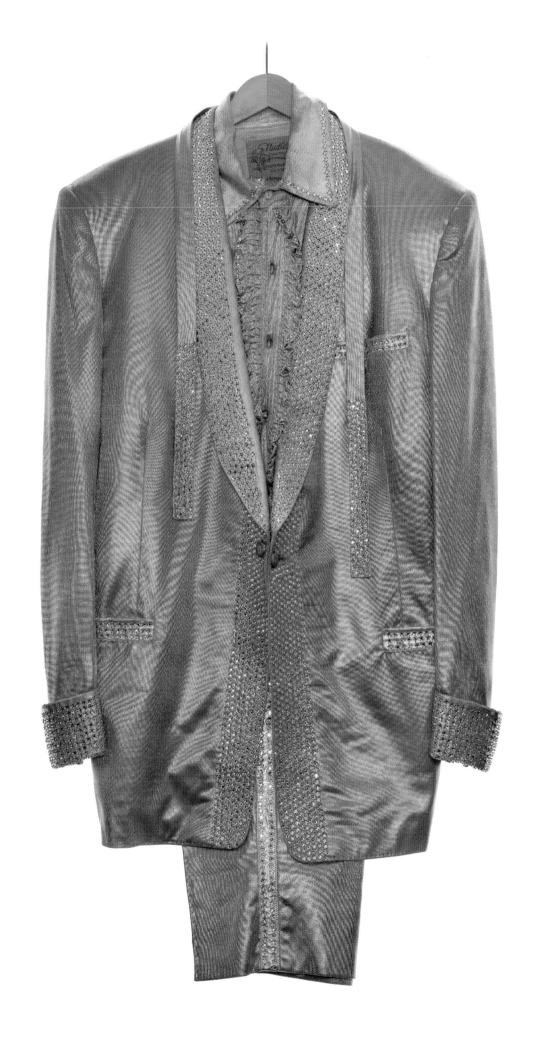

## Muhammad Ali (b.1942)

Opposite
1 Cassius Clay vs Cleveland Williams, Houston
Neil Leifer, 1966

One of the great sporting images of all time, taken with
perfect timing in complicated conditions 80 feet above
the ring of the Houston Astrodome. Ali's opponent was
a redoubtable one, having floored fifty-one of his previous
seventy opponents. Ali won in three rounds, flooring
'Big Cat' four times in the third. It was during this fight
that Ali introduced the now famous 'Ali shuffle'.

'Cleve stood there like a man wishing for a bus to hit him and it did – again and again.'
Thus the writer Mark Kram described the brutal encounter between Cleveland 'Big Cat'
Williams and Muhammad Ali on 14 November 1966 at the Houston Astrodome – a venue
which outdid even the combatants in sheer chutzpah: 'Welcome to the Astrodome,
Eighth Wonder of the World' was the greeting spelled out in flashing lights. The fight for
the world heavyweight title ended after one minute and eight seconds of the third round
(fig.1). Williams, at thirty-three years old, was almost a decade older than the champion.
He was also two pounds heavier and a shade shorter, but had a reach calculated at
one inch more. He possessed a formidable record too: of his seventy previous opponents,
fifty-one had been floored. He also carried a bullet from a .357 Magnum revolver lodged in
his abdomen, given to him by a policeman at whom he had lashed out one evening.
Yet Ali's obliteration of Williams in three rounds was described by the *Miami Herald* as
'one of the most awesome artillery exhibitions in boxing history'. Williams was put onto
the ropes four times in the third round alone before he finished up level with the ground.
Ali was dazzling. Another commentator marvelled at the combination of 'cobra and
jackhammer' on display.

   The fight, one of Ali's finest ever performances, introduced the world to the 'Ali Shuffle',
a cocky dance indicative of his unconventional style, for he moved, as everyone could
see, like a lightweight. In the space-age setting of the Astrodome, it also gave rise to one
of the most spectacular sporting images yet taken. The photographer Neil Leifer knew
that in order to fulfil the expectations of the crowd and to cope with the vastness of the
arena, the lighting rig would be jacked up to over eighty feet above the ring so everyone
could see. He simply attached his square-format camera to it. The ring from overhead in
perfect quadrilateral symmetry was his blank canvas and, as his flash slowly recycled –
once every eight to ten seconds – he chose his moment with precision. The result was
sensational: in one corner Ali raised his arms high into the air in victory; towards the other,
Williams, his hands also above his head in a horizontal parody of the drama opposite him,
lay prostrate as the referee counted him out.

   Ali was all but invincible, but six months after his bout with Williams, he encountered an
opponent that would also be swept aside but at a certain cost. On 9 May 1967
Muhammad Ali faced the United States Army Draft Board. He refused to be inducted.
'I won't go to kill people simply to continue the domination of the white slave masters,'
he insisted. Three years previously, in February 1964, after his victory against Sonny Liston
which gave him for the first time the world heavyweight title, he had called a historic press
conference. He announced solemnly and with uncharacteristic restraint that he had made
the decision to abandon his given name of 'Cassius Clay', and was to be known
henceforth as 'Muhammad Ali'. At the age of twenty-two, a household name and a
figurehead for the black youth of America, Clay had embraced the Nation of Islam (fig.5),

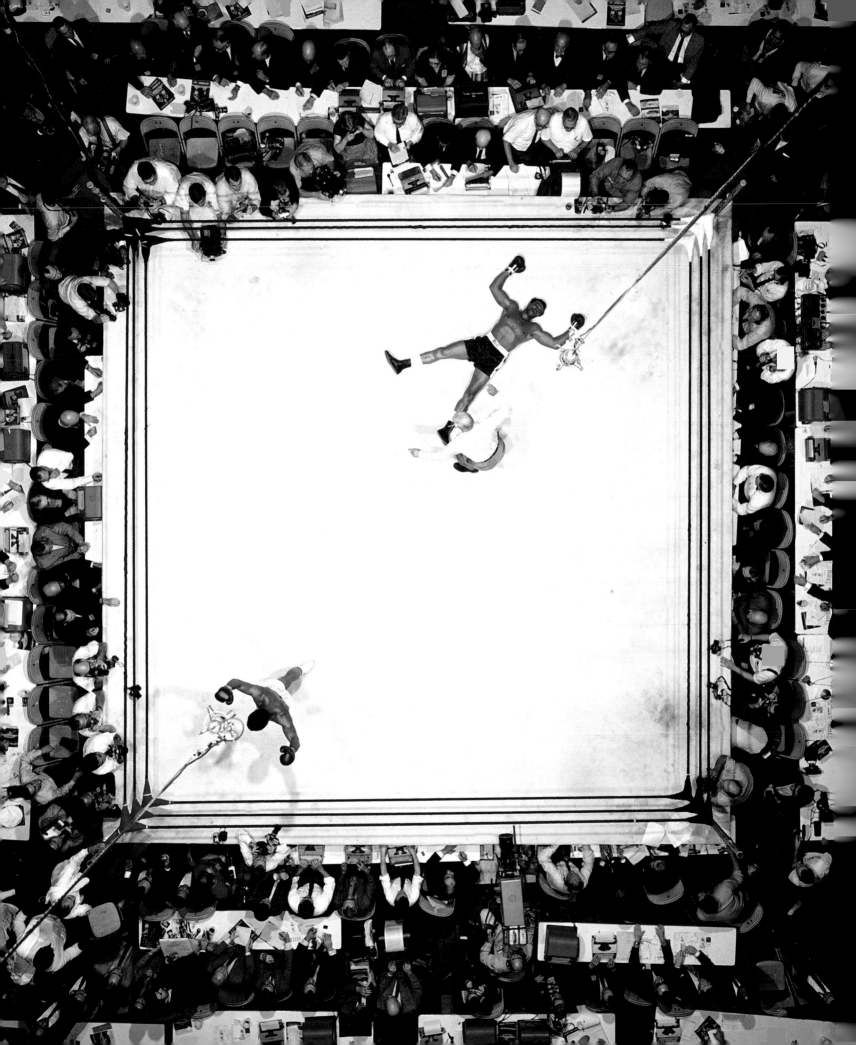

2

2 Poster for Cassius Clay vs 'Sonny' Liston
Photographer Unknown, 1964

Ali had beaten Liston in seven rounds in February 1964.
Liston had been unbeatable for the previous nine years.
A return bout was planned for the following November
and posters printed. Three days before the fight, Ali was
diagnosed with an acute hernia condition and the fight
was postponed until the following year. A surgeon at
Boston City Hospital recalled: 'It was such a marvellously
developed stomach, I hated to slice it up …'

Opposite
3 Cassius Clay vs 'Sonny' Liston, Lewiston, Maine
Neil Leifer, 1965

'Just a dream moment for a photographer' was
how Neil Leifer described this scene from the 1965
heavyweight title fight. It is one of the best-known
images of Muhammad Ali (he was by now using his
chosen name, though posters still referred to him as
Cassius Clay). The frame before this shot shows Ali
landing the celebrated 'anchor' punch that destroyed
Liston in the first round of a fight that lasted roughly
one-and-a-half minutes. This blow was as much of a
secret weapon as the 'psyching-out' of Liston that
preceded the fight.

a separatist movement notorious for its radicalism and led by a compelling figurehead, Elijah Muhammad. 'I am no longer a slave,' Ali further declared. The greatest sports titles meant nothing, he continued, if he could not 'be free'. Where pictures once caught him in moments of victorious exultation or stage-managed comedy, they now showed him surrounded by more serious figures, including the spellbinding, subversive orator Malcolm X (fig.6).

Ali's defiant refusal to do military service in Vietnam helped define forever what sporting figures could achieve and acted as a reminder to the authorities of the sway this charismatic figure possessed. His unswerving obeisance to Elijah Muhammad and his considerable articulacy were uncomfortable to an America that had so far relished his buffoonery and showmanship. In the run-up to his Draft Board appearance, those who might have thought his politicisation was waning were proved wrong. On 6 February 1967 he faced Ernie Terrell, widely touted as Ali's most dangerous opponent since Liston. The customary pre-bout mockery was as sinister as the fight would be savage: 'I had a question for him when we met to sign. It was only three words – "What's my name!" And Terrell said "Cassius Clay", using my slave name. That made it a personal thing.' He continued: 'I'll keep on hitting him and I'll keep talking. Here's what I'll say: "Don't you fall, Ernie." Wham! "What's my name!" Wham! I'll just keep doing that until he calls me Muhammad Ali. I want to torture him.'

Terrell was convincingly beaten over fifteen rounds, but the brutality of the last eight had alarmed many. 'Somebody,' as one commentator put it later, 'had pushed the wrong button that night … it was a side so out of character that to this day I find it hard to believe it was him.' In the seventh, Ali slammed Terrell time and again in the side of the head before a swingeing right uppercut opened a large gash that was already creasing his right eye. Next Ali slammed his face. The ninth saw Terrell bleeding badly as Ali asked him 'What's my name!' After a flurry of punches, Terrell was all but blinded and now bleeding profusely from both eyes and his nose. Afterwards Terrell explained: 'I would have fought him harder, only I couldn't see …' Ali had removed the last serious contender for the heavyweight crown. The only opponent awaiting the undisputed heavyweight champion of the world was Uncle Sam and his jabbing finger.

Ali's anti-war stance was considered a flagrant betrayal of his country and America was enraged. None were more vocal than the boxing fraternity, several with scores to settle. Gene Tunney: 'You have disgraced your title and the American flag and the principles for which it stands.' Jack Dempsey: 'He [Ali] should be careful. It's not safe for him to be out on the streets …' But he had staunch, if unlikely defenders. 'They will try to break you,' the Nobel Prize Winner Bertrand Russell told him, 'because you are a symbol of a force they are unable to destroy, namely, the aroused consciousness of a whole people …' Later, for the cover of *Esquire* in November 1969, Truman Capote and other writers stood in a boxing ring, claiming that it was only within its ropes that Ali's title could be taken from him. An accompanying open letter in defence of the champion was signed by, among others, Dirk Bogarde, Igor Stravinsky, Peggy Lee and Rear Admiral Arnold E. True.

Ali's fall was swift. He had been stripped of his title, his licence to fight and his passport. He received in addition a $10,000 fine and over him loomed a five-year jail sentence. It was revealed too that Ali's $3.8 million career earnings, much of it believed to have swollen the war chest of the Nation of Islam, had been dissipated. What was left, it was further conjectured, funded lifestyles for an entourage composed intermittently of hustlers, gamblers and con men. He was also sued for $250,000 by his attorney and was paying

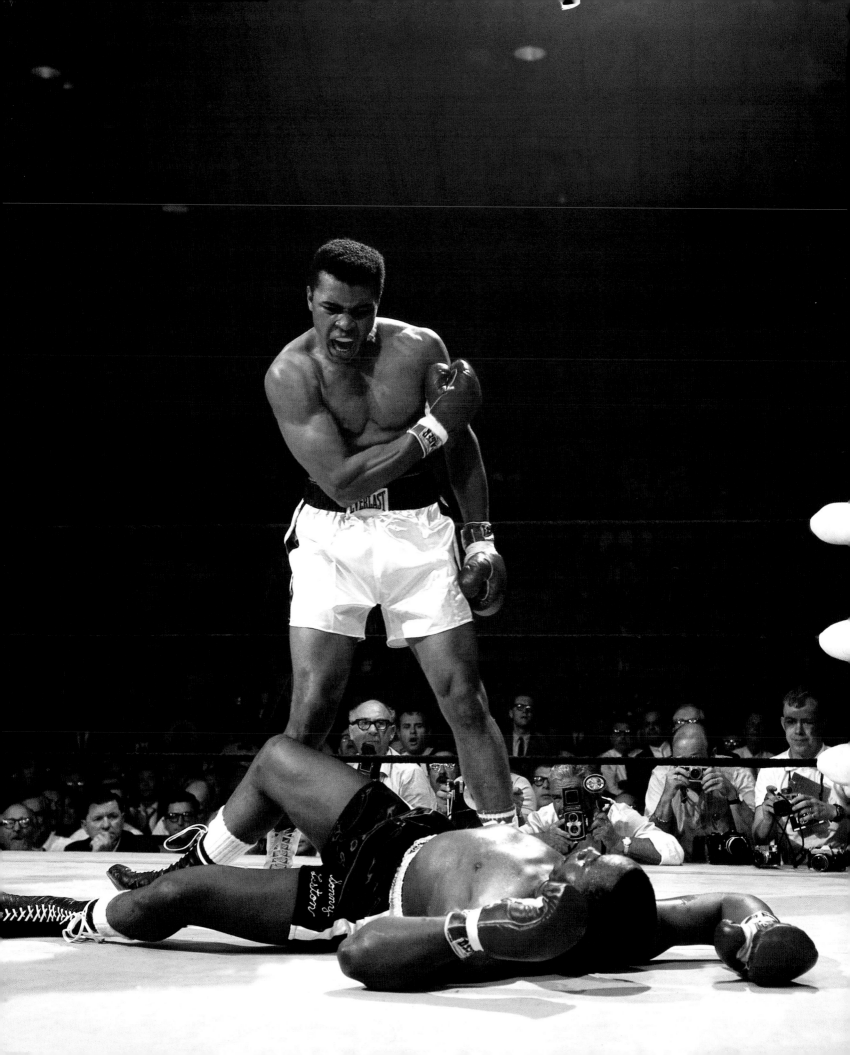

4

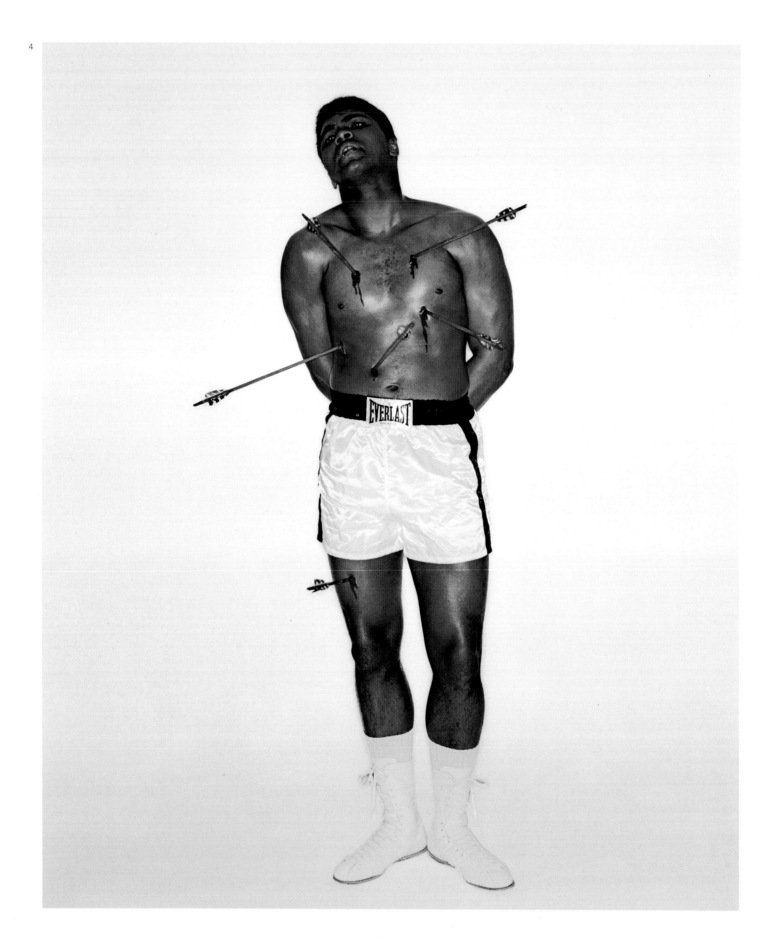

5 A Black Muslim Meeting
Roger Malloch, 1966

Ali, who had embraced the radical movement known as the Nation of Islam, remained a nightmare for white America and a hero for a generation of disaffected young people, both black and white. His refusal to do military service in Vietnam helped define what sporting figures could do and, as he stood in defiance, he acted as a reminder to the authorities of the sway this charismatic figure possessed.

6. Muhammad Ali and Malcolm X
Bob Gomel, 1963

Cassius Clay's natural exuberance was tempered by his association with figures of great significance to the civil rights struggle. In 1964 he abandoned the name Cassius Clay for one more indicative of his new beliefs: Muhammad Ali.

Opposite
4 'The Passion of Muhammad Ali'
Carl Fischer, 1968

Carl Fischer's concept for the cover of *Esquire* magazine (September 1968) provoked some anxiety in Ali, who felt that it might create ideological confusion. Andrea del Castagno's *The Martyrdom of St Sebastian*, upon which Fischer based his tableau, was clearly a symbol of Christianity and Ali's faith was fundamentally Islamic. The shoot went ahead. The ends of the arrows were tipped in fake blood, and then suspended on monofilament lines. *Esquire*'s art director greeted the result with 'Jesus Christ, it's a masterpiece!', an apposite comment, perhaps, in light of the context.

alimony to his first wife, who had refused to embrace his Islamic principles. Slowly the crowds of admirers that he had taken for granted moved on, and camera lenses were trained elsewhere.

His friend the photographer Howard Bingham did not desert him. Instead, in these wilderness years, he produced a series of haunting and intimate portraits of the fallen idol. As Ali faced up to the privations of real life outside the ring, Bingham allowed him, for the first time, to be simply himself. Slowly Ali appeared to the world not as America's greatest nightmare but as a genuine hero. The more his own homeland vilified him, the more his stature increased overseas, though he was unable, due to the confiscation of his papers, to enjoy it. By the late 1960s, Ali was a fixture on college campuses across the nation, a rallying point for the disaffected young, both black and white. In a debate at Harvard he took on Henry Kissinger and received a standing ovation. In April 1968 *Esquire* magazine put him on its cover, photographed by Carl Fischer as a latter-day Saint Sebastian (after the painting by Andrea del Castagno), the arrows of die-hard patriotism and colour prejudice transfixing him (fig.4). *Esquire*'s art director, George Lois, managed to get Ali to agree to this tableau (a symbol, after all, of Christian martyrdom) only after a lengthy theological debate with Elijah Muhammad. The result was sensational.

By 1970 the body count from Vietnam had reached 50,000 and Ali was no longer a barely audible, minority voice. Thousands started to take to the streets in protest and Ali's otherwise extremist views (for example, on the role of women) and his still divisive racial politics were overlooked in favour of his anti-war sacrifice. 'I tell you,' he once said, 'if the average man had my problems he'd be jumpin' out the window.' But as Bingham's photographs reveal, Ali had met adversity without bitterness and with a tenacity for keeping himself somehow in the public eye, despite darker moments when he would drive aimlessly for hours on end, attempting in solitude to re-evaluate his circumstances: 'I drive up to Milwaukee and when I get there, I turn back.'

It was in Atlanta, Georgia, that Ali was allowed to fight 'Irish' Jerry Quarry (fig.16). In 1971 the Supreme Court overturned Ali's conviction and his licence to fight was renewed. But the years away from the ring had taken their toll on Ali's health, fitness and his

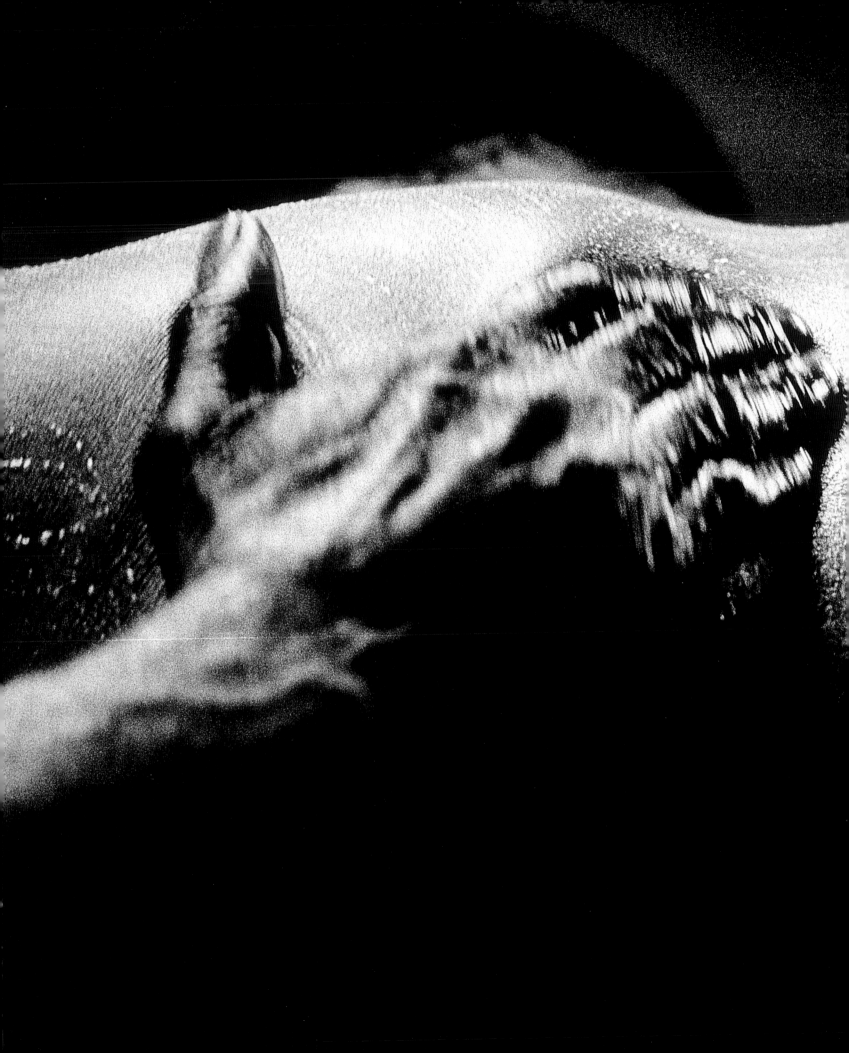

8

8 Hoarding Advertising 'The Rumble in the Jungle'
Abbas, 1974

For the first time the heavyweight championship would
be held in black Africa, in Zaire. Ali did not underestimate
the resonance: 'I am not fighting for fame or money.
I'm not fighting for me. I'm fighting for the black
people who have no future … I want to win so I can
lead my people.'

Preceding pages
7 Ali in Training for 'Superfight II', Deer Lake,
Pennsylvania
David King, 1974

Ali's opponent would be Joe Frazier. The hand upon
Ali's back belongs to Louis Seria, one of his training
team. The photographic historian Bruce Bernard
particularly admired this image of which he wrote,
'this gnarled old hand with its slight movement blur
is one of the greatest hands in all photography'.

Opposite
9 Muhammad Ali vs George Foreman, Zaire
Abbas, 1974

At 4am, in Kinshasa, Ali unveiled the 'rope-a-dope'
strategy that slowly unravelled Foreman. By withstanding
Foreman's flurried punches, which never truly connected,
he ebbed the reigning champion's strength. He was
supposed to put Ali on the ropes but for some reason
Ali was already there, at the angle, the writer George
Plimpton noticed, 'of a man leaning out of a window
to see if there's a cat on his roof'.

legendary agility. For the first time he was defeated. He realised that a new strategy was
needed if he was ever to regain his incontestable dominance. In 1974, at the age of
thirty-two, he began preparations for the biggest challenge of his professional career –
restitution of the heavyweight title from George Foreman. He enclosed himself in his
training camp at Deer Lake, Pennsylvania, away from the distractions of fame and the
intrusion of the media. He focused his energies on beating an opponent who was
regarded, even by Ali's staunchest admirers, as utterly invincible. But Ali knew that one
method of out-psyching his opponent was to reclaim the pages of newspapers and
magazines. One photographer penetrated the sanctuary of Deer Park and was given
unique access to Ali's rigorous training regime. Bill Peronneau (fig.17) was given just
fifteen  minutes in the inner sanctum, previously uninfiltrated by the press, to document
Ali the contender, now facing his last chance to prove himself 'The Greatest of All Time'.
The run-up to the legendary 'Rumble in the Jungle' had begun. Ali, as ever, was
calling the shots.

But Peronneau's photographs displayed none of the stage-management that followers
had come to expect. Instead, the photographer recalled: 'I always knew there was
another side to this loudmouthed showman. I felt instinctively that his bravado masked a
deeply private and spiritual man who had a lot more depth to him than his media image
suggested.' In Peronneau's ten usable shots, he captured the essence of the private Ali,
unprotected by an entourage. They showed that the man whose phones had been
tapped, who was put under 24-hour surveillance by the FBI and who had been routinely
denigrated as a subversive influence, was at peace with himself and that this might be the
secret weapon he needed. Ali, by this time, had also turned his back on the philosophies
of the Nation of Islam. Peronneau captured the moments of privacy before Ali took on the
world again, catapulting himself back into the international spotlight.

For the first time the heavyweight championship would be held in black Africa, in Zaire
(figs 8, 9). Ali understood the message. Foreman had appeared unconquerable, his
punches arriving, as one observer put it, 'with the impact of a wrecking ball'. He had won
every professional fight he had started and, at twenty-five years old, was seven years Ali's
junior. On 30 October 1974 Ali stunned a public that had all but written him off as bloated
and washed up. At 4am in the gathering humidity of dawn in Kinshasa, Ali landed the first
blow, straight to the middle of Foreman's forehead. Next, he allowed himself to be
pummelled again and again by Foreman against the ropes. Then he stood stock-still.
'Move for Christ's sake, move!' yelled Angelo Dundee, Ali's long-time trainer, but Ali
refused to dance, or to trade blows. The famous agility that had felled Liston and all the
others had clearly gone. But everything had a purpose and Ali's tactic, the 'rope-a-dope'
technique honed in Deer Lake, slowly revealed itself through the first five rounds to a
bewildered Foreman. In the eighth round, Ali slammed Foreman with a left hook and,
dazed, Foreman went down after a right slammed him again. Foreman had exhausted
himself and Ali had gone in for the kill. After ten seconds, pandemonium broke out,
hysterical fans mobbed Ali's corner and riot police had to force a passage back stage.
And then the rains came; a tropical downpour of such ferocity that, had they arrived two
hours earlier, would have flooded the stadium. Ali was mindful of his night of destiny.
'You'll never know how long I waited for this,' he said with measured calm. 'You'll never
know what this means to me.'

In 1964, Ali had become heavyweight champion for the first time and had proved
irresistible to photographers, his self-confidence chiming with the climate of hope and

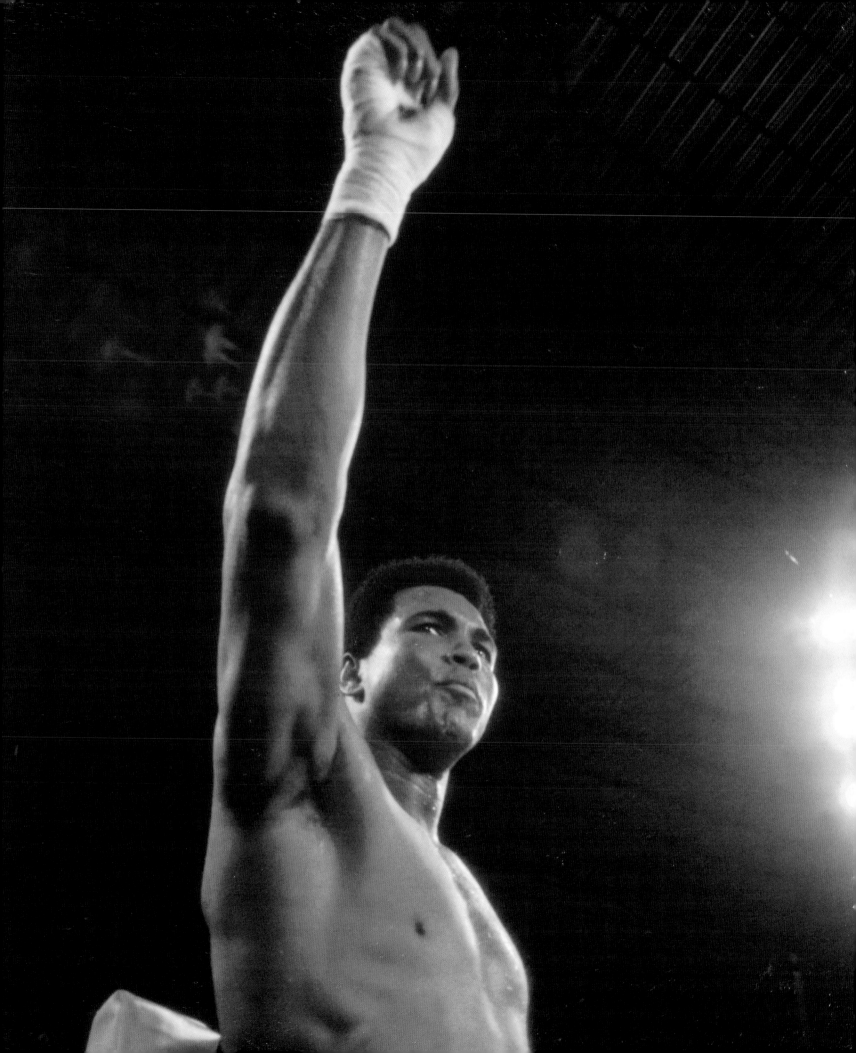

10

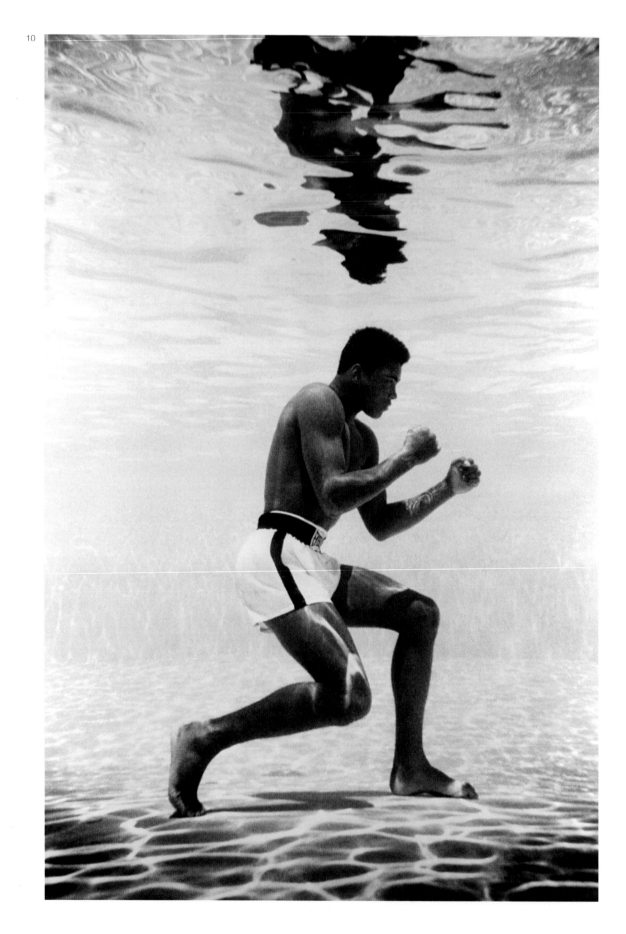

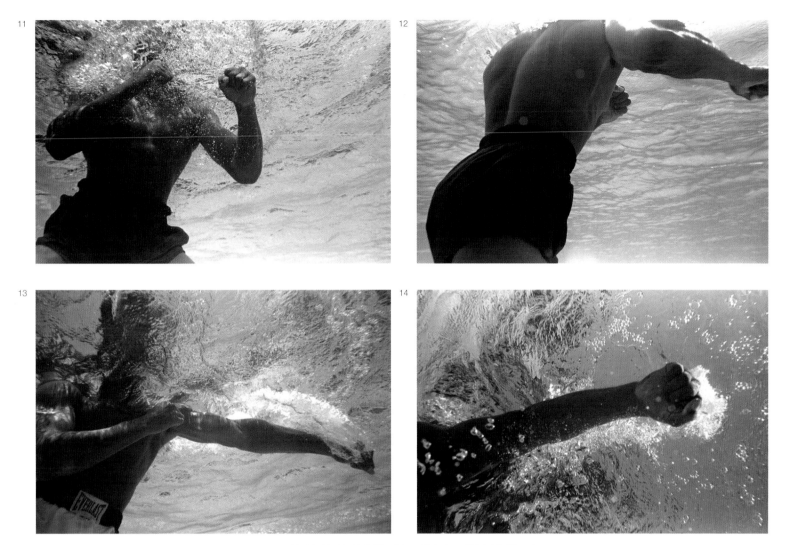

10, 11, 12, 13, 14 'A Wet Way to Train for a Fight', *Life* Magazine
Flip Schulke, 1961

In September 1961, *Life*, America's most popular general interest magazine, featured Ali in a double-page of photographs. These swimming pool shots were taken at Ali's instigation, the young boxer claiming that underwater sparring was a vital part of his training regimen. In pugilistic stance, Ali (still Cassius Clay) looked like nothing so much as a Hellenic statue salvaged from beneath the Aegean. The pictures were, recalled photographer Flip Schulke, some of the best he had ever taken. 'Not to be bragging or anything like that,' Clay told *Life*, 'but they say I'm the fastest heavyweight in the ring.' He concluded, 'That comes from punching underwater.' In fact it didn't. It was all an elaborate fabrication, made up with the collusion of his trainer Angelo Dundee to gain Ali maximum exposure in the widely read magazine. At this early point in his career, he could not swim but he showed great promise as a media manipulator.

15

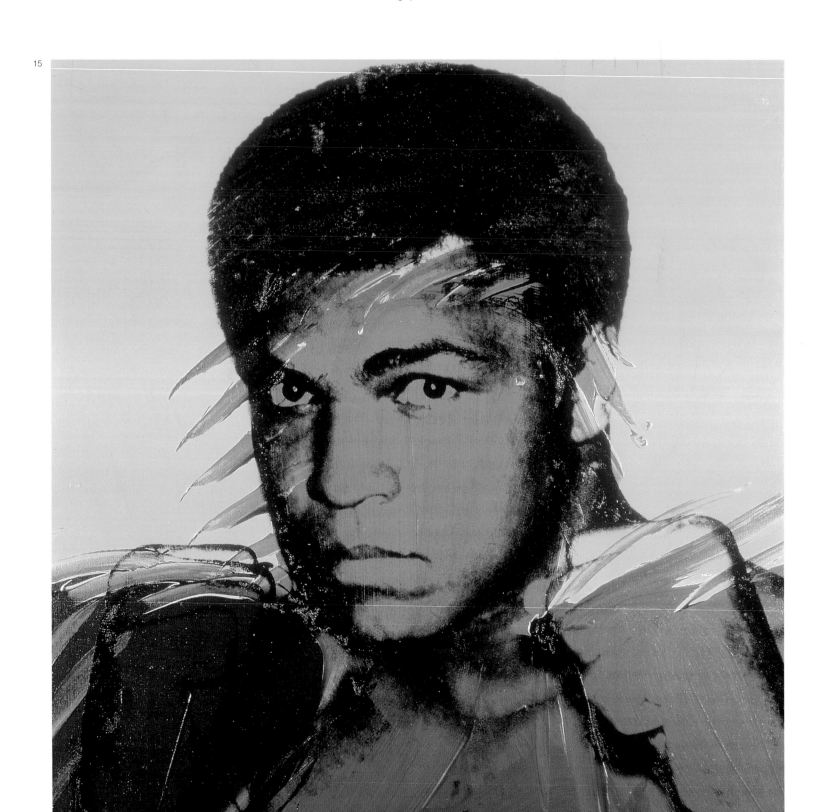

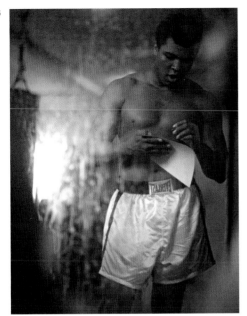

16 Ali Training at Chris Dundee's Gym, Miami, Florida
Thomas Hoepker, 1970

Despite long periods of inactivity – and invisibility - a new
decade found Ali continuing to attract photographers as
moths to a flame. A documentary photographer for the
Magnum agency, Hoepker's best-known photographs
of the boxer show him in more pugilistic attitudes but this
image of the fighter, reflected in a mirror, is a more
impressionistic vignette .

Opposite
15 Portrait of Muhammad Ali
Andy Warhol, 1977

In 1977, at Deer Lake, Andy Warhol cemented Ali's
position as one of the world's most recognisable faces.
This photograph became Ali's all-time favourite portrait of
himself. When he saw the finished piece, he declared
that he looked fearless, but that he saw a softness and
compassion too.

Overleaf
17 Still Life at Deer Lake, Pennsylvania
Bill Peronneau, 1974

As Ali faced one of the biggest fights of his career, he
allowed one photographer to document his regimen at
the secluded training camp at Deer Lake. Bill Peronneau
was allowed access into the heart of Ali's private
sanctum – but for fifteen minutes only. He photographed
not only the fighter at home but also several emblematic
still lifes, their quiet simplicity contrasting with the media
circus outside.

liberalism, the legacy of its youthful President, John F. Kennedy. Now ten years older, he
was just as alluring, his manipulation of the world's press just as skilful. These assets had
come to the fore in 1960, shortly after he had won an Olympic gold medal in Rome and
had turned professional. Ali was desperate for the imprimatur an appearance in America's
mass circulation magazine, *Life*, would bring, but knew that his recent successes were
not a big enough draw. He discovered that the photographer Flip Schulke was a
specialist in underwater photography and revealed to him his secret: a training regimen
underwater. Schulke agreed that this could be an exclusive for the magazine. The
pictures duly appeared in the 8 September 1961 issue illustrating the amazing training
technique of the 19-year-old boxer (figs 10-14). But it was all a masterful scam. Ali had
never trained underwater. He could not even swim but he had revealed an early and
estimable ability for self-promotion and media manipulation.

Ali's charisma out of the ring became part of an elaborate strategy to outwit his
opponents in it. This psychological warfare devastated his first serious opponent, Sonny
Liston, before their historic meeting on 25 February 1964. And it was further proof of Ali's
ability to ensure the mass media picked up on his every startling, controversial move.
Howard Bingham recalled that Ali and his entourage drove a bus to Liston's house in the
dead of night, whereupon Ali goaded the 'big, ugly bear' to come out and fight on the
spot. If he had peered out, Liston would have found a bear-trap planted on the lawn
outside his window – and the local press.

At the weigh-in a few days later, Ali whipped up a media frenzy by feigning mental
illness. Jim Murray of the *Los Angeles Times* wrote that his public utterances 'have all the
modesty of a German ultimatum to Poland'. The cover of *Sports Illustrated* had him
sitting on top of $1 million, representing what the young fighter had earned in his career
so far. But as the *Miami Herald* put it, in a parody of Ali's sing-song vernacular, 'the
Money's on Sonny to Put Clay Away'. Yet Ali would prove them wrong. He achieved a
technical knockout in seven rounds and was the new heavyweight champion of the world
(figs 2, 3). He announced afterwards, 'I'm so great. I'm so great. I shook up the world.
Wasn't that so good? Tell me, I AM THE GREATEST.' A week after his victory, Ali – still
Cassius Clay – made the cover of *Life*.

The Liston fight of 1964 and the Frazier fights of 1974 (fig.7) and 1975 fixed Ali as an
almost mythological figure, an icon of contemporary popular culture, a redemptive figure
who had taken on America, lost and won again. Total fights: 61. Won: 56. Lost: 5.
Knockouts: 37. In an astonishing career, Ali had become symbolic of many things: of
bravado and defiance, of skill and conviction, of athleticism and self-confidence, and
perhaps of beauty too. His presence was mercurial. Hundreds of photographers took his
picture but only a handful – Bingham, Peronneau and, unexpectedly, Andy Warhol (fig.15)
– revealed a side to Ali that approximated to the truth.

Ali was made aware of the effect of the visual image from an early age. While working
with his biographer, he reflected on the first photographs to have made an impression on
him. In the summer of 1955, with the Southern states of America still racially segregated,
a 13-year-old Clay glimpsed images in the black newspapers that marked him profoundly
for life. Emmett Till, a boy not much older than he, was lynched, his beaten body thrown
into the Mississippi. His crime had been to flirt with a white woman. An all-white jury
acquitted his three killers in just over one hour's deliberation. That photography had
immeasurable power had not been lost on the young Cassius Clay. That photography
could embody tension, flamboyance and drama was never lost on Muhammad Ali.

# Picture credits

pp.2-3 Getty Images/Time Life; p.13 © HM Queen Elizabeth II 2005/Royal Collection/Roger Fenton; p.14 © HM Queen Elizabeth II 2005/Royal Collection/William Constable (attrib.); p.15 © HM Queen Elizabeth II 2005/Royal Collection /Henry Collen (attrib.); pp.16-17 © HM Queen Elizabeth II 2005/Royal Collection/William Kilburn; p.18 Mary Evans Picture Library; p.19 © HM Queen Elizabeth II 2005/Royal Collection/John Mayall; p.20 t&b NPG/Charles Clifford; p.21 V&A Images/Victoria & Albert Museum; p.22 NPG/John Mayall; p.23 courtesy Private Collection, London/Roger Fenton; pp.24-5 Getty Images/W. & D. Downey; p.26 NPG/Lafayette; p.27 tl Getty Images/Robert Milne, bl © HM Queen Elizabeth II 2005/Royal Collection/Gustav Mullins, r Courtesy Private Collection, Surrey/Charles Knight; p.28 NPG/Anon.; p.29 and jacket NPG/Bassano; p.33 and jacket GhandiServe Foundation/D. R. D. Wadhia; p.34 tl Getty Images; p.34-5 Getty Images/Margaret Bourke White; p.36 Getty Images/Elliott & Fry; pp.37, 38t GhandiServe/ Vithalbhai Jhaveri Collection/Anon., 38b GhandiServe/Kallenbach Archive/Anon; p.39 NPG/Elliott & Fry; pp. 40-1 GhandiServe/Vithalbhai Jhaveri/Anon.; p.42 Getty Images/Topical Press; p.43 GhandiServe/Vithalbhai Jhaveri/Anon.; p.44 *Vogue*/ © The Condé Nast Publications Inc./Constantin Joffé; p.45 t, cl, br GhandiServe/Vithalbhai Jhaveri/Anon., bl Popperfoto/Anon.; p.46 © Magnum Photos/Henri Cartier-Bresson; p.47 GandhihServe/ Kanu Gandhi; pp. 51-2, 53 tr Rudolf Herz Collection /Heinrich Hoffmann, 53 br Bayerische Staatsbibliothek/Heinrich Hoffmann; p.54 BPK/Heinrich Hoffmann; p.55 Ullstein Bild/Heinrich Hoffmann; pp.56-7 Wiener Library, London/Heinrich Hoffmann; pp.58-60 Getty Images/Hugo Jaeger; p.61 V&A Images/Victoria & Albert Museum, r Walter Frentz Archive, Berlin/Walter Frentz; p.62 Getty Images/Heinrich Hoffmann; p.63 Ullstein Bild/Anon.; p.64 *Homes & Gardens*/Heinrich Hoffmann/courtesy Christopher and Diana Carr; p.65 Photo-Baumann-Schicht/Ernst Baumann; pp.66-7 Walter Frentz; p.68 t © Lee Miller Archives/Lee Miller; p.68-9 Walter Frentz; p.73 *Vanity Fair*/ © The Condé Nast Publications Inc./Arnold Genthe; p.74 Kobal Collection/Don Gillum; p.75 l Courtesy Robert Dance Collection/R. H. Louise, r Courtesy Private Collection, Surrey/Bertram Longworth; p.76 tl, bl *Vanity Fair*/ © The Condé Nast Publications Inc./Edward Steichen, r Getty Images/Clarence Sinclair Bull; p.77 Robert Dance Collection/R. H. Louise; p.78 NPG/Fox Photos; p.79 and jacket NPG/C. S. Bull; p.80 NPG/C. S. Bull/ Cecil Beaton; p.81 Rosenbach Museum and Library, Philadephia/ Bull et al; p.82 Cecil Beaton Archive/Sotheby's, London/Cecil Beaton; p.83 NPG/Cecil Beaton; p.84 © Harry Benson; p.85 *Vanity Fair*/© The Condé Nast Publications Inc./Miguel Covarrubias; p.86-7 Courtesy Barry Paris/Ted Leyson; p.91 © Magnum Photos/Elliott Erwitt; p.92 tl Estate of Jacques Lowe/Jacques Lowe; pp.92-3 © Magnum Photos/Cornell Capa; p.94 tl Bettmann/Corbis/Anon., tr © Magnum Photos/Erwitt Collection/Anon., b NPG/ Dorothy Wilding; p.95 and jacket © Estate of Jacques Lowe/Jacques Lowe; p.96 © Magnum Photos/Cornell Capa; pp.97-8 Peabody Institute, Johns Hopkins University, Baltimore/Orlando Suero; p.99 *Vogue*/ ©The Condé Nast Publications Inc/Irving Penn; p.100 *Glamour*/ © The Condé Nast Publications Inc/Milton Greene; p.101 Library of Congress/Washington Star/Anon.; p.102 tl © Magnum/Wayne Miller; p.102-3 © Estate of Jacques Lowe/Jacques Lowe; p.107 Getty Images/Baron; p.108 Bert Stern; p.109 Getty Images/Anon.; p.110 t&b The Estate of André de Dienes/Ms Shirley de Dienes/OneWest Publishing, Beverley Hills/André de Dienes; p.111 c Tom Kelley Studios/Tom Kelley; p.112 Photofest/Anon.; p.113 Getty Images/*Life* Magazine/Philippe Halsmann; p.114 Courtesy of Elaine Schatt/Roy Schatt; p.115 Kobal Collection/Anon.; p.116 NPG/Cecil Beaton; p117 l, c, r Shaw Family Archives/Sam Shaw; p.118 Popperfoto/Anon.; p.119 and jacket Shaw Family Archives/Sam Shaw; p.120 Courtesy of the Barris Trust/George Barris; p.121 Shaw Family Archives/Sam Shaw; p.125 NPG/Cecil Beaton; p.126 Kobal Collection/Anon.; p.127 l Courtesy Audrey Hepburn Foundation/Anon., r Getty Images/Bert Hardy; p.128 tl *Vogue*/ © The Condé Nast Publications Ltd/Clifford Coffin, bl NPG/Angus McBean, r © Ben Ross; p.129 © Magnum/Dennis Stock; p.130 Kobal Collection/Anon.; p.131 Getty Images/*Life* Magazine/Anon.; pp.132-3 and jacket © Norman Parkinson Ltd/Norman Parkinson; p.134 NPG/Cecil Beaton; p.135 *Vogue*/© The Condé Nast Publications Ltd/Henry Clarke; pp.136-7 *Vogue*/ © The Condé Nast Publications Inc/Bert Stern; p.139 UNICEF/Betty Press; p.143 Cpi/ © Phil Stern; pp.144-6 © Magnum/Dennis Stock; p.147 James Dean Memorial Gallery/Anon.; pp.148-9 © Magnum/Dennis Stock, p.149 r Kobal Collection/Anon.; pp.150-1 Courtesy of Elaine Schatt/Roy Schatt; pp.152-3 © Magnum/Dennis Stock; pp.154-5 MPTV/Sanford Roth; p.159 and jacket © Alfred Wertheimer; pp.160-1 Courtesy Gerry Rijf/William V. Robertson (attrib.); p.162 Courtesy Gerry Rijf/Anon.; p.163 Courtesy Martin Harrison/Marvin Israel; p.164 © Alfred Wertheimer; p.165 © Lew Allen; p.166 © James Reid; p.167 Courtesy Gerry Rijf/Apger (attrib.) and Anon.; pp.168-9 © Alfred Wertheimer; pp.170-1 Courtesy Jochen Fey/Rudolf Paulini; pp.172-3 © Alfred Wertheimer; p.174 Courtesy Private Collection, London/Anon.; p.175 © Albert Watson; p.179 © Neil Leifer; p.180 Christie's Images/Anon.; p.181 © Neil Leifer; p.182 © Carl Fischer; p.183 l © Magnum/Roger Malloch; r Getty Images/Bob Gomel; pp.184-5 © David King; pp.186-7 © Magnum/Abbas; pp.188-9 © Flip Schulke; p.190 © Photo SCALA, Florence/Andy Warhol Foundation/Andy Warhol; p.191 © Magnum/Thomas Hoepker; pp.192-3 © Bill Peronneau.

# Acknowledgements

For their help in making this book and its accompanying exhibition possible, I am grateful to all the photographers whose work appears here and the administrators of their archives and, in many cases, their estates. I am, especially grateful to: Lew Allen; George Barris; Harry Benson; Carl Fischer; David King; Neil Leifer; Irving Penn; Bill Peronneau; Flip Schulke; Phil Stern; Dennis Stock; Albert Watson; Alfred Wertheimer.

For their generous sponsorship of the exhibition I would like to thank Taylor Wessing and especially Michael Frawley for his enthusiasm and for writing the sponsor's note.

I am also grateful to the following and their respective institutions: Kate Best (The Victoria & Albert Museum, London); Ian Blackwell (Popperfoto); Lucinda Blythe, Tito Magrini and Sue Daly (Sotheby's, London); Carole Callow, Arabella Hayes and Tony Penrose (Lee Miller Archive); Fiona Cowan and Leigh Yule (Norman Parkinson Ltd, London); Shirley de Dienes (The Estate of André de Dienes); Frances Dimond and Lisa Heighway, (The Royal Archives, Windsor); Lisa Dubisz (MPTV); Sean Hepburn Ferrer and Jessica Diamond, (Audrey Hepburn Foundation, Los Angeles); Hugo Flesichmann, Thomasina Lowe and Michelle Wild (Jacques Lowe Estate); Hanns-Peter Frentz (Walter Frentz Archive, Berlin); Frank Frischmuth (Ullsteinbild, Berlin); Anne Garside (Peabody Institute, Baltimore); Howard Greenberg and Jessica Blumenthal (Howard Greenberg, New York); Bill Hall (High Valley Books); Marek Jaros (The Wiener Library, London); Kim Lloyd-George (Carl Fischer Photography); David Loehr (James Dean Memorial Gallery, Fairmount); Norbert Ludwig (BPK, Berlin); Sarah McDonald, Helen Drew and Caroline Theakstone (Getty Images, London); Ron Mandelbaum (Photofest, New York); Angela Minshull (Christie's Images); Phil Moad and David Kent (The Kobal Collection, London); Chuck Murphy (OneWest Publishing, Beverly Hills); Angelika Obermeier (Bayerische Staatsbibliothek, Munich); Hugo Reyes (Creative Photographers, New York); Peter Rühe (GandhiServe Foundation, Berlin); Gary Saal (Pacific Licensing, Santa Rosa); Rudolf Schicht (Photo-Baumann-Schicht, Berchtesgaden); Karen Schoenewaldt (Rosenbach Museum and Library, Philadelphia); Larry Shaw, Edith Shaw Marcus and Meta Shaw Stevens (Shaw Family Archives, New Jersey); Nicky Sims (Lupe Gallery, London); Aaron Watson (Albert Watson Studio, New York); Sophie Wright, Head of Exhibitions, Hamish Crook and Nick Galvin (Magnum, London).

I am no less grateful to several private individuals, including lenders of items vital to the course taken by *The World's Most Photographed*: Christopher and Diana Carr; Robert Dance; Jochen Fey; Philippe Garner; Philip Gibson; Jennifer Gyr; Martin Harrison; Rudolf Herz; Barry Joule; Paul Lyon-Maris; Barry Paris; Gerry Rijf; Bill Roedy; Mimi Ross; Elaine Schatt; Michael Shelden; Dr Angelika Strittmatter; Gary Truman.

I have received enormous help from my colleagues at The Condé Nast Publications, both in London and New York: Harriet Wilson (The Condé Nast Publications Ltd, London); Janine Button, Brett Croft, Jooney Woodward and Jeb Crowell (Vogue Library, London); Anthony Petrillose, Leigh Montville, Michael Stier and Gretchen Fensten (The Condé Nast Publications Inc., New York); Cynthia Cathcart and Deirdre Nolan MacCabe (Vogue Library, New York).

It has also been a great pleasure to work again with the National Portrait Gallery, London and I would like to thank the following: Sandy Nairne (Director); Pim Baxter (Communications and Development Director); Howard Smith and Kathleen Soriano (Exhibitions); Rob Carr-Archer; Shirley Ellis, Pallavi Vadhia and Ruth Müller-Wirth (NPG Publications); Naomi Conway, Neil Evans, John Haywood, Jonathan Rowbotham and Hazel Sutherland (PR and Development); Roger Hargreaves; Jude Simmons; Claire Grafik; James Heard, and in particular for their specialist knowledge Terence Pepper and Clare Freestone (Archive) and for her tireless efforts in securing loans Claire Everitt (Exhibitions Manager).

I owe a special debt of gratitude to Denny Hemming for her editing of this book, to Celia Joicey for co-ordinating it and to Andrew Ross, who art directed and designed it.

I owe a great debt to the following members of the BBC, who have made this joint venture so enjoyable and I thank them for sharing their researches and their finished documentaries: Sally Benton; Louise Hooper; Emily Kennedy; Deborah Lee; Kate Misrahi; Victoria Page; Mark Bates; Ellen Hobson; Jon Morrice; Karen Bonnici; Natalie Breeden; Maurice May; Michelle Clinton; Imogen Cornwall-Jones; and especially, Chris Granlund, Series Producer and Kim Thomas, Executive Producer of BBC TWO's *The World's Most Photographed*.

Finally, it was my good fortune nearly two years ago to meet Joanne King, picture researcher to the BBC TWO series. It was still more fortunate that she agreed to co-ordinate the retrieval of the photographs to this book and further to assist with the exhibition. Both would be immeasurably poorer without her knowledge, determination and enthusiasm, for all of which I am very grateful.

**Robin Muir**
Author and Curator

The National Portrait Gallery would also like to thank the following for their assistance in the production of this book: Professor David Cannadine for reading the text, Alison Effeny for proofreading, Kate Phillimore for researching the chronologies and Vicky Robinson for compiling the index.

The staff of the BBC including Terri Belassie, Sarah Burgess, Imogen Carter, Mark Harrison, Sabreena Peedoly, Sharon Smith, Donna Spencer and *The World's Most Photographed* production team.

# Index